P9-DEK-614

Contents

DIGITAL
PHOTOGRAPHY
HACKS™

Derrick Story

O'REILLY®

Beijing · Cambridge · Farnham · Köln · Paris · Sebastopol · Taipei · Tokyo

Digital Photography Hacks™
by Derrick Story

Copyright © 2004 O'Reilly Media, Inc. All rights reserved.
Printed in the United States of America.

Published by O'Reilly Media, Inc., 1005 Gravenstein Highway North,
Sebastopol, CA 95472.

O'Reilly & Associates books may be purchased for educational, business, or sales
promotional use. Online editions are also available for most titles (*safari.oreilly.com*). For
more information, contact our corporate/institutional sales department: (800) 998-9938 or
corporate@oreilly.com.

Editor:	Rael Dornfest	Production Editor:	Emily Quill
Series Editor:	Rael Dornfest	Cover Designer:	Hanna Dyer
Executive Editor:	Dale Dougherty	Interior Designer:	David Futato

Printing History:

May 2004:	First Edition.

RepKover™ This book uses RepKover,™ a durable and flexible lay-flat binding.

ISBN: 0-596-00666-7
[C]

Credits

About the Author

Derrick Story is a photographer, writer, and teacher. He starting hacking on cameras long before his first shave, date, or kiss. Most likely, this passion for tinkering delayed the latter two by many years. During the formative period of his career, he was much better at taking cameras apart than putting them back together. He learned that duct tape leaves a nasty residue on glass optics, that plastic bags aren't always watertight, and that just because you think something should work a certain way doesn't mean it will.

Now, more than 30 cameras later, he runs his Northern California photo business, Story Photography (*http://www.storyphoto.com*), writes articles and books for O'Reilly & Associates, and teaches digital photography at technology conferences such as Macworld Expo.

You can read Derrick's online articles at MacDevCenter (*http://www.macdevcenter.com*) and check out his other books at O'Reilly's web site (*http://www.oreilly.com*), including the *Digital Photography Pocket Guide*, *Digital Video Pocket Guide*, and *iPhoto 4: The Missing Manual*.

Contributors

The following people contributed their writing, images, and creative souls to this project. Without them, this book would not have the diversity and charm that is imbued by their efforts.

- Jan Blanchard is a freelance photographer in Northern California who believes there's no such thing as too much magnification. When she doesn't have her lens hood buried in the pistils and stamens of flowers, you can find her shooting weddings and building digital slideshows on her iBook. You can see more of her work at *http://homepage.mac.com/photogal*.

- David Goldwasser is the owner of Inertia, LLC, which he started in 2000 to provide visual media services to the design and construction industry. He is a lifelong photography enthusiast who racked up seven years' experience in the architectural field prior to venturing out on his own. He has a Bachelor of Architecture degree from Tulane University and a Master of Construction Management degree from Washington University.

 David's focus is on high-resolution panoramic photography, as well as architectural, travel, landscape, and commercial photography. Not only does he love the art of photography, but he also loves exploring the science and technologies related to the capturing and application of digital images. If he's not busy working on a project, he's probably out finding new things to photograph or rigging up some odd-looking device or workflow to push photographic technology a little further along. You can email David at *info@inertia-llc.com* or visit his web site: *http://www.inertia-llc.com*

- Terrie Miller is the Production Manager for the Online Publications Group of O'Reilly & Associates. For fun, she maintains PointReyes.net (*http://www.pointreyes.net*) and is a hawk-watch volunteer for the Golden Gate Raptor Observatory (*http://www.ggro.org*) during the fall raptor-migration season.

- Todd Ogasawara focuses on two distinct topics. The first is Mobile Workforce and Mobile Lifestyle technology, with special attention paid to the Microsoft Windows Mobile platform (Pocket PC and Smartphone). Microsoft has recognized his demonstrated practical expertise and willingness to share his experience by recognizing him as a Microsoft Most Valuable Professional (MVP) in the Mobile Devices category.

 His other technology focus is in the effort to bring commercial (especially Microsoft-related products) and GNU/open-source software together in a synergistic and productive way. For lack of a better term, Todd calls this concept Eccentric Technology.

 Todd has written several articles related to mobile devices, including camera phones, for the O'Reilly Network Wireless DevCenter (*http://www.oreillynet.com/wireless/*). He previously worked as a technology analyst for GTE/Verizon. He also served as the contracted Forum Manager for the MSN (and later ZDNet) Telephony Forum and Windows CE Forum. More recently, he served as project lead to develop an intranet portal for the State of Hawaii using open source tools.

 You can find Todd's Mobile Workforce and Lifestyle commentary at *http://www.MobileViews.com*. You can learn more about Eccentric Technology at *http://www.OgasaWalrus.com*. For comments related to

camera phones, you can reach Todd by email at *Phone-Cam@OgasaWalrus.com.*

- Mike Pasini edits Imaging Resource's Digital Photography Newsletter (*http://www.imaging-resource.com/IRNEWS*), helping subscribers "get the picture" with tutorials, reviews, columns for beginners and pros, real-life adventures, and free, personal technical help. Shorter than he appears in print, he has escaped serious injury behind the lens and the keyboard thanks only to the hacks he has gleaned from family, friends, and nearly perfect strangers. He's happy to share a few favorites here, not just to help reduce the need for medical care but also to express his gratitude.

- Hadley Stern is a designer, writer, and photographer residing in Boston, MA. Hadley was born in London, England, relocated at age 4 to Singapore, then to Canada at age 10, and finally to America at age 22, where he met his lovely wife, Meiera.

 Hadley studied creative writing and western civilization and culture at Concordia University before studying graphic design at the Rhode Island School of Design (RISD). While at RISD, he began to pursue photography seriously, working in black and white and color and always experimenting with different techniques, including learning how to print Cibachromes.

 Since graduating from RISD, Hadley has worked as a professional designer at Malcolm Grear Designers, Rykodisc Records, and Razorfish. He has worked on corporate-identity projects, CD packages, web sites, flash banner advertising, and a wide variety of print collateral. Equally adept as both a print and interactive designer, he uses his technical knowledge of design production to further enrich his photography. Hadley now works as a freelance designer, consulting with various clients. His personal site is *http://www.hadleystern.com.*

 Hadley also finds time to photograph, working in a variety of media, both digital and traditional. His current tools include a Canon EOS Elan IIE, Bronica ETRS, Graflex Speed Graphics, a Canon S50, a PowerMac G4, and a Jamcam. His work has been exhibited in Kentucky, Providence, Newport, and Kansas.

 Hadley has written for WebMonkey, *American Photo* magazine, and iPodLounge.com, and is the Publisher and Editor-in-Chief of AppleMatters.com. AppleMatters is a serious yet irreverent look at all things Apple. Covering opinions, news, and interviews, AppleMatters has done tremendously well since its launch over a year ago. Design, writing, photography—each informs the others.

- Andrzej Wrotniak ("Un-jay," if you want to pronounce it right) is a long-time amateur photographer, computer enthusiast, and web publisher. In his free time, he is also a chief scientist and software engineer at a small aerospace company in Maryland, working with air traffic applications. A physicist by education, he spent 16 years in cosmic ray research in his native Poland before settling in the United States 20 years ago.

 Andrzej's eclectic web site (*http://wrotniak.net*) provides about 300 pages of original material, including photography (mostly digital), travel, and a number of shareware Windows applications: some advanced math tools for scientists and engineers, but also an addictive puzzle game.

 His articles on photography range from in-depth, technical reviews of selected digital camera models, through general how-to articles, to a historic section on the first 35mm SLR ever made. His web site also includes a number of photo-gallery pages, with high-resolution images from Uzbekistan, Japan, the Outer Banks, Monument Valley, and more.

 When you visit his web site (refreshingly, without any advertising, pop-ups, frames, or scripts), be prepared to spend quite a while. This is what the Web was supposed to be about. You can contact Andrzej at *andrzej@wrotniak.net*.

Acknowledgments

I'm indebted to the contributors to this book, who shared their secrets to help readers better enjoy the art and science of photography.

None of this would have happened at all if Rael Dornfest hadn't called me one day at work and asked me who I thought might be a good author for this book. Thanks, Rael, for ringing me up! And I've so enjoyed having you as my editor.

I like the philosophy of the Hacks series and the format of these books. This approach brought out my creativity and helped me become a better writer. Dale Dougherty originated this series, and I tip my lens hood to his enduring ingenuity.

Finally, I know that having a writer in the family, or as a friend, requires patience and tolerance. I am blessed to have the support of those dear souls who touch my daily life, encourage my work, and endure my endless brainstorm of crazy ideas. And despite the disruptive influence I bring to their lives, they still love me. Thank you!

Foreword

Why Push the Envelope?

Capturing a decisive moment in the camera lens and knowing that you "got the shot" is one of the most satisfying feelings a photographer can experience. Best of all, it's an experience you can enjoy in the moment and then relive again later with others. And if you're lucky, when you share your image with others, they might also feel what moved you when you clicked the shutter.

You have to *pursue* photographs, not just in the physical sense—as I did when I traveled to Australia to work on *From Alice to Ocean*—but mentally and emotionally as well. Photography is a fascinating marriage of art and physics. It's a journey of the mind as well as of the body. And that's precisely why I'm drawn to this collection of photography hacks by Derrick Story.

The tagline for this book is "100 Industrial-Strength Tips and Tools." Here, *hack* is defined as a clever solution to an interesting problem. Anyone serious about taking good pictures knows that great photography is full of constant problem solving. When you find the solution, you're often rewarded with a striking image. This book can help you solve those problems—not just in the sense of choosing the correct aperture and shutter speed, but also in terms of looking at your photography in an entirely new way.

The hacks in this book range from the artistic, such as using infrared imaging to record striking landscapes, to cutting-edge consumer technologies, such as weblogging with a camera phone (known as *moblogging*). Each technique is an experience unto itself, and the book invites you to pick it up, open it to any page, and discover something new to do with your camera and your photographs.

The exploration of photography has been awakening the artist, scientist, and adventurer within us for over 100 years. And now, digital tools have opened doors we never knew existed. It's possible that by trying the techniques and exploring the concepts in this book, you might find your true photographic voice. And even if you feel you are well versed in the world of photography, it never hurts to speak a second language.

—Rick Smolan
Against All Odds Productions
http://www.America24-7.com

Preface

Photography attracts creative problem solvers. Masters such as W. Eugene Smith, Jerry Uelsmann, and Ansel Adams worked with more technical aces up their sleeves than a riverboat gambler. Their ingenuity and photographic prowess inspired this book.

If you were able to see an original contact print for Adams's "Moonrise, Hernandez," you'd realize that the raw photograph he took in 1941 looked much different from subsequent enlargements hanging on museum walls years later. By Adams's own admission, it was a difficult negative to print. He masked certain areas and intensified others. What is arguably Ansel Adams's most acclaimed picture required every ounce of his talent and creative problem solving. In other words, he hacked the heck out of it.

Our tools are different now. Instead of an 8" × 10" view camera, many photographers are toting pocket-sized digicams. What was once the red glow of a darkroom safelight has been replaced by the cool, white radiance of an LCD computer monitor.

I'm one of those heretics who believe that digitizing the photographic process has strengthened, not weakened, the medium. The practice of making creative imagery is more accessible to more people than ever. Access to innovation is what this book is all about.

Digital photography brings out the most wonderful things in people. An otherwise conservative businessman will shoot with carefree abandon when a digital camera is placed in his hands. Self-conscious teenagers transform into rock stars in front of a zoom lens, and senior citizens become instant and adept historians.

Digital photography encourages you to take risks. If it doesn't work out, erase it before anyone knows. The path to photographic success is littered with discarded pictures that no one ever saw.

I hope this book helps you take lots of pictures and that you find things here that you would never have dreamed of trying. Nothing could make me happier than to hear that you took a creative risk and ultimately succeeded. If that happens, please write me at *dstory@storyphoto.com* and tell me all about it.

Most of us will never enjoy the acclaim of W. Eugene Smith, Jerry Uelsmann, and Ansel Adams. That isn't the point. If we can satisfy our own creative yearning, and possibly touch the hearts of others along the way, then this endeavor is a success.

Why Digital Photography Hacks?

The term *hacking* has a bad reputation. It is often referred to as the process for breaking into computers and turning them into weapons of discord. Among people who write code, though, the term *hack* refers to a "quick-and-dirty" solution to a problem, or a clever way to get something done. And the term *hacker* is taken as a compliment, referring to someone being *creative* and having the technical chops to get things done.

The Hacks series is an attempt to reclaim the word, document the good ways people are hacking, and pass the hacker ethic of creative participation on to the uninitiated. Seeing how others approach systems and problems is often the quickest way to learn a new technology.

This collection of hacks reflects the real-world experience of photographers who are steeped in photographic history and expertise. They share their no-nonsense and, sometimes, quick-and-dirty solutions to "getting the shot." This book contains tips for working indoors, outdoors, during the day, at night, in front of the computer, and even with a camera phone in hand.

Each hack can be absorbed in a few minutes, saving countless hours of searching for the right answer. *Digital Photography Hacks* provides direct, hands-on solutions that can be applied to the challenges that face both new users, who are meeting the digital camera for the first time, and longtime users, who are already toting hefty digital SLRs. I'm confident that this collection contains many gems that will delight you.

How to Use This Book

You can read this book from cover to cover if you like, but for the most part, each hack stands on its own. If there's a prerequisite you ought to know about, there'll be a cross-reference to guide you on the right path. So feel free to browse, flipping around to the sections that interest you the most.

I've written the book this way for a reason. Exploring photography is not a linear process. You don't wake up one morning and say, "Today I'm going to learn everything there is to know about aperture settings." I remember standing in a camera store and overhearing a customer talking to the salesperson. He said, "Yes, last week I mastered black-and-white photography, and now I'm ready to conquer color." Photography just doesn't happen that way.

Instead, what you might say when you wake up in the morning is, "I need to figure out how to shoot tonight's lunar eclipse." Chances are, you really don't care about the history of aperture settings or the relative brightness of the moon compared to the sun. What you want to know is how to get the shot. And if that requires clamping your digital camera to an old telescope and using gaffer's tape to hold it in place, so be it.

If this approach makes sense to you, so will the organization of this book. When you need to solve a problem, I'm hoping that you'll find the solution, or at least a clue, in the following pages. The Table of Contents is comprehensive, as is the Index. Use them to search out your answers. And if you're just in the mood to try something new, open the book to any page and say, "I'm going to do this project today."

How This Book Is Organized

Even though this book is designed for you to "open anywhere and start exploring," it's also organized into general categories. There are eight chapters, many of which contain more than a dozen hacks:

Chapter 1, *Digital Camera Attachments*
> Let's start with the goodies. This chapter introduces you to the various odds and ends that you can attach to your camera to help you accomplish hacks in subsequent chapters. Along the way, you'll become familiar with most of the basic terminology we use to describe camera parts.

Chapter 2, *Daytime Photo Secrets*
> Even though creative juices often flow in the wee hours of the night, photography requires light, and there's no source more plentiful than the sun. But if you think this is just another chapter on boring daylight technique, you're wrong. We'll have you stretching things over the front of your lens, spinning your camera around in circles, and getting so close to objects you'll think you're exploring another world altogether.

Chapter 3, *Nighttime Photo Hacks*
> The stars come out at night, and so does evocative photography. Through your lens, you'll capture streaming lights, exploding fireworks,

and glowing candles. Colors seem richer against a dark background, and the images you produce by working with these hacks will saturate your eyes.

Chapter 4, *Magic with Flash*

For many photographers, the camera flash is an untamed beast that never behaves. But there are situations in which a burst of light can make the difference between success and a ho-hum result. This chapter provides a collection of hacks that will change your mind about electronic flash.

Chapter 5, *The Computer Connection*

Your PC is a digital shoebox, sophisticated darkroom, and mad-scientist laboratory rolled into one. The minute you connect your camera to the computer, magical things can happen. Not only will this chapter help you improve your technical chops, but it also provides step-by-step instructions on how to become a movie maker, web publisher, and master printer.

Chapter 6, *Photoshop Magic*

If you really want to push the limits of photography, you need to explore Photoshop. Often, the Elements version is bundled with cameras. If it isn't included with yours, you can buy it for less than US$80. But then what? This chapter is pure Photoshop for photographers. Your entire image-editing world will change as you investigate these hacks, and you'll find yourself in charge of your pictures instead of at their mercy. Most of the techniques work with the cheaper Photoshop Elements software, while some require the professional CS version. Still, there is plenty here for anyone with any version of this outstanding image editor.

Chapter 7, *Camera-Phone Tricks*

Have you looked at the instruction manual that came with your camera phone? Not very helpful, is it? We think camera phones have great creative promise, in addition to some practical applications. So we've dedicated an entire chapter to mastering this raw but potentially exciting aspect of photography.

Chapter 8, *Weekend Photo Projects*

This chapter is a grab bag of photo goodies. Treats include instructions on how to create your own coffee-table book, maintain a digital diary, turn your camera into a virtual fax machine, and so much more. Rainy days will never be the same.

Conventions Used in This Book

The computer techniques outlined in this book are geared toward both Macintosh and Windows users. The core applications we rely on—Adobe Photoshop (Elements, 7, or CS) and QuickTime Pro—behave almost identically on both platforms. You'll notice that some screenshots are captured in Windows XP, while others use Mac OS X. Regardless of which platform you use, the information in those screenshots should apply to your work, even if the colors and fonts look a little different.

The following is a list of the typographical conventions used in this book:

Italic

> Used to indicate new terms, URLs, filenames, file extensions, and directories. For example, a path in the filesystem will appear as */Developer/Applications*.

Color

> The second color is used to indicate a cross-reference within the text.

You should pay special attention to notes set apart from the text with the following icons:

This is a tip, suggestion, or general note. It contains useful supplementary information about the topic at hand.

This is a warning or note of caution.

The thermometer icons, found next to each hack, indicate the relative complexity of the hack:

beginner moderate expert

How to Contact O'Reilly

We have tested and verified the information in this book to the best of our ability, but you may find that features have changed (or even that we have made mistakes!). As a reader of this book, you can help us to improve future editions by sending us your feedback. Please let us know about any errors,

inaccuracies, bugs, misleading or confusing statements, and typos that you find.

Please also let us know what we can do to make this book more useful to you. We take your comments seriously and will try to incorporate reasonable suggestions into future editions. You can write to us at:

O'Reilly & Associates
1005 Gravenstein Highway North
Sebastopol, CA 95472
(800) 998-9938 (in the U.S. or Canada)
(707) 829-0515 (international/local)
(707) 829-0104 (fax)

To ask technical questions or to comment on the book, send email to:

bookquestions@oreilly.com

The web site for *Digital Photography Hacks* lists examples, errata, and plans for future editions. You can find this page at:

http://www.oreilly.com/catalog/digphotohks/

For more information about this book and others, see the O'Reilly web site:

http://www.oreilly.com

Got a Hack?

To explore Hacks books online or to contribute a hack for future titles, visit:

http://hacks.oreilly.com

Digital Camera Attachments

Hacks 1-15

Digicams are good for more than just hanging around your neck. You have a wealth of accessories available to expand their capability. The threaded socket on the bottom enables you to secure your camera to a variety of unique stabilizing devices. You can hang things from the top of your camera, screw them onto the front, strap them to the side, and when all else fails, use gaffer's tape to hold an otherwise incompatible optical apparatus in place. To help get your creative juices flowing, here's an everything-but-the-kitchen-sink tour of helpful attachments for the adventuresome photographer.

HACK #1 Pocket Tripods on the Go

Yes, your full-size tripod is important, but when you want to travel light, a pocket tripod is great for getting into your own group shots and capturing twilight landscapes.

For so many creative endeavors, you need a way to stabilize your camera; it comes with pushing the limits of photography. Every serious photographer needs to have a full-size tripod. But beyond that, a variety of smaller stabilizing devices can help you cope with various shooting situations. At the top of this list is the pocket tripod.

Before I get into the equipment itself, I want to review why tripods contribute so much to image sharpness. They help prevent *camera shake*: soft, fuzzy images that result from not holding the camera steady during exposure.

When you want to photograph a subject without a flash in low ambient light—such as when you're indoors, or during dusk or early morning hours—your camera chooses a long shutter speed. When I say *long*, I mean 1/8, 1/4, 1/2 of a second, or longer. Now, those times probably sound pretty fast to you. But in camera terms, they are as slow as molasses in winter. Most daylight pictures are recorded at 1/60, 1/125, 1/250 of a second, or faster.

Once your shutter slows down to 1/15 of a second or longer, you need to stabilize the camera. If you don't, the slightest movement you make during the exposure will actually cause softness in the image. In low lighting, even the act of pressing the shutter button itself can cause camera shake.

This is why tripods are necessary. Unless you're going to limit your shooting to broad daylight or flash photography, you're going to need a way to stabilize the camera. For big jobs, such as photographing a starry night, you'll need a big tripod. But for many situations, you can get by with a mini tripod that fits in your back pocket. These are important tools, because compact tripods are more likely to make the trip than their bulkier big brothers, who are often left at home.

The results of camera shake and poor focusing are different. With camera shake, the overall picture will look a tad fuzzy. When you focus poorly, *something* in the shot will be sharp, just not the part you wanted.

Let's look at a few pocket tripods and see what's available:

UltraPod II

Pedco (*http://www.pedcopods.com*) makes two sizes of their versatile UltraPod. I recommend the larger UltraPod II because it's the more stable of the two. These portable tripods include ball heads, and they fold up nicely to fit in your back pocket or camera bag. They are made from durable plastic that can handle abuse. They include a sturdy Velcro strap that enables you to secure the camera to signposts and tree limbs. This increases their usability greatly, because you don't always have to find a level surface. Most retailers sell the UltraPod II for US$29.

Sony VCT-TK1 Compact Pocket Tripod

This Sony camera support doesn't look like your normal tripod. It is extremely portable because it folds flat, but it's better designed for tabletops and other flat surfaces. It sells for only US$15 from retailers such as MainSeek.com (*http://camera.mainseek.com*).

Quantaray QT-75 Mini Tabletop Tripod

Quantaray's offering has three legs that spread a pretty good distance, providing stable support on flat surfaces. The screw-mount head allows for both vertical and horizontal tilting. This mount isn't as versatile as a ball head, but it's easier to level the camera quickly, increasing your odds for a straight horizon line. The QT-75 is available from retailers such as Digital Cameras4All (*http://www.digital-cameras4all.com*) for about US$15.

Regardless of which tripod you use, keep in mind that it's best to trip the camera's shutter by using the self-timer or the remote release, as shown in Figure 1-1. That way, you won't jar your digicam by pushing the shutter button directly.

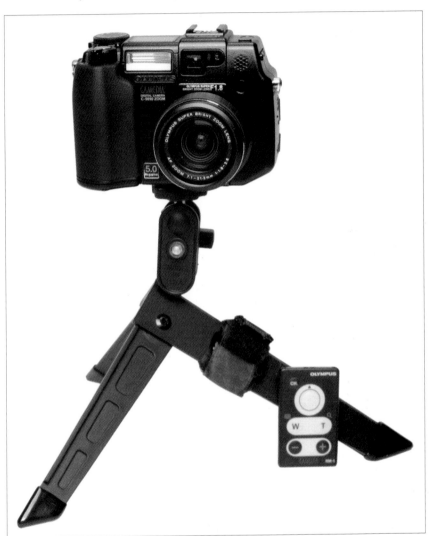

Figure 1-1. Using a remote release with an UltraPod II

Pocket tripods aren't perfect for every situation. But they are remarkably versatile and will enable you to capture many shots you would otherwise miss. And unlike their big brothers, they won't put a strain on your shoulder or your pocketbook.

Travel Tripod: A Happy Compromise

HACK #2

When tabletop supports are just too small, but you can't afford to pack a full-size tripod, you might want to consider a travel model that folds flat and fits in the smallest of suitcases.

On my last trip to Europe, I knew that I wanted to photograph landscapes and other subjects that would require a tripod. But I needed to travel light, because I was taking only a midsize duffle and my camera bag to store all of my belongings. A key piece of equipment for this adventure turned out to be a unique travel tripod called the Magic 2, made by Cullmann (see Figure 1-2).

Unlike other tripods that have a large circumference even when collapsed, the Cullmann's legs fold flat, forming a compact rectangle that is only 1.5 inches thick and 13.75 inches long. It fits almost anywhere. And even though it's constructed of anodized metal for durability, the Magic 2 weighs only 2.5 pounds.

You can extend this marvel of engineering to 57 inches, but I don't recommend it. Instead, resist extending the center post to maximum height and keep the tripod to about 50 inches for better stability. I also recommend you hang your camera bag over one of the legs or around the center post for a more stable shooting surface.

One of the reasons this unit is called *Magic* is that it also converts to a better-than-decent monopod. That's right, one of the legs detaches from the main unit and screws into the center post to create a walking stick with a ball-head mount on top. This is really nice for day hikes when you want to leave the rest of the unit back in the hotel room.

In online reviews, some photographers have remarked that the tripod legs don't spread wide enough to provide adequate stability on uneven surfaces. I agree. I had to be careful where I set up the Magic 2 and had to remember to stabilize it with my camera bag.

The legs extend to full height via four collapsible sections. They twist one way to loosen and the other to tighten, which works well most of the time. An important tip to remember is not to tighten the legs when you collapse the tripod. You'll have a hard time getting a good grip to loosen them later. I think it's a law of nature that tripod legs get tighter on their own over time. Keep them loose except when extended.

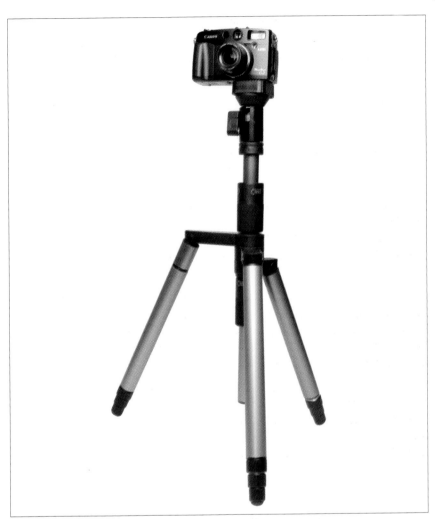

Figure 1-2. The Cullmann Magic 2, ready for action

The ball-head tripod mount that comes with the Magic 2 enables you to position the camera at just about any angle. It even has a quick-release plate, so you can easily detach and reattach the camera.

You can purchase the Cullmann Magic 2 from most photo retailers, including *http://www.adorama.com* or *http://www.bhphoto.com*, for about US$115. It's quite effective for most of today's digicams. Even though it's not perfect, I've recorded many fine images with it that I would have otherwise missed.

Walking-Stick Mount

HACK
#3

A trusty walking stick is helpful for fording streams and navigating slippery trails. But why not use it to steady your camera, as well as your footing?

In the wide world of walking sticks, there are basically two types: the ones you buy and the ones you make. Either version can become a steadying friend for your outdoor photography.

A trip to the mountaineering store reveals that today's walking sticks—or *trekking poles* as those in the know call them—are lightweight, sturdy, and have comfortable grips. Most are constructed in collapsible sections, enabling the stick to fit nicely in a suitcase or be lashed onto the outside of your backpack. Most trekking poles have a rubber tip that provides good traction on paved walkways and a metal tip for digging into the side of hills.

Leki (*http://www.leki.com*) is a popular supplier of trekking poles that range from US$50 to over US$100. Outdoor photographers should take a look at the Sierra Antishock (model TK2091-04), which has a removable wooden knob that exposes a camera mount, as shown in Figure 1-3.

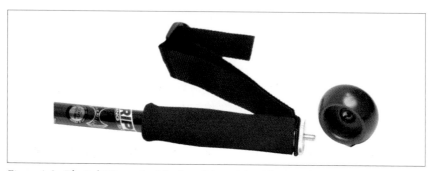

Figure 1-3. The Leki Sierra Antishock walking stick with camera mount

By attaching your camera to the walking stick, you can create the third leg of what I call the *human tripod*. You supply your two legs, and the walking stick becomes the third. Simply position your feet about shoulder's width apart, and then lean forward slightly on the walking stick while composing your picture in the camera's viewfinder. You'll find that this method is much easier for stabilizing the camera than trying to hold it with just your two hands.

If you'd rather not spend the money on a Leki stick, you can make your own. First, make a quick trip to the hardware store for a 1/4" screw with 20 threads per inch. Get one about an inch or so long. Screw it into the tripod socket on the bottom of your camera. I recommend that you add a plastic washer to serve as a cushion between your camera and the walking stick.

Slip the spacer on the screw and position it so that it's flush against the bottom of the camera. With a felt-tip pen, mark the screw right beneath the washer, and then remove both pieces from the camera.

Drill a hole that's slightly smaller in diameter than the 1/4" screw in the top of your walking stick, and then twist the screw into the hole so that the mark you made is just below the top surface. Be careful not to damage the threads while doing this.

Now, slip the plastic washer onto the post. It will serve as a cushion. Attach your walking stick to the tripod socket in the bottom of the camera. Do this with care the first time to ensure that you measured correctly, and don't damage the bottom of the camera by screwing the post too deep into the socket. If you miscalculated, sink the post further into the walking stick and try again. The post should fit snugly in the camera socket, but it shouldn't go too deep.

If you want to add a crowning touch, add a decorative knob to the top of the stick to cover the post when the camera isn't attached. You can drill a hole in the knob and sink in a 1/4" nut so that the knob easily screws on and off.

Regardless of whether you go the homemade route or opt for the slick Leki model, a walking stick that doubles as a camera stabilizer can help you take sharper pictures when you're in the great outdoors.

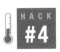

Convert Your Monopod into a Makeshift Tripod

HACK #4

Monopods are lighter and far more portable than tripods. But they're also not as versatile—unless you add a little extra support.

Monopods, otherwise known as *one-legged tripods*, have been popular with sports and outdoor photographers for years. They give you that extra bit of stability to help keep your photos as sharp as a tack.

The problem with monopods is that they can't stand on their own. Often this isn't a problem, unless you want to capture really long exposures of 1/4 of a second or more. Those are the times that you yearn for your tripod. The fact of the matter is that many photographers don't like lugging tripods around. This is especially true on long hikes, when you're trying to keep your equipment weight to a minimum. Happily, there's a solid compromise that is stable, versatile, and, most importantly, not too heavy.

Bogen Imaging (*http://www.bogenimaging.com*) makes a nifty device called the Monopod Support (catalog #3422), a modified ball-head mount that attaches to the top of your monopod. What's unusual is that it has a bracket that folds down and enables your monopod to stand on its own, er, two feet, as illustrated in Figure 1-4.

Figure 1-4. The Bogen Monopod Support bracket

This special support head has a standard tripod socket in its base, which enables it to screw snugly onto any standard monopod. Once attached, you can hike comfortably with the bracket folded against the monopod. But when you need extra stability, you can loosen the wing nuts, pull the bracket away from the monopod, set your rig on a stable surface, and tighten the wing nuts to secure your setup. Now, you can use your remote release or self-timer to trip the camera shutter without jarring it.

I've made exposures several minutes long with the Bogen support, and I wouldn't dream of having any other type of mount on my monopod.

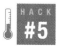

HACK #5 Steady Shots from the Comfort of Your Car

Not everyone is John Muir, roaming the wilds with just a walking stick and a broad-rimmed hat. Some folks would rather shoot without leaving the comfort of their automobile.

Sometimes, you're not allowed out of your car, such as when you're visiting certain wild game preserves or protected wildlife areas. Other times, you can use your vehicle as a duck blind of sorts. Animals seem less concerned about

people when they are safely strapped inside an automobile. And then there are those days when you just don't feel like taking a hike.

Regardless of the situation, you want sharp images from your day's outing. And the best way to keep things nice and crisp is to steady the camera during exposure. But in a car, that's easier said than done. It's not like you can set up your tripod on the front seat.

But what you *can* do is use the car itself as a stabilizer. Roll down the window about 2/3 of the way and attach a Bogen Car Window Pod (catalog #3292) with a Junior Tripod Style Head (catalog #3407). You can find out more about these at *http://www.bogenimaging.com*. The combination sells for about US$85, and they are well made and extremely sturdy.

If $85 is a little more serious than you care to get for your front-seat shooting, take a look at Pedco's UltraClamp (US$29.95) with UltraMount (US$10.95), shown in Figure 1-5. If you really need to go on the cheap, try the Pillow Pod Beanbag, available for about US$6 from Porter's Camera Store (*http://www.porterscamerastore.com*). Photo beanbags are great accessories to keep in the trunk because you can use them in so many situations. The bag conforms to the surface on which its placed, providing a steady support for your camera while protecting it from the surface itself. You can plop it over the edge of a car window, on a tree limb, or even on the ledge of a balcony, and it will help you take sharper shots.

Figure 1-5. The UltraClamp from Pedco

Here's one word of advice: be sure to keep the camera strap around your neck when you place your expensive investment on the edge of anything. One false move and both camera and beanbag might go tumbling to their doom. You'll get over the loss of the beanbag pretty quickly. Recovering from a shattered camera might take a little longer.

H A C K #6 Attach Your Camera to Bicycle Handlebars

Put your pictures in motion by attaching your digicam to the handlebars of your bike.

Some people might wonder why the heck anyone would want to attach their digital camera to the handlebars of their bike. Well, in the old days of traditional photography, this didn't make much sense. You couldn't see through the viewfinder while pedaling, so composition was little more than a wild guess.

But many of today's digicams have variable-angle LCD monitors. This means that you can pull the monitor out from the back of the camera and adjust it to your viewing angle. This is a perfect example of how one technology (digital still photography), can be borrowed from another (digital video). Digital video camcorders have used swiveling LCDs from the get-go.

For cycling fans, this means that you can mount your camera on the handlebars, swing the screen upward, and monitor your composition in real time while you're peddling; just don't forget to watch the road, please! This is a great opportunity for you to share your adventures with those who don't ride with you.

If your camera has one of these nifty swiveling monitors, then chances are good that it also has a remote release that you can hold in one hand while riding. Most of these releases not only enable you to trip the shutter, but they also have buttons to let you zoom the lens to different focal lengths. You can literally compose and shoot while on the ride.

If you really want to get creative, enable the Movie mode on your camera and take short video clips of your travels. Try to find a smooth surface while recording video so that the movie isn't too choppy.

A clever way to make all this happen is to get an UltraClamp (US$29.95) and UltraMount (US$10.95) by Pedco, and secure the entire rig to your bicycle. Pedco's products, including the fantastic UltraPod, are distributed by BKAphoto.com (*http://www.bkaphoto.com*). The store finder on their site can help you find the closest retail outlet.

Once your digicam is mounted, choose still pictures or movies and fire that shutter. You will get images unlike any others that you normally shoot. Just remember to be safe while you're doing so.

Flash Brackets for Pro Lighting

If your camera accepts an external flash, you might think that will solve your problems with red eye. Well, almost.

Many prosumer digital cameras provide a means for attaching an external flash. More often than not, the connection is provided by what is commonly called a *hot shoe*: a postage-stamp-sized bracket on top of the camera into which you can slide an external flash.

Photographers usually think that purchasing an optional flash unit and attaching it to the hot shoe will make their red-eye problems **[Hack #40]** magically disappear. Indeed, an external flash does help reduce red eye. But sometimes merely sliding a flash into the hot shoe doesn't get rid of the problem altogether.

The best way to ensure that you'll never have red eye again is to use a special bracket to move your external flash even farther away from the camera. You'll also need a dedicated flash cord (made by the camera manufacturer) that allows the flash to communicate with the camera as if it were still mounted in the hot shoe. Typically, these special flash cords cost between US$35 and $50.

As for the flash bracket itself, I think the best commercial one is the Stroboframe Quick Flip 350 (catalog #310-635) distributed by Tiffen (*http://www. saundersphoto.com*). The Quick Flip is easy to use. You mount your camera to the base of the bracket by turning the screw into the camera's tripod socket. You then put one end of the dedicated flash cord into the camera's hot shoe and attach the other end to the top of the bracket. Now all you have to do is attach the flash to the cord on top of the bracket, and you're in business (see Figure 1-6).

Depending on the height of your camera, the flash is now positioned six to eight inches higher than it was previously in the camera's hot shoe. Not only does this configuration eliminate red eye completely, it also serves the dual purpose of lowering those unsightly shadows cast on walls directly behind the subject. By raising the flash, you thereby lower the shadows out of the frame of view.

This Stroboframe model is called Quick Flip because it solves another problem. Normally, when the flash is mounted directly to the camera, the flash is above the lens (where it should be) for horizontal shots. But when you turn

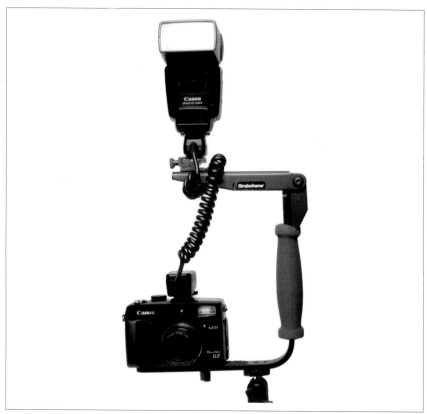

Figure 1-6. Stroboframe Quick Flip bracket, ready for use

the camera to the vertical position, the flash is now off to the side, which once again produces those ugly shadows.

However, the top part of the bracket on the Stroboframe actually flips. When you turn the camera to the vertical position, you can flip the frame too, keeping the flash directly over the lens instead of alongside it, as shown in Figure 1-7. This is a great feature.

Stroboframes cost about US$50 at your local camera store or online retailer, such as B&H (*http://www.bhphoto.com*). I've used one for years at countless wedding receptions and parties, and it works just as well today as it did the day I bought it. I can use the bracket for all of my 35mm cameras, as well as with any digicam I own.

You'll really look like a pro when you use the Stroboframe. More importantly, your pictures will too.

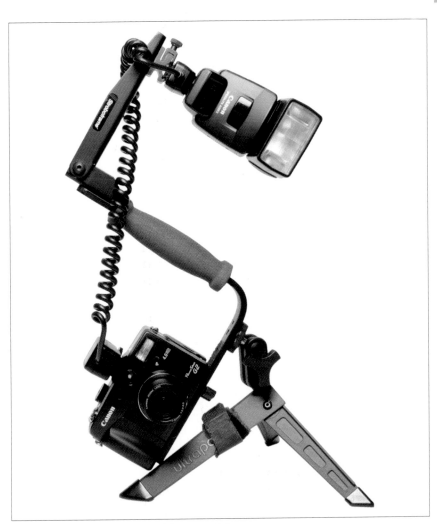

Figure 1-7. Stroboframe, flipped for vertical shots

HACK #8 A Flexible Arm to Hold Accessories

How many times have you wished for an extra hand when you're shooting?
Here's one you can attach to your camera's hot shoe or tripod socket.

When you're shooting without a tripod, it's best to have both hands on the camera to keep it steady and record sharp images. But sometimes you need to shade the lens from the sun or hold a small item while you photograph it. An extra hand would be invaluable at those times.

The folks at GranView Camera have invented a unique accessory called the Flare Buster (*http://www.multiclip.com*) that might turn out to be one of the

most versatile tools in your camera bag. This ingenious item is simply a flexible arm that's 15 inches long with a camera mount on one end and a sturdy clip on the other. You can attach it to your camera via the tripod socket or the hot shoe. Then, use the clip on the other end to hold whatever it is you need held.

The Flare Buster kit comes with a card that can serve as a shade against the sun, two vignettes that are handy for portraits because they soften the edges of the frame around the subject, and a couple of reflectors.

Now, the fun begins. If you need a simple lens shade, put the supplied card in the clip and position it so that it protects the front of your lens from the glare of the sun. The flexible arm moves easily but stays firmly in position. For cameras that don't accept filters, simply attach the filter to the clip and position it in front of your lens. Who needs filter screw threads when you have a Flare Buster?

Digital cameras have amazing close-up focusing ability. Usually, the hardest part is correctly positioning the item you're photographing. Why not attach the item to the Flare Buster and position it any way you want, as illustrated in Figure 1-8? You don't even need a tripod; because the item is now connected to the camera, they move in unison.

For a super-soft background when shooting close-ups with the Flare Buster, try moving the camera from left to right during the exposure. This is called *panning*, and you can get some evocative effects with it.

Or, for close-up subjects that are fine where they are, such as a flower in the ground, attach one of the reflectors to the clip and use the flexible arm to reflect a little fill light to your close-up photography by bouncing light back onto the subject.

Flare Buster kits range from US$30 to $36 depending on the configuration. They are well made and fit easily in your camera bag. You'll always have that extra hand available to make photography just a little bit easier.

H A C K
#9

Bubble Levels to Keep Things Straight

Many digital photographers have a difficult time keeping their horizons straight while peering into their digicam's LCD monitor. Here's how to straighten things up.

For some reason, it's more difficult to compose a straight horizon line with a digital camera's LCD monitor than with a traditional SLR viewfinder. You could use the optical viewfinder that's included with most digital cameras, but the problem is that many of them show only about 85% of the actual area that's being photographed. Plus, quite honestly, they're not that accurate.

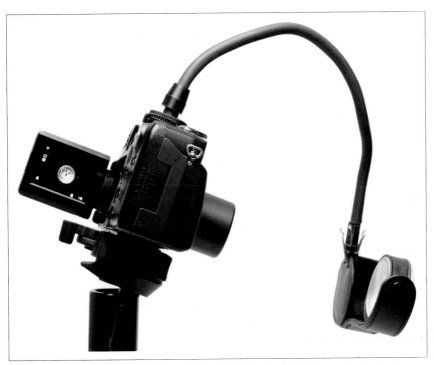

Figure 1-8. Flare Buster, holding an item for close-up photography

Regardless of how you frame your shots, LCD or optical, a bubble level attached to your camera can really help straighten things out. Bubble levels are helpful for composing architecture, landscapes, panoramas, and anything else that needs a straight horizontal line.

At various online retailers, you can buy bubble levels designed specifically for cameras. For example, the Hama Double-Bubble Level is a precision instrument that slides into the hot shoe atop your camera, enabling you to level it on two axes. The only downside is that these accessories are relatively expensive. The Hama level, for example, runs about US$30.

If you have more time than money, you can make your own bubble level. Hardware stores carry pocket bubble levels, often for US$3 or less. Find one that looks suitable for your camera. If your model has a hot shoe, all you have to do is find a spare shoe that will slide into it. This is one reason why I have a box of old equipment that includes broken cameras, dead flashes, and orphaned straps. If you have an old flash or any accessory that was designed to fit in your camera's hot shoe, you can detach the foot and attach it to your bubble level with a spot of glue. The trick here is to make sure the foot and the level are flush against each other when you glue them. Otherwise, your homemade device might not be accurate when you attach it to the camera.

If your camera doesn't have a hot shoe, just get a level with a flat bottom and set it on top of your camera. As long as the level rests flush against the camera's surface, you're in business.

To use the bubble level, simply mount your camera on a tripod and attach the level. Adjust the tripod until the bubble is centered, as shown in Figure 1-9, and the resulting picture should be nice and square. This is particularly helpful when shooting multiframe panoramas.

Figure 1-9. Adjusting a bubble level

Regardless of whether you buy a professional photographer's bubble level or make your own, you'll find that it will help you overcome crooked horizons and leaning buildings. Just like the carpenter says: measure twice and shoot once.

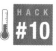
Battle the Sun with an LCD Hood

#10 Your camera's LCD viewing screen is one of its most exciting features—except, that is, when you're standing in bright sunlight and can't see the pictures on it.

If you ask people what they like best about their digital camera, many will say it's the LCD viewing screen that provides instant gratification right after you take the shot. How could you not love it? You can review the image,

analyze its pros and cons, and then either keep it or try again—instant gratification at its best.

Too often, though, this love affair comes to a screeching halt when you're working in bright, direct sun. Your once color-rich LCD fades to a nearly indistinguishable shell of its former greatness. What happened?

The sun happened. Many LCD monitors hate the sun and don't fare well in its presence. To combat this problem, you have two options. You could purchase a state-of-the-art digital camera, such as the Contax SL300R T* shown in Figure 1-10, that uses a new technology called *DayFine* to preserve the screen's color fidelity regardless of the ambient light. Contax's parent company, Kyocera, originally developed this screen for their smart phones, which are constantly used in these types of lighting conditions.

Figure 1-10. The Contax SL300R T with DayFine*

If you're not in the mood to go out and buy a new digicam, you have to find a way to shield your existing LCD monitor from the sun's blinding rays. Hoodman (*http://www.hoodmanusa.com*) has excelled at providing glare relief for digicam owners. They make a variety of custom hoods that attach to almost every digital camera LCD on the market. The nylon hoods are well made and most sell for US$15 to $20. They fold up and take up hardly any room in your camera bag.

You might also want to take a look at the offerings from Screen-Shade (*http://www.screenshade.com*). They offer LCD shades for digital cameras, camcorders, and laptops. Their camera shades run between US$20 and $40, depending on size and whether a glass magnifier is included.

A clever homemade solution for photographers who have magnifying loupes to view their film transparencies is to adapt the magnifier to mount on the LCD screen. Models such as the Peak 2038 4X and the Horizon 4X, which have a two-inch viewing base for looking at medium-format film, can also be used as a nifty LCD viewer, as illustrated in Figure 1-11. You want to make sure you use the opaque base so that no stray light comes in, and stay away from loupes stronger than 4x, as that's just too much magnification for your LCD monitor.

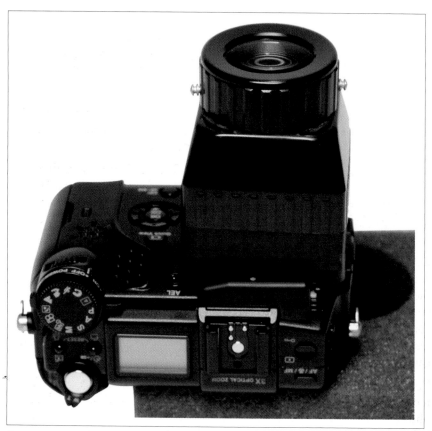

Figure 1-11. Magnifying loupe used as an LCD shade

If you want, you can attach the loupe to the camera by cutting strips of adhesive-backed Velcro and adhering them the base of the loupe and the

body of the camera. That way, you can easily remove the magnifier when it isn't needed. Not only does this rig provide you with sun relief so that you can actually see the picture you just took, it also makes it easier to inspect the fine details of the image.

Another trick is to take a plastic slide box, drill a hole in the bottom about the size of a U.S. quarter, and then use the Velcro strips to attach the open side of the box to the camera. If possible, use a black box to block out the light better. The main drawback of this solution is that it doesn't fold up like commercially made shades.

No matter which route you take, they're all better than cupping your hand around the LCD while squinting and trying to discern the picture you just took.

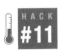

Convert Your Digicam to a Digital SLR

Shading the LCD monitor for easier viewing during replay is one thing, but why not go all the way and use the monitor as a virtual SLR viewfinder for shooting images too?

Shading your LCD monitor makes viewing the picture in bright sunlight much more enjoyable. But with a little refinement, you can adapt this technique for taking pictures too, creating a virtual digital SLR.

One of the major attractions of single lens reflex (SLR) cameras is that you see the picture through the same lens that records the image. It's WYSIWYG ("what you see is what you get") photography. In contrast to SLRs, most compact digital cameras provide one lens for taking the picture and another (often referred to as the *optical viewfinder*) for viewing the image.

One of the problems with optical viewfinders is that they're offset from the picture-taking lens, so the composition you're looking at isn't the same one the camera is going to record. This setup is called *parallax*, and the closer you get to the subject the more pronounced the effect will be. The other common problem with most digicams' optical viewfinders is that they're just not very good. You don't get a full view of the subject, and what you do get isn't that great.

You do have another option: you can look through your digicam's LCD monitor when you take the picture. This has created a whole new look in photography: the arm's-length shooting pose. Photographers everywhere are holding their digital cameras out from their body to align what's on the screen. Not only is this pose awkward at times, it's also not good photographic technique, because it's harder to steady the camera during exposure at arm's length. Beyond that, some people have a hard time keeping a

straight horizon line when holding an LCD this way. Something seems to get lost in translation.

When visiting the Hoodman (*http://www.hoodmanusa.com*) booth at the Photo Marketing Association show in Las Vegas, I discovered a great solution to all of these problems. Hoodman has designed a special monitor hood, called the Digital Camera Hood, that straps onto just about any model with a 1.8-inch or smaller LCD screen. Figure 1-12 shows the Digital Camera Hood attached to a Canon Digital Elph S400.

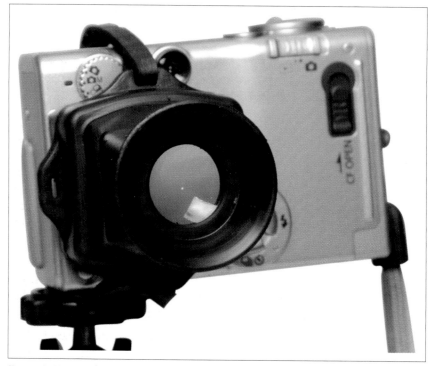

Figure 1-12. Hoodman's Digital Camera Hood

The open end fits around the outside of your LCD monitor, and the other end holds a 2x magnifying eyepiece. The Digital Camera Hood attaches easily in just a few seconds. When not in use, it folds up compactly, taking up little space in your camera bag.

To use the Digital Camera Hood, just attach it to the camera, turn on your camera, and view the picture through its eyepiece. Your simple digicam has just been upgraded to a virtual digital SLR with electronic viewfinder.

You can use this rig in any lighting condition. You can both shoot and review your images with it, and you can now hold the camera normally,

enabling you to take sharper pictures because you're holding the camera more steadily. As a bonus, the increased magnification of the LCD monitor makes it easier to determine picture quality *before* you take the shot. This is a great time-saver, because you don't have to stop and review the image you just recorded (using the camera's magnification function) to see if you got the shot you wanted.

You might not want to use the Digital Camera Hood when you're on the go, toting your digicam in your pocket. But when you're engaged in serious shooting, close-up work, landscapes, and anything with a tripod, I think you'll find that this setup is a good way to improve your pictures.

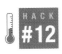

T-Mounts and Other Threaded Tricks

Digital SLR users can connect their camera bodies to a variety of bargain optical attachments by using one of the most enduring adapters of all: the T-mount.

The best camera for photographer-hackers is certainly the digital SLR (DSLR). From outward appearances, these cameras look just like the 35mm single lens reflex (SLR) models that photographers have been using for decades. SLRs are distinguished by the ability to remove the lens from the body and replace it with another type, which makes them extremely versatile. The other advantage is that you view the picture through the same lens you use to take the photo, so what you see is what you get. DSLRs work the same way. The only difference is that they have an image sensor instead of film.

DSLRs are a lot of fun for hackers, because when you remove the lens, you can attach just about any optical accessory to the camera body, including microscopes, telescopes, slide copiers, and much more.

At first, you might hold the microscope in one hand and the camera body in the other and wonder how the heck these two items can work with each other. Generally, this happens via some type of adapter. For example, telescopes have an adapter that replaces the eyepiece, and you attach your camera to the adapter. The same goes for microscopes and other optical goodies.

But you still need a way to connect your camera to the adapter. If you don't want to shell out the big bucks for a custom adapter made by your camera manufacturer, you can make this connection by using a common photographic tool called a *T-mount*.

T-mounts are simple devices, really nothing more than a thick metal ring. On one side, there's a bayonet-styled mount (like the one on the base of your camera lens) that attaches the ring to your camera body. Inside the

ring, you'll notice there are threads. These are a standard size that most adapters in the universe screw into snugly.

So, all you have to do is screw the optical adapter (as for a telescope) into the T-mount, tighten it, and then attach the unit to your camera body. You're in business! Now, your camera will mount on whatever optical lens the adapter is designed for.

It's a good idea to find a T-mount that works with your digital camera. Once you do, just about any optical adapter you find in the bargain bin will now mount on your state-of-the-art camera. For example, my slide copier is over 20 years old, but it works great on my state-of-the-art DSLR because I have a T-mount to hook the two together, as illustrated in Figure 1-13.

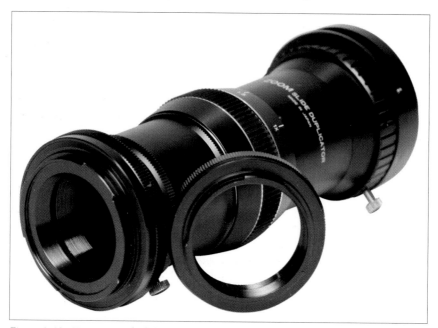

Figure 1-13. T-mount with slider copier attachment

Adapters Made by Scope Manufacturers

Many spotting-scope and telescope manufacturers provide camera adapters for their products. For example, Kowa (*http://www.kowascope.com*) makes a photo and video adapter (TSN-VA1); you simply slide the camera lens into the adapter, tighten the mounting screw, and connect it to a Kowa spotting scope. If your camera has a filter ring, Kowa's TSN-DA1 adapter will screw into it.

Many other scope manufactures make similar adapters. If you plan on buying a telescope or spotting scope, be sure to check the accessory line for camera adapters.

The Simple Reversing Ring

T-mounts have a first cousin called the *reversing ring*. A reversing ring looks similar a to T-mount, but instead of having internal threads to attach a variety of optical accessories, it has external threads that screw into the filter ring on the front of your lens. This enables you to literally *reverse your lens* so that the front optic is mounted to the camera and the back optic is pointed out to the world.

Why the heck would you want to do such a thing? Well, when you turn your lens around, you increase its magnification. So suddenly, thanks to this little round piece of metal, you can get closer to your subjects for some serious macro photography.

Some camera makers, such as Nikon, make special reversing rings for their electronic cameras, with delicate contacts near the lens mount. Make sure you get a reversing ring that's suitable for your camera; otherwise, you might damage its electronics.

Extension Tubes

If you don't like the idea of having your lens turned around, there's another economical way to increase magnification for close-up photography. *Extension tubes* are "spacers" in different widths that go between your camera lens and its body. The more you increase the distance, the higher your magnification will be. Kenko makes automatic extension tubes for a variety of camera models that are readily available at many retail camera stores.

Extension tubes have the advantage of retaining some or all of the camera's functionality, such as adjusting the aperture, because they have the same contacts as your lens. Reversing rings don't provide that functionality.

The major drawback of extension tubes is that the farther you move the lens away from the camera body, the darker the image becomes, and the more light you need for a good exposure. When using tubes in low light, it can be hard to focus on your subject.

Most people invest in DSLRs so that they can change lenses more easily. But the less obvious advantage is that, by using a few of these simple adapters, you can mount your camera to just about anything with a lens. And that opens up a whole new world of photography.

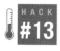

Double-Strapping on the Trail

Tired of your camera bouncing around during your hike? Strap it into place, for comfort and for fast access.

Here's the hiking photographer's dilemma: do you stash your camera in the backpack so that it doesn't bounce around and possibly get damaged, or do you leave it around your neck so that you're ready for the next shot, no matter how uncomfortable it is?

I can tell you right now that I'm a big fan of finding ways to keep your camera handy. Great outdoor shots present themselves with little warning, and they are usually gone within seconds. Your camera might be safe and sound in your backpack, but it also won't have nearly as many exciting pictures on it. You might miss the shot of a lifetime!

That said, my gosh, it's aggravating to have a camera swinging every which way as you try to navigate the up-and-down terrain of trail hiking. I've even encountered situations, such as crossing a stream on a log, when my swinging camera just about threw me off balance. Falling in the stream is not good for one's morale, nor is it healthy for the life of your digital camera.

If you've followed the evolution of outdoor and backpacking equipment, you know that things are pretty high-tech in that world too. Flashlights have multiple LEDs for illumination, camp stoves are feather-light and burn with welding-torch-like intensity, and the array of straps and pouches available provide lots of options for toting your gear. The shooter's belt shown in Figure 1-14, by Cameras Up (*http://www.camerasup.com*), is perfect for photographers on the go.

One of my favorite setups involves using one Op/Tech USA (*http://www.optechusa.com*) strap around my neck and adding a second stabilizer strap around my midsection. This arrangement holds the camera snugly against my body, while providing quick access when a shot presents itself.

I prefer the Op/Tech stabilizer strap because it is made out of a rugged neoprene material that acts as a shock absorber as you move about. The camera actually feels lighter than it does with other types of straps. Plus, the Op/Tech strap has quick-release buckles that enable you to detach the camera from the strap at a moment's notice.

Op/Tech also makes a Bino/Cam Harness that enables you to slide the camera up and down the straps without actually having to detach it—very nifty.

You can create your own strapping system with basic nylon straps and buckles purchased from any camping store. Just remember to get quick-release

Figure 1-14. Shooter's belt by Cameras Up

buckles so that you're not fumbling with your straps when Big Foot goes strolling by.

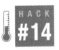

Stay in Charge of Your Batteries

#14

The Achilles heel of digital cameras is that they need power—lots of it. But what do you do when you're in the middle of nowhere and you want to keep shooting?

I'm going to start out by saying that you should always have an extra battery on hand. Digital cameras are power-hungry beasts that behave only as long as you feed their insatiable appetite for electricity. Once the juice runs out, they're about as useful as the box they came in.

When you're traveling, be sure to take your charger and extra battery with you. Each night, put the battery you've been using all day in the charger and put the spare in the camera. Then, when you take off the next morning, pull

the freshly charged battery out of the charger and put it in your camera bag. Continue this rotation throughout the trip.

If you have a particularly demanding shooting day, that extra battery will be as welcome as the Calvary when the first one fails. Just remember to charge both once you return to the room.

Car Chargers for Road Trips

The previous routine should work great for 90% of your travels. But what do you do on extended road trips and hikes in the backcountry, when an electrical outlet isn't right there beside your bed at night? You could take enough extra batteries to last the entire trip. If you figure one cell a day, you're probably safe, with a little discipline. My problem is that I always want to review my images at night, and that uses battery power. So I find that the one-cell-a-day regimen is a little stringent for my diet. Not to mention that most rechargeable Lithium batteries cost US$50 or more each.

Car travelers have a great alternative. Almost every camera manufacturer makes a cigarette-lighter attachment for their chargers, as shown in Figure 1-15. Your charge-and-use routine is a little different when using these tools. Instead of recharging at night, while you sleep, you charge up during the day, while you're driving. The trick to car chargers is to use them while the engine is running; otherwise, you'll drain your car battery. Running out of juice for your camera is one thing, but a dead car battery is a whole new level of distress.

Figure 1-15. Cigarette adapter for car charger

Once you get your routine down, you can span the entire country with just two camera batteries and your car charger. If, for some reason, your camera doesn't have an optional car-charger accessory, all is not lost. Every electronics store carries DC to AC inverters that will also do the trick. You plug

the inverter into your cigarette-lighter socket and plug your regular battery charger into the inverter. Yes, this system is a tad more bulky than the dedicated car charger, but it works just as well.

Solar Chargers in the Middle of Nowhere

If you plan on spending some extended quality time with Mother Nature, you'll discover that it's much easier to recharge your mind, body, and soul than it is to recharge your digicam. This is the most challenging scenario.

Solar cells have become more efficient and definitely more portable in recent years. One impressive example, the Brunton Solarroll 14, rolls up to a 12" × 3" cylinder for easy travel. It weights only 17 ounces but produces 14 watts of power. When it's time to charge your camera battery, just roll out the mat, attach your battery charger to the solar cell, and put Mother Nature to work for you. Solar power might be free, but the Solarroll isn't cheap. It costs about US$399.

Certainly, there are cheaper alternatives that you can construct yourself. Solar World (*http://www.solarworld.com*) is a great resource for build-your-own solar projects. They carry a variety of modules that you can custom-configure for your needs. Just make sure you have enough cells to recharge your camera battery in a six-hour period. Otherwise, you might not be able to keep up with your camera's appetite for power.

For every power challenge you might encounter on the road, there's a solution. The key to success is planning ahead and gathering the right equipment so that you and your camera can stay charged and shooting for the duration of the trip.

HACK #15 Gaffer's Tape When All Else Fails

Sometimes, there just isn't an adapter to hook things together elegantly. Does that mean you don't get the shot? Hardly! That's when you reach for the gaffer's tape.

Gaffer's tape, shown in Figure 1-16, has been used on Hollywood movie sets for decades. It's known by brand as Permacel P-665. This versatile cloth-backed black tape allows you secure just about anything, from an abused camera bag to a misbehaving reflector that just won't stay in place. What's remarkable about gaffer's tape, and what makes it superior to other alternatives, is that the adhesive doesn't leave a residue on your equipment. So you can strap your camera to a street sign's pole, take a series of pictures, and then peel the tape off without a trace of evidence.

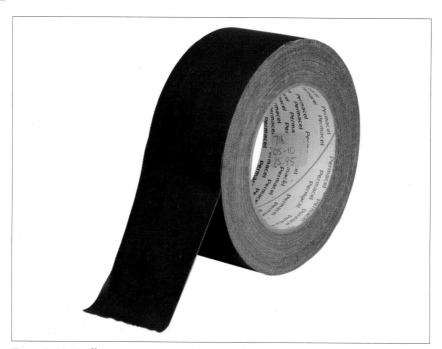

Figure 1-16. Gaffer's tape

Gaffer's tape comes in one-, two-, three-, and four-inch-wide rolls. Because it's cloth-backed, however, you can peel it off in straight strips, creating any width you need for the job. Often, I'll peel off a number of strips and hang them off an edge of a table before I start working, just to keep them handy.

The black backing also makes this tape useful for blocking out stray light and eliminating reflections off metal surfaces. You can use it to hold power cords in place, tape them to the floor so that people won't trip over them, and even hold down the edge of curled-up carpet.

One full roll costs about US$15. But unless you're running a full-time studio, it will probably last you for years. And you'll sing its praises every time it bails you out of a jam.

Daytime Photo Secrets
Hacks 16-28

Photography requires light. And the best place to find light is outdoors. It's cheap, abundant, and, at times, stunningly beautiful. Indeed, this is the appropriate place for us to begin the hacks on shooting technique.

In this chapter, you will learn how to tame the great outdoors by using everything from sunglasses to pantyhose to infrared filters. If you're under the false impression that al fresco photography is less than scintillating, that will soon change. This is the greatest photo studio of all. Grab your shades and let's get to work.

HACK #16 Pantyhose Diffusion Filter for Flattering Portraits
Razor-sharp optics are great—unless, that is, you're photographing the love of your life. In those instances, you might want to borrow her pantyhose.

A flattering portrait is often praised for its soft lighting, good angle, and natural expression. You'll rarely hear a subject rave about a picture that highlights her pores, wrinkles, and blemishes. Sometimes, modern camera lenses can be too sharp!

A popular solution used by pros is what's known as a *softening* or *diffusion* filter. Simply put, these accessories attach to the front of the camera lens and downplay the appearance of texture on the face. The wrinkles don't go away; you simply don't notice them as much.

These specialized filters can cost as much as US$200 and are difficult to find for less than US$20. Plus, if you use a variety of lenses for your portrait photography, you might have to buy more than one filter to fit the different lens diameters. That's fine if you shoot portraits for a living. But what if you just want to take a nice shot of your sweetie?

Ask her for her pantyhose.

That's right, by stretching a piece of light beige pantyhose over the front of your lens and securing it with a strong rubber band, you can create the same flattering effect achieved in professional portraits. The more tightly you stretch the material, the milder the effect—the looser the material, the softer the image.

You can capture good portraits without filtration, as shown in Figure 2-1, if you use good technique. But there will be situations in which you'll want to use a *pantyhose filter* to add a little softening effect, as shown in Figure 2-2. Be sure to keep a knee-high stocking, along with a couple sturdy rubber bands, in your camera bag for just these occasions.

Figure 2-1. A portrait without a softening filter

I actually prefer knee-highs to pantyhose, because I don't have to cut the material. One knee-high fits nicely in my accessory pouch. And it doesn't run or unravel, because I haven't had to trim it.

For best results with this technique, I recommend the following camera setup:

- Use a mild telephoto lens, such as 85mm or larger. On a point-and-shoot camera, extend the zoom lens all the way out to the telephoto setting.

Figure 2-2. A portrait using a pantyhose filter

- Set the camera to Portrait mode. This opens up the aperture to help produce a softer background. If your camera doesn't have a Portrait mode, switch to Aperture Priority and set the f-stop at its widest setting, such as f-2.8 or f-3.5.

- Position the subject at least 10 feet from a background that has few distracting elements. A big green bush, wood fence, or even the side of a house works well.

- Look for diffused lighting, such as an overcast day. If the sun is too harsh, you can also place the subject in the shade of a tree and use the fill flash. The best lighting is usually before 10 a.m. or after 4 p.m.

- Take lots of shots using different tension levels of pantyhose stretched over the front of the lens. You won't be able to pick your favorite by looking at the image on the camera's LCD monitor. Having lots of pictures to choose from once they've been uploaded to the computer will ensure success.

If you don't get results you like with one pair of pantyhose, try another with a different weave or thread count. You'll be amazed by the results.

HACK #17 Capture Kids Without Going Crazy

Sure, kids are cute in real life. But when it comes to capturing them with your digital point-and-shoot camera, they can be as elusive as leprechauns.

Digital *point and shoots* are great general-use cameras. But most of them are plagued by a phenomenon called *shutter lag*: the response time from the moment you push the shutter button to when the picture is actually captured is too long, sometimes as long as a second. In kid photography, a second might as well be a week.

Choosing a DSLR Camera

This next section of this hack provides ways to increase your odds of success with point and shoots. But first, if you want to cut right over to the fast lane, consider getting a digital SLR (DSLR), which has a much faster response time and performs better overall. DSLRs look and behave just like your favorite 35mm single lens reflex (SLR) cameras of years past, but they have a sophisticated image sensor instead of film.

Not long ago, this wouldn't be practical advice for parents, because DSLRs were just too darned expensive. But you no longer have to choose between a camera and a college fund. Both Canon and Nikon have introduced quality DSLRs for under US$1,000, and more are sure to be on the way. The Canon Digital Rebel and the Nikon D70 are two examples of DSLRs that will help you keep up with your kids without maxing out your credit card.

DSLRs have minimal shutter lag times, allow for generous sequential shooting, accept a variety of lenses, and enable you to use external flash. In other words, they are perfect for action, er, kid photography.

Hacking the Point-and-Shoot Camera

Now that you know what your next camera should be, how do you get the most out of the one in your hand? OK, here are some tips to increase your odds of success.

First, get everyone outdoors, where there's more light, better backgrounds, and lots of things for kids to do. Then, make these three adjustments on your camera:

Set for the highest resolution your camera allows. This enables you to later crop out part of the picture, yet still have enough pixel information to make a good-sized print. It's like adding a powerful telephoto lens to your little point and shoot.

Find Infinity Focus mode and activate it. Essentially, this disables the autofocus (which is slow as mud on most consumer digicams) and lets you capture perfectly focused images from about eight feet to infinity. By doing so, you've just shortened the length of time from when you push the shutter button to when the image is recorded. This also allows you to hang back a few feet, so you're not spending all your energy chasing kids around instead of photographing them.

Enable Continuous Shooting mode. Instead of taking a bunch of single shots and missing the action, Continuous Shooting mode lets you hold down the shutter button and fire a series of frames. The knack to this is starting the sequence right before the decisive moment and shooting through it. Then, review your pictures on the LCD screen, remove the obvious misses, and keep the winners.

Here are a few other things to keep in mind. Arrange your shoots for the time of day that your children feel the best. They will cooperate more and act less fussy. Remember to get down low, at their level, for the most intimate photographs. If you can engage them in an activity, such as playing with their favorite toy, you will get more natural expressions and fewer posed-looking shots. Don't be afraid to bribe them with treats either, such as a slice of apple, to get them to slow down just a bit (see Figure 2-3).

Once you're back on the computer, select a few of your favorite images to refine. Use the cropping tool to select the most interesting aspects of the image and discard the rest. I recommend you copy the image (using the Save As command) before resizing it, just so you have the original handy if you want to crop it another way later on.

Now, make your print or send it as an attachment to show others how utterly beautiful, brilliant, and charming your kids are.

Use Sunglasses as a Polarizing Filter

Chances are, you have a high-quality polarizing filter with you at all times, right under your nose. (Actually, it's sitting *on* your nose.)

Next to a fully charged battery and a huge memory card, a *polarizing filter* is the digital photographer's best friend. It reduces unsightly glare, deepens the richness of skies, and improves overall color saturation.

The problem for most shooters on the go is that they don't always have their full kit of accessories with them. And many point-and-shoot cameras don't even provide a way to attach an external filter, even if you wanted to.

Figure 2-3. Bribe a child to slow down with an apple slice (photo by Jan Blanchard)

So what's a photographer to do? Does this mean you'll have to suffer with glare-y subjects and desaturated skies, just because you want to tote a convenient digicam instead of lugging around an albatross of a camera bag?

Not at all. Your solution is sitting there right on top of your nose. Your sunglasses! Great lighting usually results in good photographs, with or without filtration, as shown in Figure 2-4. But sometimes you want to enhance an already good lighting situation. Often, polarization is the perfect solution, as shown in Figure 2-5. If you don't have a polarizing filter with you, try your sunglasses. You might be surprised by the results.

Many quality shades are made out of the same material that camera polarizers are made out of. Simply take off your sunglasses and place one lens as close to your camera's shooting lens as possible. Then, take the shot. If you want to see the difference, take the same picture again without the sunglasses.

Figure 2-4. Without a sunglasses filter

Figure 2-5. With a sunglasses filter

As with any good hack, there are ways to maximize the effect:

- Stand with the sun at one shoulder. The polarizing effect is more pronounced when the sun is coming from the side.

- Glasses with bigger lenses are much easier to use as filters than small-lens models. If you're shopping for a pair of photo shades, get a pair with decent-sized glass.

- Stick with neutral tinted lenses. You can always adjust the color balance on your camera, but unless you want all of your shots to look like pop art, stay away from colored lenses.

- Use sunglasses that actually say they produce polarizing effects. Many quality brands do.

So, next time you want to enhance that beautiful blue sky with lots of big puffy clouds, loan your sunglasses to your camera for a few frames, and marvel at the results.

Get the Big Picture with a Panorama

HACK #19

They say two heads are better than one. When it comes to showing the "big picture," many heads—er, shots—are definitely bigger than one.

Many people are frustrated by their inability to capture the majesty of awesome natural monuments such as the Grand Canyon. I've heard this phrase a dozen times: "This picture doesn't really do it justice. It looked so fantastic when I was there."

Bad photography isn't the culprit here; inadequate coverage is.

Let me ask you this: if you went to the Grand Canyon and had to look at it through a toilet-paper tube, how impressive would you think it was? Probably not much. The same thing happens when you try to capture the magnificence of a vast location with single shots on your point and shoot. This doesn't mean that you have to go out and buy a camera with a superwide lens. Instead, put the magic of digital photography to work for you.

Almost every digital camera available today is capable of creating breathtaking panoramas by stitching together a series of shots into one gigantic, seamless scene. Back in the days of film, you probably played around with this technique by taping together snapshots to make a bigger picture. One of my favorite artists, David Hockney, put a creative spin on this technique with works such as "The Brooklyn Bridge Nov 28th 1982" and "Pearblossom Hwy." Hockney's works are usually referred to as *photographic collages*. But the concept is similar to our exploration here—taking a bunch of small images and combining them to make a big picture.

Unlike Hockney's work, however, our panoramas are very linear, moving from left to right. If your camera has a Panorama mode, use it; it helps you capture the images in a way that's easier for your computer to deal with later. That's the process. You shoot 3 to 12 pictures, moving from left to right, then upload them to your computer where they can be stitched together as a sweeping vista.

Let's start with the shooting technique. You'll get the best results if you use a tripod, and you'll have even better luck if you have a bubble level to go with it. That way, you can align your camera to keep a straight horizon line through the entire picture-taking sequence. If your tripod doesn't have a built-in level, go to the camera store to buy one that attaches to your camera's hot shoe.

See Figure 8-19 if you want to know if your camera has a hot shoe or not. It's a bracket, typically about the size of a postage stamp, primarily designed to accommodate an external flash.

Look for a location with the sun to your back. Most panoramas cover about 180°. You want the lighting as even as possible on that scene so that you don't have abrupt shifts in the color of the sky, which makes it more difficult to stitch together the scene and end up with continuous tones.

Once you have your camera mounted and aligned, swing through the scene and follow the horizon line to make sure it stays level.

Don't compose the shot in such a way that the horizon line splits the frame in half. Either move the horizon line down to the lower third of the composition, making a big-sky shot, or move it to the upper third of the frame, creating a rich landscape.

If your camera has a Panorama mode, enable it. Otherwise, just make sure you overlap one third of the frame as you move from shot to shot. This will give your computer lots of information to stitch the scenes together.

Swing the camera to point in the direction of your left shoulder and shoot the first frame. Move the camera one frame to the right (remembering to overlap the scene by one third) and shoot again. Work all the way through the sequence until your capture the scene in the direction of your right shoulder.

Review your images on your camera's LCD monitor. If you like the way they look, you're finished. Otherwise, recompose and shoot the series again.

If you don't have a tripod with you, shooting a panorama is still possible. Put the strap around your neck and extend the camera until the strap is taunt. Align your first shot to the left and fire. Don't move the camera after the exposure. Instead move only your feet and align the next shot. Essentially you have turned yourself into a human tripod.

Pay close attention to the horizon line as you work through the sequence. You won't get the full height of the scene by using this method, because you're bound to misalign the camera slightly as you work through the series of shots. But you can crop the picture after stitching and still get an amazingly good panorama.

Here's an example of the technique in action. Standing on a balcony overlooking New York's Grand Central Station gives you an inspiring view. So why does the picture in Figure 2-6 look so uninspiring?

Now take a look at Figure 2-7. Ah, now that's better! By stitching six shots together from a Canon Digital Elph S-400, I was able to show how Grand Central really looks to my friends back home.

Cameras with a Panorama mode will label the pictures differently than your standard single shots, so you can easily identify them when you start working on the computer. The normal image file will look something like IMG_0001_JPG. But on Canon cameras, for example, panorama files should read something like this: STA_0006_JPG, STB_0007_JPG, STC_0008_JPG, and so on. You can look at these files and right away know which one was first in the series (STA), second (STB), and so on.

Once your pictures have been uploaded to your computer, you can either use the stitching software that came with your camera, or the Photomerge function in Photoshop Elements or Photoshop CS. Either way, the software will endeavor to stitch together the sequence of files into a continuous composition. The more careful you are when you record the scene, the more success you'll have when working on the computer.

Even if your camera doesn't have a Panorama mode, you can still use Photoshop to connect the shots. The pictures won't be labeled differently, so you'll have to preview them, figure out the order in which they were shot, and then move them into Photomerge. Photoshop will take it from there.

One of the great advantages of shooting panoramas is that your 3-megapixel camera suddenly becomes an 18-megapixel monster when you stitch together six 3-megapixel shots. You can make prints that are 3 feet wide instead of just a regular old single-frame 4"×6".

Many camera stores carry frames in panorama dimensions. You can print your final composition on 8.5"×11" inkjet paper, trim it, and display it in

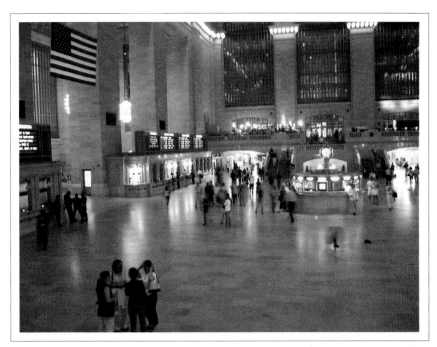

Figure 2-6. An uninspiring photo of an inspiring view

Figure 2-7. A panoramic composite of the same view

one of these frames. I guarantee that it will make a much more powerful impression than the original 4"×6" print that just didn't do the scene justice.

 HACK #20 Secrets of Whiteboard Photography

Never rewrite anything you can digitize. If you've ever been tasked with copying a full whiteboard after an intense brainstorming session, you know what I mean.

You've just finished participating in one of the most amazing brainstorming sessions of your career. The massive whiteboard, which covers an entire wall of the conference room, is covered with words, arrows, and diagrams.

You're about to rush from the room to begin putting these plans into action when your boss says to you, "Robertson! Would you please copy down these notes and circulate them to everyone who attended the meeting?"

Copy those notes?! Not even Leonardo Da Vinci could reproduce those drawings. Suddenly, an air of calm comes over you as you recall "Secrets of Whiteboard Photography" from *Digital Photography Hacks*. You pull your digital camera out from your backpack and go to work.

Why rewrite something that's already been written, when you can photograph it, save it as a *.jpg* file, and circulate it to anyone with a browser on their computer?

This hack will make more sense to you if you first understand how a camera sees the world. Most cameras are calibrated for capturing blue skies, green grass, and other middle tones. And, more often than not, your camera will try to convert anything on the extreme end of the exposure scale to those same middle tones. So the black cat becomes gray and the whiteboard becomes a murky beige color.

So, job number one is to find your *exposure compensation* adjustment and set it to +1. That will tell your camera to overexpose the subject and make the whiteboard white, not gray.

Then, turn up the room lights, open the shades, and turn off your camera's built-in flash. Those little strobes might be fine for blinding your best friend at her birthday party, but they're not so good for shooting whiteboards—unless, that is, you don't care about reading the writing. Flashes tend to *nuke* white shiny surfaces.

Now, take a test shot like the one shown in Figure 2-8. How do the colors look? Some cameras have excellent auto white balance settings and will compensate for most lighting situations. If the color looks off, you might want to override the auto setting.

If the lights in the room are fluorescent, look for the fluorescent setting on the white balance and try a test shot with that. Often, the adjustment will greatly improve the color balance. In addition to fluorescent, you also have a preset for tungsten bulbs. Use the one that best suits the lighting in the room.

Here is where the true art comes in: composing the shot. To avoid extreme distortion, where the whiteboard looks like a parallelogram from high school geometry, you must keep the plane of the camera parallel to the plane of the whiteboard. In most cases, this means nice and straight on the vertical axis (no tilting) and level on the horizontal axis (such as placing it on a table). This will minimize distortion and render the photo of the whiteboard closer to how it appeared during the meeting.

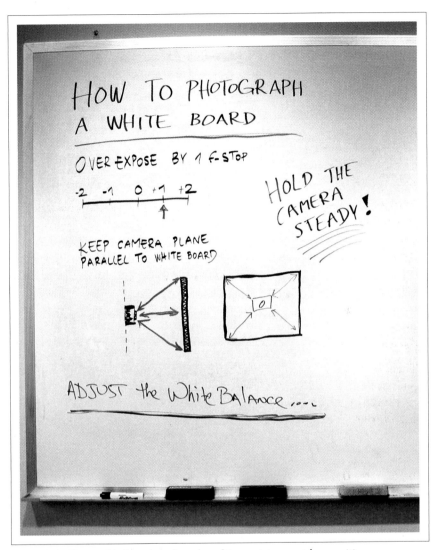

Figure 2-8. Tame whiteboard madness by taking a picture, not by rewriting

 Most cameras, especially point-and-shoot models, produce some degree of *barrel* and *pincushion* distortion. So if your lines around the edges of the frame are a little bowed, don't think you are necessarily doing this hack wrong. Of course, you can always cheat a little and not show the frame of the whiteboard in your shots.

For large whiteboards, you might want to record the information in two or three shots so that it's readable on the computer screen and doesn't look

like tiny tracks left by ants with dirty feet. You can zoom in on key concepts (and name the file accordingly later) or simply shoot the board in sections, moving from left to right. Use your judgment here.

If your shots look a little blurry, that's probably because the room lights aren't bright enough for a decent shutter speed and you're getting what's known as *camera shake*. Most of the time, you can solve this problem by increasing the ISO setting from 100 (the default on most digicams) to 400 or even 800. That will give you a faster shutter speed, which should result in sharper images.

> Remember to return to the default ISO setting after shooting the whiteboard, or you'll be very disappointed with your next batch of landscape shots.

Now that you have the pictures in the camera, upload them to your computer and give each one a descriptive filename. You can send them as email attachments, but I find that rather inelegant. Instead, build a quick-and-dirty web page and post it on the company server. All you have to do now is send everyone the link. That way, they can look at the pages they want and use their browser's forward and back arrows to move from image to image.

> Photographing whiteboards is a good option for occasional use, but if this becomes a daily task, you might want to investigate *digital whiteboards* that transfer the scribbling directly to a connected computer. Check out Smart Technologies (*http://www.whiteboards-usa.com/smart/whiteboards/*) for more information.

This might sound like a lot of work, but actually, the shooting takes only a few minutes, and how long does it take to build a quick-and-dirty web page [Hack #50]? Most image editors will do it for you as an automated process. Now that the notes are out of the way, you can get back to putting those great brainstorms into action.

HACK #21 Make Your Own Passport Photo

Don't spend money for a terrible passport picture that you'll be embarrassed to show to strangers all over the world. You can take your own shot, and make great first impressions instead.

Why is it that whenever you have an official photograph taken, you're made to look like a criminal or terrorist? Sometimes, you don't have a choice in the matter, such as for your driver's license (or booking at the county jail).

But when it comes to passport photos, you can submit your own picture, and I recommend you do.

There are general requirements for an acceptable photo:

- Photographs must be identical and recent (within six months), with a clear full-face and front-view image. They may be in color or black and white.
- The photographs must be at least 2"×2" (5cm×5cm), exclusive of any white borders. The image size, from the bottom of the chin to the top of the head (including hair), should measure between one inch and one and three-eighth's inches. There should be at least one half inch between the top of the head and the photograph's border.
- There must be a clear contrast between the background and the image of the subject. The background of the photographs must be white. Grainy photographs cannot be accepted.

Easy enough, right? Now let's talk about actually taking the picture, because that's the important part. Here is the equipment you'll need:

- Digital camera with a self-timer or remote release
- Tripod or alternative way to position the camera
- Two pieces of white foamcore, cardboard, or some other sturdy, reflective surface
- A stool or something else to sit on
- Inkjet printer with photo paper, preferably with matte surface

You want to avoid that stark, deer-in-the-headlights appearance that's usually caused by using a single flash in a darkened room. You might still use a flash for your shot, but if so, it should be a fill flash and not the sole source of illumination.

Look for a well-lit area that has a white or light background. You might use a brightly lit room in the house (with lots of light coming through one or more windows) or an outdoor setting, where you can use the side of the house for the background. But you don't want the sun shining right in your eyes. Diffused light is better.

Position your sitting stool at least five feet away from the background. You don't want to record much background detail. Instead, you want the background a little out of focus, and distance is the best way to create that effect.

Put the camera on the tripod and point it at the sitting stool. A trick I like to do is to put a lamp on the stool to act as my model while I'm aligning the camera. If you have a helper for this project, that person can serve as your

stand-in. Position the camera slightly above eye level of the subject. By doing so, the picture will be more flattering and, if you do use a fill light, the shadows will be cast downward and out of the picture.

For your first test shot, turn off the flash. Let's see how it looks with natural light only. Turn on the self-timer, have a seat, smile slightly, and hold still until the camera has recorded the image.

How does it look? If one side of your face is too shadowy, then position one of the pieces of white foamcore so it reflects light onto the dark side of your face. Try another exposure and make more adjustments to the reflectors until you get something you like.

Sometimes, you just can't get enough *pop* in the image if the room lighting is too flat. In this situation, turn on the *fill flash* function. If you camera has a control for flash exposure compensation, set it to −1. The goal here is not to have the flash serve as the main light source. Instead, you just want a little additional pop to augment the ambient lighting.

> If you're taking your own photo, try positioning a mirror behind the camera to help you pose. Also, some digicams have swiveling LCD monitors. If you have one, turn the flip screen all the way around so you can see yourself in the monitor. It's a great time-saver!

Finally, once you get the exposure you want, take a look at the color balance. Is it too cool? Sometimes, in this type of lighting, the color tint tends to be on the bluish side, which isn't good for anyone's skin tones. To compensate, set the white balance to *cloudy* and try again. By now, you should have a pretty good-looking photograph. Figure 2-9 shows a more flattering passport picture than I'd get from government photographers.

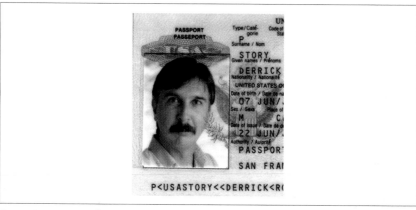

Figure 2-9. A more flattering passport picture

Upload your images to the computer and pick your favorite. Adjust the brightness and contrast to suit your taste, but don't get artsy. Remember, this has to be a clear, evenly lit image.

Once you have everything in order, make a duplicate of the picture by using the Save As command. Resize your copy so that it's slightly bigger than a 2" ×2" or 5cm×5cm square, and print out two copies on your printer. I think that matte surface photo paper looks better for this application.

Trim the photos to size, and head on down to the government office. You now have a passport that you can proudly show to strangers across the globe.

HACK #22 Get Super Close

Digital cameras have macro capability built right in. But what if you want to get real close? Here's how to get a bug's-eye view of the world.

Since the early roots of photography, people have been fascinated with capturing the world up close. Super close. Bumps-on-a-frog close. Most digital cameras come with a Macro mode that allows you to get very close to your subject. Sometimes, this mode is simply called Close Up and is denoted by a flower icon on your camera. Depending on your camera, *close* can be defined as anything from 6 inches to 18 inches. But what if you want to see the very pores? This hack will help you get started.

There are a few ways to get these types of startling shots. The first way is to buy a *macro* lens that is designed specifically for this type of shooting. Unfortunately, these lenses are often quite pricey. A second option is to buy *extension tubes* for your DSLR. An extension tube is a light-tight tunnel that extends the distance from your lens to the camera body, thereby increasing magnification—the greater the distance, the more magnification.

But what if your digital camera isn't an SLR or doesn't take interchangeable lenses? The third, and most affordable, option is to buy a close-up lens that mounts on top of your current lens, the same way that filters attach. Some cameras have adapters for these auxiliary lenses. But if yours doesn't, third-party manufacturers such as Raynox (*http://www.raynox.co.jp/index.htm*) have devised clever workarounds to enable this capability on just about any digital camera. The advantages are that you don't have to buy a whole new lens and that you can use the close-up lens with any camera, including an SLR. This is the tool we're going to use for this hack.

Get the Glass

First, go down to your friendly photo dealer and see what type of close-up attachments are available for your camera. I've had a lot of luck with the

aforementioned Raynox lens, which is well made, affordable, and readily available. Raynox makes a wide variety of goodies for all kinds of cameras, including close-up accessories for digital cameras. The lens comes with an attachment to help you mount it over your built-in glass. Turn on your camera and—voilà!—you have a super-macro digital camera.

How close can you get? Close-up lenses are described by a *diopter number* that indicates how close your lens can get to the subject, in units of fractions of a meter. For example, a lens marked +12 will let you get within 1/12 of a meter (or within just 8 centimeters). For those of you inclined to use the imperial system, that's just over 2 inches away—also known as *pretty darn close*! What's fun about all of this math madness is that these measurements are based on the lens of your camera being set to infinity. If, like many cameras, yours has the ability to focus manually, you can get even closer by using the close-up lens and its built-in close-focusing setting.

Mount the Camera for Best Results

So now you have a close-up lens attached to the camera and are ready to shoot, right? Well, almost. Shooting one inch away from a subject is tricky, because the lens has very little tolerance for being even a little too far or too close to the object. If you move out of that one-inch *in-focus* area, your object will quickly get soft. This means that to take really good shots you need to mount your camera on a tripod.

In super-close-up photography, moving the camera to correct focusing is easier than fiddling with your digicam's focusing mechanism. Many used-camera stores carry *focusing rails* for just this purpose. You mount the rail on your tripod and then secure the camera to the rail. Then, just turn the focusing knob to move the camera closer or farther from the subject in small increments. It really helps!

You'll also need a good location to shoot the object. Place the object on a table with a white background, either cloth or paper. Ideally, you want your camera to be facing straight at the object. So, get a chair and sit down in front of your camera.

One advantage of shooting with a tripod is that you can have long exposures without having to worry about camera shake. To be safe, either use a shutter cable or, if your camera can't accept one, use the built-in self-timer. Even the shake from you holding down the shutter button can blur the image.

Try getting as close as 4x (Figure 2-10) with your regular camera lens. It won't work—that is, unless you add a little glass. But don't stop there. Try 8x (Figure 2-11)! But wait, there's more! Is 12x (Figure 2-12) close enough for you?

Figure 2-10. A close-up of a flower at 4x

White Balance for Good Color Tone

Before taking your shot, it's a good idea to measure the *white-point* of the image and set your camera accordingly. This will save you lots of color-balancing work later in Photoshop. For most digital cameras, this is done by selecting the *measure white-point* feature on your camera and holding the shutter halfway down. The camera will then measure the light of your image and base the white-point on the particular lighting you are using. If you can't measure the white-point manually, some cameras will let you choose from a menu of presets, such as tungsten, florescent, or daylight. Set your camera appropriately to get the best color balance possible.

Flash Versus Available Light

So what about flash? Why bother with it if you can just use tungsten or available light? Well, one of the advantages of using flash is that you can

Figure 2-11. A close-up of a flower at 8x

Figure 2-12. A close-up of a flower at 12x

control how the item is lit and where the shadows will fall. You can try using your camera's built-in flash, but this will often not give you the kind of control you need because the flash will be literally inches from your subject. Small *soft-box* flash units are ideal here, providing a soft, even, neutral light to your close-up images. You can pick up a soft box flash unit from your local pro-camera store. A soft box is simply a portable enclosure for your flash that has a translucent nylon face that softens the intensity of the flash as the light passes through it. This makes the light softer, a more suitable quality for close-ups and portraits. I recommend using two soft boxes, one on each side, to produce even illumination.

Final Thoughts

Super-close-up shooting can make even everyday items more interesting and will allow you to discover a whole new way of seeing the world and creating images. Experiment with different kinds of objects, both natural and human-made, and get ready for some visual surprises. You already have the camera and, with a minimal investment, you are well on your way to capturing the world from a bug's-eye perspective.

—*Hadley Stern*

HACK
#23

Multiple Exposures, Digital Style

If you're looking for the multiple-exposures setting on your digicam, forget about it. It probably isn't there, unless you own a Fuji pro SLR camera or one of a handful of other models with this capability. So, what's the creative digital photographer to do?

In the film world, multiple exposures are a great way to create interesting, unexpected visual effects. Traditionally, this was done either in-camera by exposing one frame of film many times, or in the darkroom by sandwiching negatives together.

Unfortunately, most digital cameras don't support multiple exposures. But that doesn't mean it can't be done. Photoshop, the digital darkroom of choice for many, comes to the rescue.

There are a couple ways to approach gathering your source material for Photoshop. You can previsualize the final image you're after, shoot its parts (layers) with your digital camera, and then assemble these layers on the computer. Or, if you just want to experiment, grab a few pictures out of your existing library, mush them together, and see what happens. Suddenly, every digital image in your photo library becomes potential fodder for an interesting photo montage.

Assembling Multiple Images into a Montage

For the first option, we're going to shoot three images, as illustrated in Figure 2-13.

Figure 2-13. A photo montage

As you shoot, try to imagine each shot layered on top of the next one, resulting in an interesting image. For each shot, we're going to underexpose by a factor of 2. Set your exposure compensation to –2 and take three different shots. You've now captured three underexposed images that, when added together, will create one well-exposed image.

Bring these pictures into your computer, start up Photoshop, and open each one in turn. Copy two of the images and paste them into the first. You should now have a single image file with three layers. If you open the Layers palette (Window → Layers), you'll see your three images in the palette, as shown in Figure 2-14.

Figure 2-14. Three images in the Layers palette

When doing this type of work in Photoshop, you'll often hear the term *layers*. This is a powerful feature that enables you to make precise adjustments to aspects (layers) of the overall image. In Photoshop CS, you can view the Layers palette by going to Window and choosing Layers from the drop-down menu.

Once you've finished working with the image, save it as a Photoshop file (*.psd*) to preserve the layers. This is your master image. Then, you can go back and quickly make subtle changes to each layer. If you want to publish your image or send it to a friend, use the Save As command to convert a copy of the picture to JPEG.

You'll now adjust the blending mode to Multiply. Click on the layer in the Layers palette to indicate that you want to work on it. Then, select Multiply from the drop-down menu (in the Layers palette). In Figure 2-14, Layer 1 is highlighted, with Multiply selected in the upper left. Photoshop's Multiply feature takes each layer and adjusts its density and highlight colors relative to the layer beneath it. This accurately creates the same effect as traditional film-based multiple exposures.

Because you compensated for exposure when you recorded the pictures, these three light images should now look like one well-exposed shot, with the random and interesting effects you get from multiple exposures. You can also make minor density adjustments by using the Opacity setting in the upper-right corner of the Layers palette.

Creating Multiple-Exposure-Like Effects

But what if you don't want to go through the bother of shooting images with exposure compensation? The second option is to use your current pictures to experiment with multiple-exposure-like effects. Open up any number of images and bring them into one Photoshop document. As in the previous example, adjust the layers to Multiply. Now, adjust the opacity of the individual layers until you get an even exposure. Of course, one of the benefits (and frustrations too, because when do you stop fiddling?) of Photoshop is that you can adjust to your heart's delight. If a particular image (layer) is too dominant, adjust its opacity or delete it altogether.

Working in a Truly Digital Darkroom

Back in the darkroom days, technicians often employed techniques called *burning* and *dodging*. And guess what, Photoshop does too! This means that if you don't like the density of a certain area of your image, you can tweak it with these adjustments. Select the part of the layer you want to emphasize or deemphasize, and use the burn tool to darken it or the dodge tool to lighten it.

Even though creating multiple images has its roots in film photography, it's a terrific digital-imaging technique too. Let your visual imagination run wild.

—*Hadley Stern*

Go Low-Rez

#24

There's much more to digital photography than megapixel brute force. And if you're artistically minded, you might try your hand at going low-rez, Jam Cam style.

As digital photographers, we're often obsessed with getting every last pixel we can—the more megapixels, the better the shot, right? This hack allows you to let go of your pixel-counting tendencies and helps to remind you that photography, analog or digital, is all about capturing compelling images, regardless of the technology used.

Traditional photographers have long used cheap or low-tech cameras to capture interesting, *artistic* images. Perhaps the best example is the US$20 Holga camera that uses 120 film, tape, and a plastic lens and gives images a beautiful, halolike look. Fear not, digital photographers, there are many inexpensive digital equivalents to the Holga that will stretch your creativity.

For this hack you need to get the cheapest, lowest-resolution digicam you can find! I highly recommend the Jam Cam. This little plastic beast captures images at an astounding 640×480 or 320×240 pixels and has a focus-free lens. The built-in memory stores eight images and, believe it or not, it can connect to your Mac or PC via USB. The battery is the old standby: the 9-volt that powers up smoke detectors all across the land.

Does the Jam Cam create artistic images? Take a look at the picture in Figure 2-15, and you be the judge.

Figure 2-15. An artistic Jam Cam image

The great thing about the Jam Cam is that it is wholly unpredictable. One fun way to use it is to bring it along with you when you are shooting with your regular digital camera, take pictures with each camera, and compare the results. Expect strange color shifts, horrible color balance, random pixelation, and some interesting results. I used the Jam Cam to take portraits. Embracing the low resolution, I took the images at 320×240 pixels and printed the 150 KB JPEGs at 11×14.

You can also experiment with other ultra-low-rez cameras, the cheaper the better, and see the results you get. Toy digital cameras are a great place to start, as are camera phones or anything with a resolution no higher than 640 ×480. But resolution is not everything! In low-rez mode, your current digital camera might shoot images at only 640×480. However, because of your camera's quality lens, the images won't come out looking quite as funky or interesting as an image from a toy camera. A focus-free plastic lens in combination with low resolution is going to give you the most interesting results.

But what if you don't want to plunk down the 20 bucks or so to get a super-low-resolution camera? You can always use Photoshop as a tool to add distortion and noise to your current shots.

One way to start is to greatly reduce the resolution of a current image you have and print it to see the results. Convert your image to 20 ppi at 8"×10" (by selecting Image → Image Size) and have a look. Or even try 10 ppi, as shown in Figure 2-16. Suddenly, your pristine image becomes like a Chuck Close painting, which, depending on the image, can be interesting.

One thing that the low-rez camera does so well is perform tasks in random ways. To duplicate this randomness in Photoshop, you need to select only certain areas of an image. To imitate the effect of the Holga camera I mentioned previously, for example, use the circular select tool and begin a selection from the center of your image, ending about halfway out. Now, go to Select/Feather to feather the selection by 50 pixels and blur the image.

To recreate some of the randomness of a low-rez digital camera, you can make some duplicates of the layer, offset them, apply a multiply effect or a screen effect, and see what happens. You can also use layer adjustments to adjust the hue and saturation, change the brightness and contrast, and add some noise. Layer adjustments are a great way to experiment.

To use layer adjustments, select a layer, go to Layer → New Adjustment Layer, and select the adjustment you want to try. After you've made the adjustment, a smaller layer will appear in the Layers palette above the original layer. This means you can turn on or off the layer adjustment or discard it entirely; the original layer data is intact. When using Photoshop as a low-rez darkroom, try to use the randomness of the low-rez digital camera as

Figure 2-16. An 8"x10" print at 10 ppi

inspiration. Think of yourself as a digital and photographic version of Jackson Pollack, applying digital splatters with a sense of freedom yet control.

Using either low-rez digital cameras or Photoshop as a low-rez randomizing tool can provide you with some incredible results. Keep an open shutter and mind, and let the beauty of the images be your guide.

—Hadley Stern

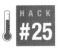 Painless Infrared Photography

#25 What kind of eerie world makes the sky go dark and trees turn white? It's the stunningly beautiful realm of infrared photography.

If you've ever tried shooting and processing infrared film, you know what a pain in the aperture it is to deal with. You have to load the camera in complete darkness, guess wildly about the exposure settings, process the film, and then cross your fingers that at least one or two shots turned out the way you had hoped. The results could be stunning, but they came at a painful price.

Digital photography has changed all that. Not only is persnickety film handling a thing of the past, but you also now get to preview your infrared images on the LCD monitor before taking the shot. And the best part? They will look every bit as beautiful as their film counterparts, as you can see in Figure 2-17, which was shot with a Canon G1 digital camera. This barn shot was taken at 1 p.m. Most photographers are diving for cover at this time of day—that is, unless they're shooting infrared.

Figure 2-17. An infrared shot of a barn

Infrared photography deals with the spectrum of light that you can't see but that your digital camera can. If you buy a filter to eliminate the normal light rays and capture only the infrared rays, you can add this look to your photographic bag of tricks.

The first thing you'll notice in infrared photography is that the blue sky goes dark and that most trees turn very light. Glare is minimized, giving your pictures an eerie clarity.

A popular filter for digicam infrared photography is the Hoya R72. If your camera accepts filters, then go get an R72 at the camera store, attach it to your camera, and look at a brightly lit scene in the LCD viewfinder. You'll know right away if your camera is suitable for this kind of shooting. You can test the "infraredness" of your camera by pointing a remote control toward

the lens and seeing if the beam registers the camera's LCD monitor (Figure 2-18).

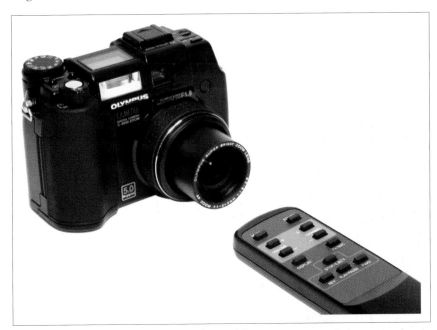

Figure 2-18. Use a remote to test infrared capability

What's interesting is that older digital cameras often work better than newer models. Over the years, many camera makers have added internal filtering to improve overall picture quality (color, that is) that unfortunately hamstrings the camera's infrared capability. For example, my Canon G1 takes great infrared shots, but the G2, G3, and G5 don't perform nearly as well. This is a great argument for hanging on to your older digicams, because you never know what they'll be good for up the road.

Other older models that shoot great infrared shots include the Nikon CoolPix 800 and 950, Canon S10, Olympus C-3000 series, and Kodak DC 260. Many others also work well. If you want to test a few cameras you have on hand, try this. Line them up and activate their LCD monitors in Record mode. Take a TV remote control and point it directly into the lens of each camera while pressing any button, such as the channel changer. The camera that displays the brightest light from the remote on the LCD monitor is your leading candidate for infrared photography.

Now, take your camera with a Hoya R72 filter out into the bright sunlight. The best conditions for infrared shooting are a blue sky, puffy clouds, and some trees in the landscape. Mount your camera on a tripod and put it in Program mode. You need to steady the camera because the shutter speeds will be very long, even in bright sunlight, due to the density of the R72 filter.

Preview the scene in the LCD monitor and find a composition that best shows off the drama of infrared. Some trees will turn white and others won't, so you have to preview the scene to see what's most dramatic. Take a few shots, and then switch to B&W mode and take a few more. Later, while viewing the pictures on your computer, you can decide which type you like better. In Figure 2-19, the sky turns dark, the foliage light. What kind of weird world is this?

Figure 2-19. Experimenting with infrared photography

That's all there is to it. Now, during the bright midday sun, when other photographers refuse to go outside, you can create dramatic, artistic images that will truly impress your friends.

Create the Maximum Depth of Field

Imagine the kind of pictures you could take if everything were in focus from one foot to infinity? Here's the inside scoop on one of the oldest secrets in photography.

Galen Rowell, one of my favorite photographers, used to create landscape compositions in which both foreground objects and distant elements appeared in perfect focus. The effect is stunning. The viewer can both study a delicate pattern of petals in a foreground flower and marvel at the beauty of outlying mountains. How did he do that?

Galen found a way to capture tremendous depth of field in his images. In other words, he could have everything in focus, from inches away to infinity. You can employ this same technique in your photography; you just have to know the hack.

Three important factors come into play on these types of shots:

The focal length of your lens
 The wider the better.

The lens aperture
 The smaller the better (f-16, f-22, etc.).

The object on which you focus in the composition
 Contrary to expectation, it's not the thing closest to you.

Once you've properly set these adjustments, you can create depth of field that spans from a foot in front of you to the puffy clouds drifting by.

Focal Length: The Wider the Better

Wide-angle lenses, or zoom lenses set to wide angle, are a key factor in depth-of-field photography. They help create the illusion that more things are in focus.

Galen Rowell usually shot with 35mm film cameras, and often he would use a 24mm wide-angle lens for this type of landscape image. For this hack, I recommend you find a digital lens that provides a film-camera equivalent of a 28mm lens. You can go wider if you want (such as 24mm), but as you'll see, that's easier said than done in the digital world.

For example, if you're shooting with an SLR, such as a Nikon D70, then you would need to use Nikon's 17–55mm zoom lens to get roughly the same angle of view as Galen's 24mm lens on his 35mm SLR.

Why? Well, the D70 and many other digital SLRs have image sensors that are smaller than 35mm film. That changes the relationship between lens and

camera, and the result is that you often have to multiply the focal length of the lens by a factor of 1.5 to get the same angle of coverage that you would with the lens mounted on a film camera.

If you multiply the Nikon 17–55mm zoom lens by 1.5, you get the 35mm equivalent of a 25.5–82.5mm lens. You may or may not care about all of this. But what you do need to know is that you have to find a lens with a film-camera equivalent of at least a 28mm lens for this type of photography. The Nikon 17–55mm zoom on a D70 should work nicely.

If you're shooting with a digital point and shoot, such as a Canon Power-Shot A80, then your built-in zoom lens (7.8–23.4mm) has the film-camera equivalent of a 38–114mm zoom lens—not quite as wide as we'd like for this type of shooting. The good news is that Canon offers a wide converter (WC-DC52) for this camera that attaches over the built-in zoom lens. It extends your field of view to a healthy film-camera equivalent 24mm lens. Cool!

In fact, many digital point and shoots accept wide-angle lens attachments. If you're interested in this type of shooting, then you'll want to make sure your next camera has this capability.

No matter which route you choose—digital SLR or point and shoot—get to the film-camera equivalent of a 28mm lens, and you're in business. Scenes such as the redwood forest shown in Figure 2-20 are captivating when you're able to extend the depth of field to render all elements in focus, from foreground to back.

Lens Aperture: The Smaller the Better

The second factor for extending your depth of field is to use a small aperture. If we go back to the Nikon 17–55mm zoom, for example, it has an aperture range from f-2.8 to f-22. When the aperture is set to *wide open* (f-2.8), your images will have a shallow depth of field. For this assignment, you want to use the opposite (f-16 or f-22) for maximum depth. You can achieve this by using the Aperture Priority or Manual Exposure mode on your camera. If you don't have these modes available, look for Landscape in your menu of options. It will *stop down* the aperture for you (*stop down* is an old photography term for making the iris hole smaller by choosing an f-stop such as f-16).

When you have the aperture closed down to a diameter this small, you're usually going to have long shutter speeds, such as 1/8 or 1/4 of a second, to compensate for the reduced amount of light coming through the lens. These shutter speeds are too long for handheld photography, so a tripod is in order.

Figure 2-20. Extending the depth of field in a redwood forest

If you attempt to hand-hold the camera with these long shutter speeds, your pictures won't be sharp, due to camera shake. The best way to avoid camera shake is to use a sturdy field tripod and a remote shutter release, so as not to jar the camera when you trip the shutter. You can use the self-timer instead, if that's more convenient.

The main thing to remember is to steady your camera and stop down your aperture to f-16 or smaller.

Set Your Focus Manually

Now, here's the real secret to success: switch to manual focus mode and focus on an object that's one-third deep in the composition. Think of it this way: if the flower is the closest object in the picture and the mountains are the most distant elements, then manually focus on something that is one-third the distance between them.

Your tendency will be to focus on the nearest object—in this case, the flower. But that won't give you the greatest depth of field. If you're shooting with a digital SLR that has a depth-of-field preview, you can test this theory. Set your camera to f-22 and focus on a point that's one-third deep in the composition. When you initially look through the viewfinder, both the near object and the distant elements will appear out of focus. That's because you're viewing them with the aperture wide open, which shows the least amount of depth.

If you want to shoot a scene with a nice foreground object, such as a flower or pine cone, but you can't find the right composition, carry a few items with you. Bring your props from home and place them in the landscape as needed. Some photographers even cultivate indigenous plants specifically for this purpose.

Now, press the depth-of-field preview button (with the aperture still set to f-22). The image will get darker, because less light is coming through the lens. But if you look carefully, you'll see that both the closest object and the distant elements are now magically in focus.

Final Thoughts

Every lens and camera combination has its own quirks and characteristics for this type of shooting. If you're lucky enough to have a depth-of-field preview button, you can actually check your scene before shooting. But even if you don't, with a little experimentation you'll discover that you can stretch the boundaries of clarity to incredible distances. Save this technique for special compositions that are enhanced by great depth of field.

Create Soft Background Portraits

#27 Do professional portrait photographers use special lenses and accessories to soften the backgrounds in their portraits? No, they don't. They manipulate the depth of field, and this hack will show you how.

The previous hack showed how to create tremendous depth of field for landscape compositions. But when you're shooting portraits outdoors, this is usually the last thing you want. For these types of assignments, you want your viewer's attention locked in on the subject, not the background. The best way to accomplish this is to *narrow* your depth of field and focus your camera directly on the subject's eyes.

Why Soft Backgrounds?

When everything works right, the result is a dreamy, soft backdrop that makes your model *pop forward*, attracting all attention to her presence. Generally speaking, the first thing viewers look at in a portrait is the subject's eyes. The easier you make it for them to get to that spot, the happier they will be, at least subconsciously. Once they've viewed the eyes, they examine other aspects of the person until they're satisfied and move on. To get a soft portrait background, like the one if Figure 2-21, try to get some distance

between the subject and the backdrop. Then, open your aperture to limit the depth of field.

Figure 2-21. A portrait with a soft background

Distracting background elements, such as a tree growing out of the top of the subject's head, is unsettling to the viewer. That's why you often want to eliminate or at least soften these elements.

Now remember, this is not a technique that you'll use every time you shoot a portrait. If, for example, you're shooting a baseball owner standing in his

stadium, you might want the background elements distinguishable, because that tells a better story. So, soft-background portraiture is a technique to use only when appropriate for the assignment.

Here are a few tips for creating a soft background for your portrait:

Use a telephoto lens. *Long lenses*, a nickname photographers have given to telephoto lenses, inherently have shallow depth of field. If you're using a digital point and shoot, extend the lens to its greatest telephoto setting—usually, the equivalent of 105mm on film cameras.

> Digital SLR users have it much easier in this regard, because they can attach lenses that give them the focal-length equivalent of 200mm or more, which is much better for softening the background.

Open up the aperture. The wider the aperture (f-2, f-2.8, etc.), the narrower the depth of field. Use Aperture Priority or Manual Exposure mode to set your aperture to its widest setting. If you don't have these modes on your camera, look for Portrait mode in the menu of options; it will set the correct aperture for you.

Choose a background with few distracting elements. You'll find it much easier to soften a background of green foliage than you will a marina full of boats with masts. Look for backgrounds that make your job easy.

Create distance between the subject and the background. If you stand the model up against a wall, you don't have a very good chance of softening the background's texture. The more distance you can put between your subject and the background, the easier it is to soften. I like at least 10 feet, but if I can get more, I use it.

Final Touches

Now that you have your technical ducks in a row, compose the picture and focus on the model's eyes. After a few frames, review what you've shot on the LCD monitor. I think you'll be pleasantly surprised at how different this composition looks, compared to portraits you've taken in the past.

HACK #28 Analyze Metadata to Improve Your Shots

In the days of film cameras, I seldom recorded exposure settings that would have helped me better analyze my pictures. Now, digital cameras handle all that work for me, and I can use that information to figure out what went right or what went wrong.

Every time you click the shutter, your digital camera records valuable picture data that describes the image you just captured. Data such as time, shutter speed, aperture, focal length, and ISO are written to the file header

in the Exchangeable Image File (EXIF) format. This information becomes part of the total image file and can be displayed with applications such as Photoshop.

In essence, each picture file contains a complete photographic history of the decisive moment, which can be analyzed to help you understand why the image was successful or give you clues as to what went wrong. In this hack, I'll show you how to retrieve this data and use it to hone your photography skills.

What Is EXIF?

The EXIF format is an international specification, first established in 1995, that enables digital cameras (and other imaging devices) to write data to the file header of the image. EXIF files use the JPEG DCT format specified in ISO/IEC 10918-1. The picture portion of the file can be read by any application supporting JPEG, including web browsers and image editors. The metadata can be accessed by applications designed to extract that information out of the header and display it. The most common imaging applications have no problem displaying at least some of the EXIF data.

However, the picture file usually contains more information than what's typically displayed by a given application, unless that application is designed specifically to output EXIF information. For example, iPhoto on the Mac provides the basic time, date, file size, and camera information when you click on the Photo tab of the Show Info window. If you click on the Exposure tab, you get more data, such as shutter speed, aperture, focal length, exposure compensation, metering pattern, and flash status.

But iPhoto doesn't provide you with other data sitting there in the file header, such as white balance. If you need that information, you have to open the file with another application designed to grab that data. The point is that the EXIF specification dictates what goes in to the picture file, but image editors typically give you only a portion of that information. So, if you get serious about reading this stuff, you might need to add a couple tools to your imaging bag of tricks (more on this later).

Why Would I Want to Read EXIF Data?

When you take pictures, some turn out better than others. Why is that? Beyond good composition and subject matter, there are many factors that contribute to powerful images. These include time of day, depth of field, proper shutter speed, and exposure compensation as needed.

If you look at a picture of running water, for example, and you like the way it's rendered, wouldn't it be nice to know the settings that you used, so you could duplicate the effect? Before digital cameras were available, I would take handwritten notes to help me remember the settings for particular shots. I hated that! Now, the camera records all that information for me, and I'm free to concentrate on taking good pictures.

I know that I can control the way water appears by adjusting the shutter speed. The 1/250-of-a-second exposure "stopped the action" to some degree, and the 1-second exposure created a soft look. Now, the next time I shoot running water, I can capture the exact effect I want by adjusting the shutter speed.

Time of day also has a dramatic impact on pictures. (Make sure you have your camera's time and date settings correct so that they are accurately recorded with the picture.) Over the course of a few hours, a scene can totally change in appearance. When I checked the metadata for Figure 2-22 in iPhoto, it said that the image was captured at 10:45 a.m. The shot in Figure 2-23, from roughly the same location, was captured at 8:15 a.m. the following day and was rendered much differently.

Even though these pictures were captured from roughly the same location, only a day apart, they are very different. The sun was higher in the first picture and it *flattened out* the scene, rendering more even highlights and shadows. The same picture shot two and a half hours earlier on the following day shows the difference when the sun is lower and creates harsher highlights and shadow areas.

If I were to go back to these lakes at the same time next year, I could then determine what time to start shooting based on my review of the metadata for the pictures I'd already taken. If I wanted more even, less dramatic lighting, then late morning seems ideal for that effect. On the other hand, if I like the harsher contrast of darks and lights, then I know I have to get there a few hours earlier.

These are just a couple ways to review EXIF data to analyze your pictures. Other settings—such as flash on or off, exposure compensation, white balance, and aperture setting (for depth of field)—are all important clues to understanding the success or failure of your images.

What Should I Use to View EXIF Data?

You have many options for viewing the EXIF data your camera captures. As I mentioned before, digital shoeboxes such as Adobe Album, iPhoto, and iView Media Pro provide you with most of the important information that

Figure 2-22. The lake at 10:45 a.m.

Figure 2-23. The lake at 8:15 a.m.

you commonly need. Also, take a look at the software bundled with your camera. For example, both Nikon and Canon provide image utilities that are pretty good at displaying the data your camera captures. A good universal tool is Photoshop Elements, which can serve as your full-featured image editor and can show you all of the metadata you'll ever need to know via the File Browser function (Window → File Browser). Figure 2-24 shows an example of the type of information you can get from Photoshop's File Browser.

Figure 2-24. Viewing EXIF data in Photoshop's File Browser

This application shows me settings, such as white balance, that aren't displayed in more basic image editors. I don't always need this level of detail, but it's nice to know it's there if I want it.

Final Thoughts

I recommend you keep a set of original files for all of your important images. In part, I think this is just good file management. But I also like to have those original pictures because I know that the metadata will be intact for me to review whenever I want it.

When you manipulate pictures and save them in optimized formats, important metadata is sometimes removed from the header. If you don't have those original files to fall back on, you might lose that information forever. Plus, it's always wise to have the unaltered, uncropped picture stashed away safe and sound.

This hack just scratches the surface of metadata use. Soon, GPS-equipped cameras might be able to record positioning coordinates to the EXIF file, which could later be translated into locations when browsed with the image editor. Who knows what else? But for now, tapping EXIF data can certainly help you take better pictures and serve as a permanent record for when you recorded them.

Nighttime Photo Hacks
Hacks 29-38

If daytime is the ultimate photo studio for portraits and landscapes, then nighttime becomes the perfect setting for the creative use of light. With a darkened backdrop, you can record eerie glowing objects and streaking lights. You can turn candles into stars, and stars into iridescent bands of light.

The hacks in this chapter are designed to bring out both the artist and the scientist in you. Who knows what magical images you can create with a tripod and a little patience? You're about to find out.

HACK #29 Nighttime Portraits with Scenic Backgrounds

Sometimes, capturing the background of a nighttime portrait as just as important as capturing the subject itself.

Long ago, in a distant place, a camera designer made the decision to set the shutter speed to 1/60 of a second when the flash is activated. I don't know exactly when this happened, but that's the way it's been ever since I can remember.

The problem with 1/60 of a second is that it often creates night flash shots with muddy or nonexistent backgrounds. To prove my point, find a vibrant night scene, such as a street composition in New Orleans's French Quarter, turn off your flash, and take a meter reading. I doubt that the shutter speed will be 1/60 of a second. Most likely, you will get a reading of 1/30, 1/15, or slower. Brightly lit night scenes usually require that the shutter stay open longer than in brightly lit daytime scenes. Have you noticed that your daytime fill-flash shots look better than your nighttime flash shots? It all comes down to shutter speed.

When it comes to flash photography at night, shutter speed controls the appearance of the background and aperture controls the exposure of the subject within flash range. If the background doesn't look the way you want, change the shutter speed. If the subject within flash range doesn't look right, change the aperture.

If you leave your camera in auto-everything mode, it sets the shutter to 1/60 of a second when you turn on the flash. This is a safe shutter speed that provides acceptable images in a variety of lighting situations, both daytime and nighttime. But if you're in New Orleans, having the time of your life, *acceptable* isn't going to cut it.

Here's what you have to do: slow down the shutter speed when the flash is on. Almost every camera gives you some way to do this. Here's what to look for:

Nighttime Flash mode

Cycle through your flash settings and look for the icon of a subject with a star overhead. If you have this icon, kiss your camera and the person who bought it for you. Under this setting, the camera will read the background, choose the right shutter speed, and add enough flash for the subject. When it works right, both the background and subject are nicely exposed.

Shutter Priority mode

Typically, this setting is reserved for more advanced cameras. Often, Shutter Priority mode is indicated by an S. Other times, it's indicated by TV, for Time Value. Either way, you get to set the shutter speed, and the camera then automatically adjusts the aperture and adds the right amount of flash.

Long Shutter mode

If your camera doesn't have Shutter Priority mode, it might have an abbreviated version called Long Shutter. This mode allows the user to slow down the shutter speed for situations such as night photography. The camera will do its best to add the right amount of flash and set the correct aperture.

Manual mode

You'll see this setting more often on advanced cameras. Manual mode enables you to set both the shutter speed and the aperture. The camera adds the right amount of flash.

Once you find the setting on your camera that enables you to slow down the shutter, you need to figure out how to steady the camera during exposure.

The reason why auto-everything mode uses 1/60 of a second is that it's fast enough to avoid what is known as *camera shake*: an overall, soft, blurry effect that results from using a slow shutter speed with an unsteady camera.

To capture vibrant backgrounds with most brightly lit night scenes, you need a shutter speed of 1/15 of a second or slower, as shown in Figure 3-1, which was shot in Nighttime Flash mode at 1/2 second. You might not realize that your camera has switched to such a slow shutter speed when you use Nighttime Flash mode, but it has. So, you have to steady the camera during the exposure.

Figure 3-1. Nighttime Flash mode (photo by Jan Blanchard)

The best way to do this is to use a tripod. And of course, everyone carries a tripod while partying in New Orleans, right? If you left yours back at the hotel, look for a table, ledge, phone booth, or even a friend's shoulder to steady the camera during exposure. Gently squeeze the shutter button so as not to jar the camera. Tell your subject to hold still until you give the word.

You might also look into portable tripods that fit in your back pocket [Hack #1]. One of my favorites the UltraPod II by Pedco (*http://www.pedcopods. com*). Not only does it provide three legs, it also has a sturdy Velcro strap that allows you to attach the tripod and camera to posts and rails—very handy for street shooting on the go.

Look for backgrounds that tell the story. If you had a great time at a particular venue, then go out front and take a group shot with the building's façade in the background. Also, look for icons that tell the story. Everywhere in the world there are beautifully lit monuments and structures that immediately show viewers where you visited, from the Golden Gate Bridge in San Francisco to Edinburgh Castle in Scotland.

Make sure the people in the shot are within flash range. On most point-and-shoot cameras, this means 10 feet or closer. If your camera accepts an external flash, you can extend that range to 20 feet or more.

After you take a test shot, if your background is still too dark, then lengthen the shutter speed a bit more. There are a few ways to do this:

- In Shutter Priority and Manual modes, move the setting from 1/15 to 1/8 or longer.
- In Long Shutter mode, use the left button to move the shutter-speed indication down the scale for longer exposures.
- In Nighttime Flash mode, move the exposure compensation scale a few settings toward the + symbol to lengthen the exposure.

In all modes, you can increase the ISO speed setting to make your camera more sensitive to light. Try an ISO setting of 200 or 400 and see how things look. Remember, though, to set it back to ISO 100 when you've finished night shooting.

Finally, remember that shooting with slow shutter speeds indoors or at night means that any movement through the composition during exposure (out of flash range) will be blurred or have a ghostlike appearance. Sometimes, you can use this for a creative effect. For example, if you want to show lots of activity in the background at a wedding reception, then have the bride and groom within flash range, use a slow shutter speed, and let the guest activity blur, thereby showing motion.

This is a technique that has unlimited possibilities. Have fun with it. Experiment. By doing so, your night pictures will look much different, and better, than those of your peers.

Street Shooting at Night

HACK
#30

Because of their compact size, pocket digicams are excellent street-shooters, enabling you to capture the grit and the glory of urban life at night—that is, if you know how.

When you sit back and look at your travel shots, do you ever feel like you're shooting the same thing over and over, and only the locations change (same

boring group shots, blurry bus scenes through the window, and yet another statue)? One of the best ways to inject life into your photography is to grab your camera and hit the streets...on foot.

Now, I'm not talking about raw photojournalism or anything dangerous. Every major city in the civilized world has a *good* part of town and a *bad* one. Lace up your sneakers and go to the friendly part of town.

My favorite time to shoot on the streets is from about an hour before twilight until darkness. Generally speaking, there's lots of activity at this time, and the building lights come on when there is still some color left in the sky. It's a magical setting that's perfect for photography.

But if you want to capture that magic, you have to turn off your flash. This is rule number one for interesting street photography. Not only does the flash draw way too much attention to your shooting, but it also kills the shots. The possible exception is using Nighttime Flash mode [Hack #29], but for most of your street shooting, leave the flash off.

> The best time for "night" photography is actually twilight. Most city lights come on before complete darkness. Your shots will be much more colorful and compelling with the deep blue twilight sky rather than the blackness of night, as shown in the two pictures of the Chrysler Building in Figure 3-2. The first picture was shot late at night, when the sky was completely dark. I went back the next day at dusk and captured the second shot with more color in the sky. Which do you like best?

As the light goes down, however, your exposures will get longer, which means you have to look out for camera shake. Here are a few ways to combat shake so you get crisp images, even in low light:

Increase your ISO setting from 100 to 200. You can go up to 400 if you need to, but you will have more noise in your shots at the higher rating. Often, this isn't a big problem for street shooting, because the gritty look seems to work with this type of subject material. Generally speaking, though, don't increase your ISO setting any more than you have to.

Lean against buildings and other solid structures to steady your shots. You'll be surprised at what a difference this can make. Push your body weight against the building and lock your elbows against your body. Squeeze the shutter button; don't punch it. Your shots will be much sharper.

Bring along a pocket tripod, such as the UltraPod II by Pedco. By having a pocket tripod, every newspaper stand, guard rail, and building step

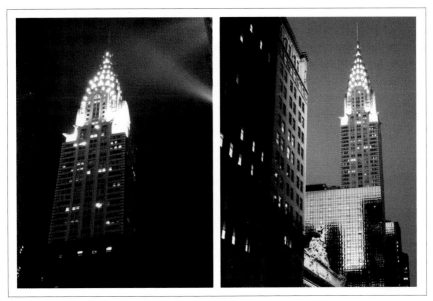

Figure 3-2. The Chrysler Building

becomes a possible shooting surface. Simply place the tripod on a suitable flat area or strap it to a pole, and then enable the self-timer. The timer will trip the shutter without jarring the camera. This technique is particularly good for shooting nighttime monuments, buildings, and bridges that require lots of image sharpness.

Now that you have some good ideas for *how* to shoot on the street, *what* do you shoot?

People are often great subjects on the street, especially when they are interacting with others. If your camera has a variable-angle LCD monitor, you can hold your camera down at your waist and follow the action through the LCD. This draws less attention to you, because it isn't obvious that you're taking pictures.

Another advantage to these types of adjustable viewfinders is that they make it easier for you to lower or raise the camera angle, bringing a fresh perspective to your images. For example, try putting the camera down on the ground. Then, raise it up over your head and look at the world from above.

If you're shooting at slow shutter speeds, try to take the picture when the subject has paused for a brief second. That way, you'll get less blurring due to movement in the shot.

If you plan on publishing your pictures, you should get a model release if the subject is recognizable (usually, if his face is discernible) in the photo. With

model release in hand, identify yourself as a serious amateur photographer and offer to send a copy of the picture via email (and follow through). Many people will give you permission to use the shot if they like the way they appear on your camera's LCD. If you do get a release, you can then enter the image in photo contests or publish it.

> For sample model releases, search Google for "photographic model release".

Street scenes with buildings and other structures also make interesting images, especially if they're shot at twilight when the sky still has color and the street lights have just illuminated. Finding a flat surface on which to rest your camera and using the self-timer to trip the shutter is a great way to capture sharp shots, even in low light. A pocket tripod is perfect for these types of pictures.

If there are cars passing through the composition, you'll get the added benefit of trailing headlights and taillights. People moving about might blur, but this isn't necessarily a bad thing. They can add to the feeling of activity and give your picture energy, as shown in Figure 3-3.

Figure 3-3. Street shot in New York's Times Square

Keep in mind that buildings constructed in the U.S. after December 1, 1990, are protected under copyright law, and you might need permission to publish the picture. Who would have ever thought that you might need a model release for a building? But many of the really interesting structures were erected long before that law went into effect. You still have lots to shoot without worrying about permission.

So, next time you're traveling, for business or pleasure, remember to take your camera out for a walk. Play with a variety of angles, try photographing moving cars and people at slow shutter speeds, and see if you can capture that impressive building at twilight just as its lights have gone on. You'll add a new dimension to your slideshows that's bound to impress your viewers.

HACK #31 Capture the Nighttime Mood and Leave the Red Eye at Home

Shooting with flash indoors against a dark, boring background often produces overexposed subjects with red eye. But it doesn't have to be that way.

Built-in camera flashes are very convenient. But they can produce deadly results when used to take pictures of people in low-light situations, such as evening parties. Aside from the plague of red eye that turns your loved ones into otherworldly demons, there's also the *nuclear look*—where the subject appears to be standing next to ground zero, glowing beyond recognition.

It doesn't have to be that way. The easiest way to increase your success rate is to get an external flash; it's just easier to control the lighting that way. But for many people, that's not practical. So, in this hack we'll look at the options for the portable digicam, then talk about more advanced techniques with external flash. Let's start with taming the pocketable point and shoot.

Pocketable Party Shots

The people who design compact digicams realize that these cameras don't always produce great flash results at night. So, many of today's models have features designed to help you get better shots in these challenging situations. Some of these features work better than others. Here's a quick overview of what to look for and what to avoid:

Red Eye Reduction mode
> Avoid using this setting. In theory, using Red Eye Reduction mode makes sense: shine a bright light in the subject's eyes before exposure to constrict the iris, thereby reducing the chance of reflected red eye. But it doesn't work out that way. Flashes are annoying anyway, and torturing

your subject with additional flash before taking the shot tends to kill spontaneity. Plus, even after you do that, you'll often still get red eye. It's just not worth it.

Nighttime Flash mode

Use this setting for artistic shots. At times, using this mode might feel like trying to tame a wild cat: you think you're making progress, then it gets away from you. The thinking here is that the camera slows down the shutter speed, allowing you to capture background scenery beyond the flash range, yet the flash still goes off, illuminating subjects within 10 feet. And it usually works quite well. But things get crazy if you don't hold the camera *really steady* or if there's a lot of movement in the scene. So, you'll get some absolutely great shots with artistic flair, and you'll get some failures. But it's definitely worth experimenting with. This control is also referred to as Slow Synchro Flash mode (see Figure 3-4).

Figure 3-4. Slow Synchro Flash mode

Flash exposure compensation

Use this setting when the flash is too "hot." You can usually find this setting in the menu of options, and it allows you to adjust the intensity of the flash. So, if your subjects are consistently overexposed (too bright), then use flash compensation to reduce the flash's output. I recommend you start with a setting of −1 and go from there.

Increase ISO speed

You can use this setting, but remember to return to default settings when you're done. By increasing your ISO speed from 100 to 200, 400, or more, you're essentially increasing the sensitivity of your image sensor. The results usually include more background information (so you don't end up with a pitch-black backdrop) and an extended flash range (from 8 feet to 15 feet or more). Keep in mind that you will get a little more image noise in the higher ISO settings. This isn't much of an issue for 4" × 6" prints, but it might be noticeable in enlargements, especially in the shadow areas. Also, remember to reset your ISO back to 100 at the end of the party.

Shutter Priority mode

If you're lucky enough to have this setting, try it. This is one of my favorite tricks. Essentially, it allows you to set any shutter speed you want, and the camera then adjusts the aperture and flash output to match. The default shutter speed in flash mode for most cameras is 1/60 of a second. If you switch to Shutter Priority mode, you can slow down the shutter speed to 1/30 or 1/15 of a second, and you'll notice a big difference in your shots. Those speeds are long enough to capture much more background information—such as twinkling lights, candles, and such—but not so slow that you get excessive blurring and camera shake. If you combine this technique with increasing your ISO to 200, you'll get some great results. This is a winner for party shooting.

To sum up these options, I'd say avoid Red Eye Reduction mode altogether. Try Nighttime Flash mode when you want to get artistic shots that show activity through blurred movement. Use flash exposure compensation in combination with any of the other techniques to adjust the amount of light your flash is producing. And, if your camera has Shutter Priority mode, start there with an ISO setting of 200.

Advanced Techniques

For cameras with hot shoes that accept dedicated external flashes, there are more options available. The two most important ones are *bounce flash* and *flash on a bracket*:

Bounce flash [Hack #42]

If you're good at playing billiards, you'll understand how to use bounce flash. You'll need an external flash with a head that rotates up and down. Instead of pointing the flash directly at the subject, you point it upward and bounce light off the ceiling so it rains downward, more like natural sunlight. The light is diffused (softer) and renders much more pleasing skin tones, without the ugly hot spots produced by direct flash.

Flash on a bracket [Hack #7]

This trick has been used by wedding photographers for years. You'll need an external flash, a dedicated flash extension cord, and a bracket that holds both camera and flash. The thinking here is that you raise the flash above the camera by six to eight inches. By doing so, you completely eliminate red eye and you move the shadows produced by flash-illuminated subjects downward and out of the frame. The setup is more bulky than carrying around a pocket digicam, but the results are consistent and professional looking.

As you may have guessed, there are a few tricks involved with using either of these advanced techniques, especially bounce flash. The first matter of concern is the surface off of which you're bouncing light, usually a ceiling.

This technique doesn't work well if the ceilings are too high. Ceilings that are 8 to 12 feet high are perfect. The higher the ceiling, the more powerful flash you need, because of the increased distance the light has to travel. Also, the color of the surface is important. As you may have guessed, white is best, because it's highly reflective and doesn't add a color cast to the light. Off-whites are okay, but they're not as reflective. Colored ceilings usually won't work; they absorb too much light and add a funky color cast to the scene.

Figure 3-5 is a good example of using bounce flash with a white ceiling that isn't too high. This technique produces natural-looking skin tones and avoids red eye. Notice a little bit of blurring in the left subject's hand as he motions. That's a result of quick movement combined with a slow shutter speed (1/15 of a second), which was used to preserve the ambient lighting.

An old newspaper photographer's trick is to rubber-band a business card to the flash head, making a little reflector. By doing so, you not only bounce light off the ceiling, but you also get a little *kick light* aimed directly at the subject's eyes. This adds twinkle and helps prevent the eye sockets from getting too dark.

Since you lose light when you use the bounce technique, use your most powerful flash and increase the ISO setting to 200 or 400. Check your pictures on the camera's LCD monitor to make sure they're not underexposed (too dark). I like to shoot bounce flash in Shutter Priority mode at 1/15 or 1/30 of a second. The backgrounds usually look much better at those settings.

For serious party shooting, such as wedding receptions, get a bracket that raises your flash above the camera lens. You'll need a dedicated flash cord to use this technique, and be warned: camera manufacturers usually charge US$50 or more for these accessories.

Figure 3-5. Bounce flash with a low ceiling

Once you have your flash mounted on a bracket, you can use any of the techniques outlined in this section, plus direct flash, and never have to worry about red eye or unsightly shadows again.

HACK #32 Take Flash Shots of People Who Blink

Every family has one: the person whose eyes are closed every time you use the flash to take a picture. Here's how to get those eyes open.

Some of the most beautiful people take the worst photographs, especially if the flash is turned on. It's almost like they have a sixth sense as to when the flash is going to fire and, in defense of their sensitive eyes, they close their lids.

For years, I struggled to find an answer to this problem. Then, one day, by accident, the solution appeared. And, of all things, the secret is that otherwise silly function: Red Eye Reduction mode.

That's right, the very flash mode that I've derided in pervious parts of this book is the shining savior for blinkers. Here's how it works.

The idea behind Red Eye Reduction mode is to shine a light, or a series of light bursts, into the subject's eyes, causing the iris to constrict and thereby reducing the chances of red eye. It really doesn't work that well. But for

people who are sensitive to the flash and close their eyes when it fires, Red Eye Reduction mode is a godsend.

This mode causes them to blink during the preshot flashes. Then, when the actual picture is taken, they've opened their eyes. True, this is an extreme measure, because you still lose spontaneity as Red Eye Reduction mode does its thing, but as a last-ditch effort for those people whom you just can't capture with their eyes open, this trick can save your night.

Auto Headlamps and Other Streaming Lights

HACK #33

You can energize your night shots by including streaming lights, such as cars passing through your composition. Just make sure you're not standing in the flow of traffic at the time.

The flow of traffic provides a great opportunity to add motion to your compositions. Automobiles are light-painting machines, and it's easy to put them to work for you.

The key to success is to find a location with ambient light—such as a well-lit street, a bridge, or a large building—to serve as your main composition. Yes, you can go stand out on a dark highway and photograph cars as they whiz by, but images of streaming lights against a pitch-black backdrop aren't really worth the danger of being there in the first place.

Think of streaming lights as an element that you add to an already interesting composition, not the sole subject of the picture itself. If you were shooting a quiet little neighborhood, you probably wouldn't add this element to the shot; you're trying to convey solitude, comfort, and a feeling of being off the beaten track. But if you wanted to show the hustle and bustle of rush-hour traffic on the Golden Gate Bridge or in Manhattan, including lots of streaming lights adds a sense of energy and activity. For example, take a look at Figure 3-6, featuring the Empire State Building rising above the activity on the street. By including streaming car lights as they drive by, you get a feel for the energy of New York City.

Your Equipment

The first thing you need to do is find your tripod. This type of photography requires exposures that are too long for even the steadiest of hands. If you don't want to lug around your big three-legged beast, buy a handy pocket tripod that you can set on top of newspaper boxes and ledges.

If your camera accepts a remote release, use it. Not only do you need it to trip the shutter without jarring the camera, but you also want to start the

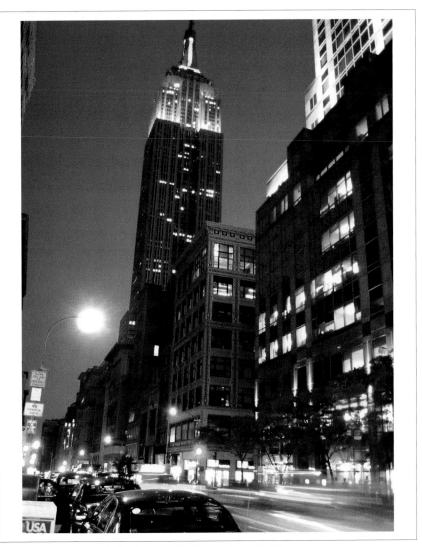

Figure 3-6. Streaming lights beneath the Empire State Building

exposure just as cars are driving by. You can also use the self-timer, but you won't have nearly as much control over when the exposure begins.

For example, say you're standing out there in the cold and you see a group of cars approaching. You activate the self-timer and...wait. 10, 9, 8 (hurry, hurry), 7, 6, 5 (come on, shoot already!), 4, 3 (the cars go whizzing by), 2, 1, click! (Nothing but darkness and a missed opportunity.) However, cameras that provide the option of a two-second delay of the self-timer do help minimize this frustration and dramatically reduce the profusion of swearing.

Another thing that's really helpful for these types of shoots is a little pocket flashlight. One of my favorite (and most dangerous for my credit card) web sites is GlowBug.com (*http://www.glowbug.com*). They have just about every type of flashlight you could dream of, and many that you never imagined.

When shopping for a flashlight, keep in mind that red bulbs will help you retain your night vision. Personally, I like the blue LED lights when night vision isn't an issue.

No Need to Increase the ISO

Now that you have your equipment in order, let's check your camera settings. You might be tempted to fiddle with your ISO settings, since this is a night shoot. But don't! In fact, increasing your ISO setting beyond the default 100 is the last thing you want to do. You don't need more *speed*, because your camera is securely mounted on a tripod. Actually, you want nice, long shutter speeds, because that allows more cars to pass through your composition and enables you to capture more streaming lights.

Also, when you increase ISO speed, you increase the likelihood of *image noise*, which is something you don't want for these shots. Speaking of image noise, if you have a noise-reduction setting on your camera, use it for these shots. Long exposures often produce some unsightly artifacts, even if you keep the ISO setting to 100. Cameras with noise-reduction systems help fight this problem.

So, use a tripod, set the ISO to 100, and turn on noise reduction if you have it.

Time to Shoot

You've found a great location and are ready to shoot. What camera settings do you use?

If you're shooting a scene with lots of ambient light, you can use Program mode as your starting point. Today's cameras are remarkably good at handling these types of lighting conditions. Many of my cameras have what's known as Long Shutter mode, which keeps the shutter open for a longer period of time in dark conditions. You might want to play with this setting and see what results you get.

If your exposures are too bright because the camera is overexposing the scene, use your Exposure Compensation option and set the scale to –1 or –2. That should help restore darkness to your composition.

You can also use Shutter Priority mode and set the speed to one second or longer. Once you have the right shutter speed to produce the amount of

light streaming you want, you can use the Exposure Compensation option to darken or lighten the scene.

Some cameras have a Nighttime Shooting mode [Hack #29], which is fun to play with. Many point-and-shoot digicams don't give you other modes, such as Shutter Priority, so you'll have to make the Nighttime mode work in these types of situations. Hopefully, you have some sort of exposure compensation to darken or lighten the scene.

As you try to figure out how to use the passing cars in your composition, keep in mind that red taillights produce much different results than oncoming headlights. So, set up the picture to suit your tastes. This might be the one good thing ever to come out of being stuck in heavy traffic.

HACK #34 Starlight Effects for Candles and Lights

Add extra sparkle to your candle and chandelier images by using an inexpensive starlight filter. You can even make your own, if you don't mind scratching a little glass.

Candlelit rooms convey a romantic or sentimental mood for your images. All you have to do is steady the camera, trip the shutter, and play from there.

The thing with candles, however, is that the light they cast on your subject is often more interesting than the candles themselves. After all, how compelling is a little flame of light? You can add a little *oomph* to these images by using a star-effect filter, which takes a normal candle flame and turns it into a blazing star, as illustrated in Figure 3-7.

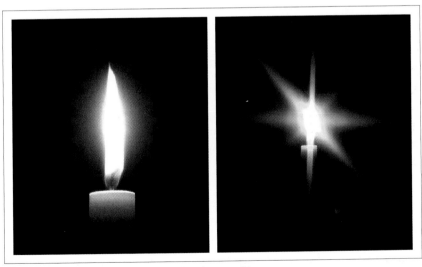

Figure 3-7. Candle flame without and with a star filter

This little bit of photographic trickery is accomplished by tiny etches in the glass that distort the light. If your camera accepts filters, you can pony up US$25 and start to play right away. One brand of creative filters you might want to take a look at is the Cokin System (*http://cokinusa.com*), which has star effects, gradual density, and special-effect filters. Cokin has adapters for every type of camera and lens, and it even has a special mount for cameras that don't even have filter rings, such as your digital point and shoot. I've played with the Cokin Star Effect #056, A Version, and have had good success, even on a Canon Digital Elph S400, which doesn't have a filter ring. Figure 3-8 shows how this rig looks.

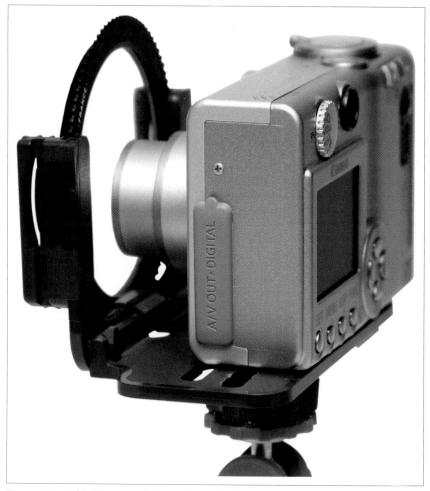

Figure 3-8. Cokin filter attached to a Canon S400

You can also make your own star effects by taking an old UV or skylight filter and etching it with a glass cutter. I recommend you use a crosshatch pattern for your etching. This of course provides you with the opportunity to create unexpected results.

Shooting Technique

I tend to like the effect of these filters when the light source is smaller, such as the Christmas lights in Figure 3-9. I've noticed quite an improvement after I trim the candle wick, thereby reducing the size of the flame. Points of light produce sharp rays of light, emanating from the source. Larger light sources, such as a light bulb or untrimmed candle wick, produce softer, less detailed effects. Chandeliers can be quite impressive too.

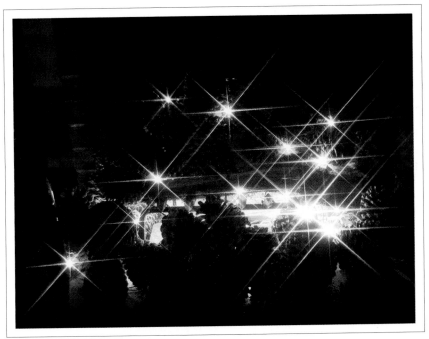

Figure 3-9. Small Christmas lights with star filter

I've had the best luck mounting the camera on a tripod and using the self-timer to trip the shutter. This helps me avoid the blurring effects of camera shake. Usually, I find that if I use −1 or −2 on the Exposure Compensation dial for close-up shots, I get better rays of light. Experiment until you get the effect you want.

Rows of candles shot with a star filter can be impressive. The room is transformed into a magical place, part of some other reality—not bad for an old UV filter with a few etched scratches in it!

HACK #35 Light Painting and Colored Gels

With an inexpensive swatch book of theater lighting gels, some nightlight bulbs, and a couple of LED flashlights, you can create ethereal color effects. And the best part is that you don't need Photoshop or even a computer.

Yes, you can manipulate photos in just about every way imaginable in Photoshop. But what if you don't like Photoshop, don't feel that comfortable with your image-editing skills, or just want to try something new? Alternatively, you can manipulate the picture as you actually capture it with the camera. Working with light painting and colored gels, such as the ones shown in Figure 3-10, is a great way to experiment with this type of creative shooting.

Figure 3-10. Crystal with colored gel

I use quartz crystals for my example because they're fun to manipulate with light, but just about any translucent or reflective subject has potential. My tools include theater lighting gels, nightlights, a photographer's light box, colored bulbs, and LED flashlights. One of my favorite combinations for experimentation is a regular nightlight bulb shining through Roscolux theater gels. For US$3.50 at Rose's Theatrical Supply (*http://www. theatricalshop.com/rosesweb/gels.htm*), you can get a Roscolux Swatch Book that contains a sample of every gel in their collection.

For the crystal shots, I made a custom light stand out of a six-inch length of 2"×4" wood. I simply drilled two holes—one downward from the top and one inward from the side—to form an L-shaped opening in the wood, as shown in Figure 3-11. The crystal sits on the top hole, and the nightlight bulb goes in the side hole. Now, I can put any color gel I want over the top hole, and that will be the color of light projected up through the crystal.

Figure 3-11. Homemade light stand and filters

When you use this setup in a darkened room, the colored light shining up through the crystal is subtle and quite striking. If you want, while the shutter is open, you can add more effects, such as light painting. This is why nightlight bulbs, which are typically only four watts or so, are good for this type of project. The dim light creates long exposures that give you the opportunity to paint with other lights, such as flashlights with colored bulbs, while the shutter is open.

Many of the new LED pocket lights that are available for US$10 or less have options for red, green, blue, and white bulbs. You can shop around at flashlight specialty shops, such as GlowBug.com (*http://www.glowbug.com*), to discover a whole new universe of creative lighting options. And when you're not painting with them, they make great additions to your keychain.

The Setup

Find a work area where you can control the ambient lighting. Set up your prop lighting (such as the light stand I discussed earlier), colored gels, and subject. Mount your camera on a sturdy tripod. You can use Auto Exposure mode, but check you camera manual for how long the shutter will stay open with that setting. Some cameras have a Long Exposure mode; if yours does, you should use it.

Most advanced cameras have Shutter Priority mode, which makes this work easier. You can set the shutter speed to three or four seconds, and the camera will handle the aperture settings for you. As you work, you'll have to lengthen the shutter exposure (such as 6, 8, or 10 seconds) to lighten the picture, or shorten the exposure (2 seconds or less) to darken it. Play with your settings until you get the effect you want.

I like to use a remote release to trip the shutter, but if you don't have a remote, you can also use the self-timer. The main thing is that you don't want to jar the camera when you initiate the exposure. Even the slightest vibration during exposure will degrade your image. Speaking of picture quality, set the ISO on its lowest rating: 50 or 100. This ISO will produce nice, long exposures under these dim lighting conditions, giving you more time to play while the shutter is open.

Now, dim the room lights and let your imagination run wild. Take the colored bulbs or flashlights and move them around in the scene while the shutter is open. You'll find that different speeds and angles create different types of brush strokes. Figure 3-12 is a good example of a broad stroke.

Figure 3-12. Light painting behind crystal spheres

Review your work on the camera's LCD monitor, and make adjustments as you go along. At some point, you'll find the perfect combination of exposure and color for the subject you're shooting. There's no need to use Photoshop now. Just print it and enjoy!

HACK #36 Secrets of Fireworks Photography

Don't let any smoke get in your eyes for this assignment. Stand upwind, bring your tripod, and capture some truly spectacular images.

Big fireworks shows are thrilling to watch, and they make thrilling photo subjects. Because it's *night* photography, you'd think that all of the rules of shooting in low light would apply for this assignment. Ha! This hack wouldn't be necessary if that were so.

In my opinion, fireworks photography is counterintuitive. In other words, my guesses for settings are wrong over half the time. But now that I've learned my lessons (through more trial and error than I'd care to admit), I can show you the secrets that can dramatically increase your odds of success.

What to Bring with You

Your chances of getting a great shot improve greatly if you have the right equipment. First, you need a camera that allows you to control the shutter speeds and aperture. Technically, you could use a little "auto-everything" cheapie, but it is such a pain in the fuse that it's hardly worth it. If you don't have a camera with decent manual controls, you might want to make friends with someone who does.

Next, you need to bring your tripod, a remote shutter release (if you have one), your red-bulb flashlight, a black piece of cardboard or baseball cap, and whatever outdoor gear you'll need to be comfortable.

Location, Location, Location

I know your first inclination will be to get as close as possible to the action. Resist that urge. Fireworks are all about perspective. Find a location that enables you to photograph the explosions without having to point your camera directly upward. Often, the best place to shoot is a ways back, and up a bit too if you can find such a position. Sometimes, a hill or atop a parking garage is the ideal place.

As you scout for the perfect spot, pay attention to which way the wind is blowing. You don't want to be engulfed in smoke when the heavy artillery gets underway (see Figure 3-13).

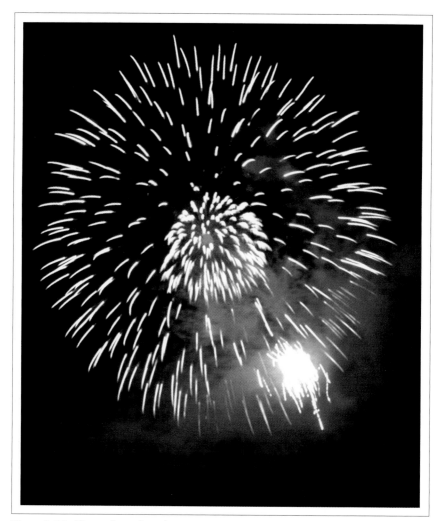

Figure 3-13. Fireworks and smoke

Here's another good hint: if there's any way you can arrange to have water in the foreground, such as a lake or reflecting pool, you'll capture some wild effects, as illustrated in Figure 3-14.

Setting Up Your Camera

Put your camera on the tripod and compose your shot to include the area in which you think the fireworks are going to appear. Leave the ISO setting at 100; this is one of those counterintuitive things. While this is technically

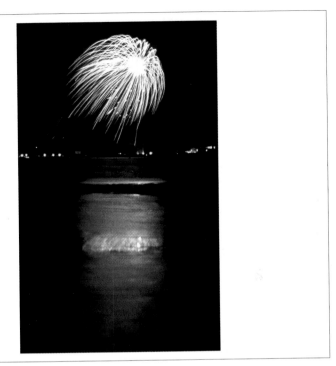

Figure 3-14. Fireworks over water

night shooting, the fireworks produce plenty of light, so there's no need to increase image noise in the dark areas of the sky by raising the ISO setting.

Now, set your aperture to f-8—even more counterintuitiveness, I'm afraid. If you were to open it up all the way to something like f-2.8, something you're probably inclined to do, your fireworks would actually be overexposed, thereby producing that sickening feeling in your stomach and waves of bitter disappointment. Avoid all of that by starting with f-8.

However, you do need to set a nice, long shutter speed. Start with four seconds or so. You might have to play with this setting a bit as the shoot progresses, but this should get you going.

Finally, I like the white balance set on Daylight, because it produces a nice, warm glow. Other photographers I know swear by using the Tungsten setting to cool things off a bit. It's your call, because it's really a matter of taste.

Taking the Shots

Once the fireworks begin, take some initial shots. You want to anticipate the action. When you think a series is about to begin, put the black cardboard

or baseball cap over your lens and trip the shutter. As the explosions begin, quickly pull back the cardboard and let the camera capture the action. I like this technique because you can control the cardboard faster than you can the camera. Digicams are notorious for shutter lag, and what you need here is pure responsiveness. Whoever thought that cardboard would outperform a sophisticated digital device?

But wait, there's more. What if you want to create a multiple-exposure shot that includes many bursts of fireworks? Just set the shutter to a really long time, like 30 seconds, and then control the exposures with the cardboard.

As the fireworks explode, move the cardboard aside. Put it back over the lens until the next series appears, and then remove it again. This way, you won't overexpose the image with the ambient light in the scene; you'll record only the bursts of fireworks. What you're really doing is creating a multiple-exposure shot. Try it; it's really fun.

Final Thoughts

The techniques I've outlined here are starting points. Review your pictures in the LCD monitor and adjust accordingly. If your fireworks aren't bright enough, open up the aperture one stop (e.g., go from f-8 to f-5.6). If they are too bright, close down the aperture one stop (e.g., f-8 to f-11). Play with multiple exposures by using the black-cardboard technique. Or, if you want to keep things simple, just set the shutter at four seconds or so and fire away without the cardboard.

There's lots of room for creativity here. Have a blast!

HACK #37 Night Landscapes and the Moon

The moon is a beautiful but often elusive element for nighttime landscapes. If your previous attempts have resulted in sheer lunacy, take a look at these helpful tips.

Nothing perks up an evening landscape like a rising moon hanging above the horizon. You walk out of the office to go home. It's dusk and there's still color in the sky. Then, like magic, the moon appears from behind the clouds. You feel like you can reach out and touch it, just like that. These are the small moments that often stay with us.

Trying to photograph that is another matter. The moon hanging just above the horizon looked so big. But it seems to shrink in size the minute you point a camera lens at it. What was once a compelling evening moonscape photographs as a bunch of clouds with an overexposed dot of light among them.

Don't despair. By making a few adjustments to how you take the shots and applying a little photographic wizardry, you can bring the moon back to its rightful splendor. But to do so you have to overcome a few common obstacles.

Obstacle 1: The Moon Is Brighter Than Everything Else

If you wait until the sky is completely dark and the moon is high above the horizon, chances are the moon is brighter than everything else in the scene. The trick here is to catch the moon when it's low and to include other bright things in the composition, as shown in Figure 3-15. When the moon is lower, it shines through more atmosphere than when it is high in the sky. The atmosphere serves as a neutral density filter of sorts and reduces the moon's luminosity.

However, if everything else in the frame is dark, then your camera will expose for the dominating dark elements and thereby overexpose the moon, rendering it as a fuzzy dot of light. Look for adjacent elements to lighten up the scene, such as brightly lit buildings (their lights often go on at dusk, before darkness sets in), illuminated clouds from the setting sun, or any other radiant element.

You could battle the exposure problem by using your camera's built-in spot meter to determine the exposure (using a healthy dose of exposure compensation, such as –2), but then you just have a properly exposed dot in the sky. Try to find a visually appealing supporting cast and catch the moon when it's close to the horizon.

Obstacle 2: The Shrinking Moon

How could something appear so big to your eyes and so small in the camera lens? When I took Figure 3-16, the moon looked a lot bigger than it turned out in the photo. Most camera lenses at *landscape* focal lengths (normal to wide angle) exaggerate distances and work against you for this type of shot. So, you have to compensate optically to make things look more natural.

If you have a digital SLR, pull out a 200mm or 300mm telephoto lens and compose the scene. You'll see that the moon looks a little more in proportion with the landscape. Telephoto lenses *compress* visual elements and are helpful for this type of shooting.

But don't despair (too much) if you only have a point-and-shoot camera on hand. Just extend the lens to the telephoto position and use your camera's highest resolution (e.g., if it's a 4 megapixel camera, shoot at 4 megapixels). You can crop the photo later on the computer.

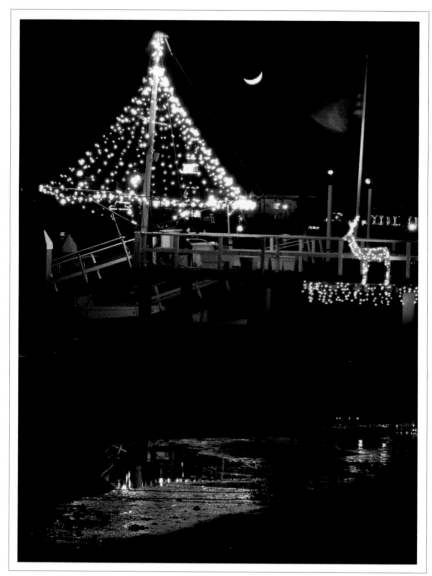

Figure 3-15. Moon with Christmas lights

If you're tempted to use the Digital Zoom function on your camera, resist! It will severely compromise image quality. You're much better off shooting at a high resolution and cropping the picture on the computer.

Figure 3-16. Minuscule moon

The Cheat

If the previous techniques still don't provide the results you want, consider using *the cheat*. You'll need a digital SLR with at least a 200mm telephoto lens to cheat properly.

First, compose your landscape with the appropriate normal lens and take the shot. Don't worry about the size or the brightness of the moon at this point; just focus on the landscape itself. Now, attach your telephoto lens and expose only for the moon. For a full moon, start with a setting of 1/125 of a second at f-16 and ISO 100, and see how it looks. For a quarter moon, try f-5.6 as your starting point.

When you return home to your digital darkroom, combine the images into one shot, as shown in Figure 3-17. I usually use the Magic Wand tool in Photoshop to select the *big moon* only (leaving the other parts of the image behind), copy it to the clipboard, and then paste it into the landscape shot over the tiny dot of the moon. Carefully clean up the edges of moon so your viewers won't detect any obvious clues from your digital wizardry.

Some photographers rail against this technique, while others love it. It's your picture and your call. My recommendation is that if you use it, don't get too carried away with the size of the moon in the final composition. If you make it too big, your viewers will probably spend more time trying to

Figure 3-17. Moon added to evening landscape using Photoshop

figure out what's wrong with the shot than appreciating the overall composition.

A Few Camera Tips

If your tripod is available, use it. Otherwise, find a sturdy surface to rest the camera on while making the exposures. Remote releases work great for these shots. In a pinch, self-timers are a good backup for tripping the shutter.

Don't bump up your ISO setting. Keep it at 100 so that you don't compromise image quality. You don't need your camera's autofocus system for these shots; in fact, the autofocus system can be fooled. Instead, use the infinity lock to ensure good sharp shots.

Also watch out for condensation, especially when you bring the camera back indoors. Keep a Ziploc plastic bag with you. When you're done shooting, put the camera in the bag before bringing it indoors. As the camera warms up to room temperature, the condensation will collect on the bag, not in the camera.

To find out when the moon rises and sets in your area, go to the U.S. Naval Observatory web site (*http://aa.usno.navy.mil/data/docs/RS_OneDay.html*) and enter your location. You'll get the precise rise and set times to help you plan your outing.

Manual Exposure mode works best for shots of the moon by itself. At ISO 100, with the aperture set at f-16, use a starting exposure of 1/125 for full moon, 1/30 for first quarter, and 1/15 for thin crescent, and adjust from there.

Final Thoughts

A beautiful twilight landscape with a full moon hanging above the horizon is an attainable shot for anyone. You just have to do a little planning, have the right equipment with you, and employ these techniques. The results can be fantastic!

HACK #38 Colorful Star Trails

For most people, stars are decorative points of light that decorate the night sky. But for you, they can also be fascinating streaks of light that add dazzle to your compositions.

Stars might appear as twinkling points of light to the naked eye, but when you point a camera at them and leave the shutter open for a while, they transform into colorful streaks across the sky. Photographing star trails is not only an artistic endeavor; it can also provide insight into the nature of stars themselves.

Stars are basically composed of hydrogen and helium, and they burn intensely. The hotter the star is, the more bluish its color, and cooler stars tend to be reddish orange. Based on this information, scientists have formed theories about the age of the stars we observe. A bright blue star, for example, is considered at the peak of its life. A duller red star, on the other hand, is much older.

Thinking about the age of a particular star on a chilly night probably demands more commitment than the average person cares to allocate to such matters. But if you point your digital camera upward and let it record trails of those stars, their colors are much easier to distinguish in the comfort of your home, gazing at your computer screen, than they are when you gaze upward into the frigid night.

Take a look at the picture of Orion's belt and sword in Figure 3-18 (the constellation Orion the Hunter dominates the winter sky in the Northern Hemisphere). This image is a four-second exposure (f-1.8 at ISO 800, taken with a Canon 10D) and is an enlargement of what you'd observe with your eyes in the sky. You can see some differences in star colors, but they are subtle.

In the eight-minute exposure (f-1.8 at ISO 100, taken with the same Canon 10D) shown in Figure 3-19, the colors of the stars are easier to determine.

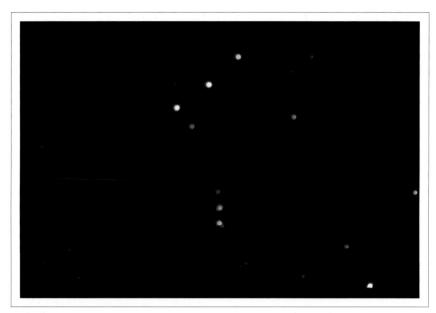

Figure 3-18. Stars without trailing effect

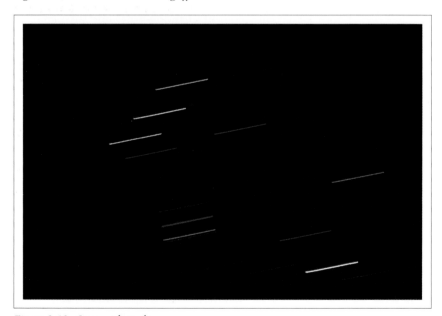

Figure 3-19. Stars with trails

The purplish "star" in the middle of Orion's sword is actually a *nebula*. Clearly, the three stars in his belt are burning hotter than the three in his sword. You can draw your own conclusions about the meaning of all of this,

such as the age and distance from Earth of each of these entities. But the point is that it's much easier to analyze stars if you have more visual information. And photographing star trails is a great method for amateur stargazers.

> This technique is only for thinking about the temperature of stars *relative* to one another. All sorts of things happen when dealing with the physics of light traveling through atmosphere that people with years of training think about on a daily basis. That said, we can use these images to play amateur astronomer for a minute.

The three stars that form a diagonal line (Orion's belt) at the top of Figure 3-19 are (from top to bottom) Mintaka, Alnilam, and Alnitak. They're about 1,800 light-years away and are much bigger than our own Sun. We can tell from their intensity that they burn hotly, changing hydrogen into helium at a furious pace.

But the brightest star in the constellation is Rigel, in the lower right corner of the frame. It's part of Orion's left foot (in case you couldn't tell that was a foot!). Rigel is 1,000 light-years away, but its luminosity is actually 50,000 times brighter than our Sun. If you study a little star history to learn more about this beacon of the night sky, you'll find out that Rigel is actually a *triple star* (three stars close together, giving the illusion of being just one).

Last, but not least, the Orion nebula emanates its fuzzy glow in the lower part of the sword. This area is know as a *stellar nursery*, because new stars are formed here within the masses of gas and dust that are the building blocks of these entities. Some of these young whipper-snappers are only a million years old. That might not sound so youthful to you, until you learn that our Sun is about 4.6 billion years old.

Now, when you look at these images of Orion, those colors begin to take on new meaning. And this is a satisfying exploration that you can enjoy until, well, the end of time.

There's More to Stars Than Science

Capturing stars in motion has its artistic side, too, especially when combined with other elements, such as a desert landscape or dimly illuminated camp tent. If you put the North Star in the center of your viewing frame, the star trails will form concentric circles around it, as shown in Figure 3-20, a picture of the Canada-France-Hawaii Telescope in Mauna Kea.

Pointing your camera at other parts of the sky produces different streaming effects. This is truly trial-and-error fun at its best. The thing to keep in mind

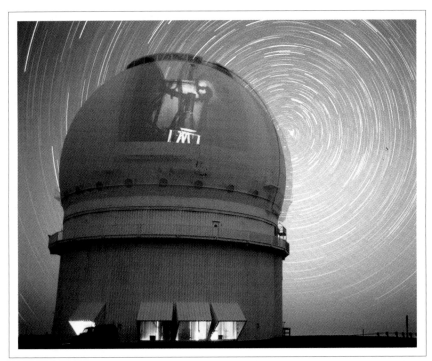

Figure 3-20. The Canada-France-Hawaii Telescope (photo by Jean-Charles Cuillandre)

is that you want to find an interesting landscape element that isn't too brightly lit and that complements the streaking stars above.

Get Your Equipment Together

Unlike some of the other hacks, where you could employ workarounds for your point-and-shoot digicam, this technique requires a camera that enables you to control the shutter. Manual mode (where you control shutter and aperture independently) is the absolute best for star trails. Your exposures will be anywhere from 30 seconds to hours in duration.

I also prefer a real cable release that allows me to lock the shutter open. I've been using the Canon Remote Switch RS-80N3 with the Canon 10D for my long exposures. The Remote Switch has a locking button, so I can trip the shutter and keep it open until I unlock the button on the switch.

Battery power becomes a real issue for this type of shooting. Prior to digital imaging, many photographers would use older mechanical bodies that didn't require any type of power at all. They would lock the shutter open with a cable release, time the shot with their watch, then close the shutter when time was up.

But digital cameras need juice for any type of shooting. And when you're making long exposures on a cold night, those batteries seem to drain pretty fast. To help deal with this situation, I recommend you have two or three extra batteries with you. Even better, consider an auto-adapter kit that allows your camera to tap power through the cigarette lighter. For the Canon 10D, I also use the Battery Grip BG-ED3 that holds two lithium-ion power cells.

Once you have your power under control, turn your attention to dew and condensation management. I suggest you keep a multicoated protection filter, such as a skylight or UV, and a lens hood on your camera at all times. The lens hood helps block out stray light and reduces the amount of moisture that accumulates on the glass part of the lens. The protection filter keeps dew and debris off the actual front lens element. And it's much easier to clean the filter than the lens itself.

Make sure you have a sturdy Ziploc bag in your camera case. When you're done shooting outside, put your camera in the bag and zip it up. Once you bring your rig indoors, the condensation will form on the bag, not in the camera. Leave it in the bag until the camera reaches room temperature. Be sure to remove your memory card before putting the camera in the plastic bag, so you don't have to wait until it warms up to room temperature before you can start viewing the images you captured.

To begin your shoot, attach your camera to a sturdy tripod, point it upward to an interesting group of stars, and set it to Manual Exposure mode. If you have a 50mm lens, start with that and open the aperture all the way to its widest setting—usually, f-1.7 or so. If you have only a zoom lens, set it to a mid focal length, such as 50mm, and open the aperture all the way.

Set the shutter speed to Bulb setting; this is often denoted by the letter B. That setting means that for as long as you hold down the shutter release, the shutter will stay open. You can already see the advantage of having a locking release: you don't have to stand next to your camera, holding the button down for 30 minutes.

Make your first exposure for five minutes and review the result in your LCD monitor. This will give you a point of reference for experimentation. You don't have to take notes about your exposure times, because your camera is recording that information and attaching it to the image.

A Few More Tips

When scouting for a location for your star shooting, try to find somewhere that has little or no light pollution—the darker, the better. A little light pollution makes a big impact on long exposures.

Be sure to bring at least one flashlight—preferably, one with a red lens that enables you to keep your night vision while working. A piece of red tissue paper and a rubber band over the flashlight lens will do in a pinch.

Another accessory that makes shooting more comfortable is a right-angle finder that slips over your eyepiece. This enables you to view the sky more comfortably by looking down into the finder, as you would with a quality telescope.

Gloves, hat, hot cocoa, and all the cold weather comforts will make this assignment more enjoyable. If you have a photo buddy, star shooting is a great opportunity to catch up with each other—you'll have quite a bit of time on your hands during those two-hour exposures.

Magic with Flash

Hacks 39-46

Daylight photography presents an ample enough challenge for most shooters, so it's no wonder that taming electronic flash sends many photographers to the edge of madness. At least with daylight you can see what you're shooting. The cards are on the table. But the burst of bluish light from camera strobes lasts only a tiny fraction of a second. There's no way to observe the light and predict how the image is going to look.

So you have to depend on technique, with a little luck thrown in for good measure. This chapter shows you some of the secrets that pros have been using for years to create flash pictures that are flattering and, yes, even beautiful.

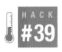

HACK #39 Outdoor Fill Flash

It might seem crazy at first, but one of the best times to turn on your flash is when you're taking outdoor portraits on a bright, sunny day.

Working with your camera's flash can be counterintuitive. Often, you'll capture more compelling indoor pictures when you turn off the flash, and get great shots when you activate it outdoors—quite the opposite of what you'd expect.

In fact, I'd go so far as to say that *the one killer tip* that will improve your pictures more than any other is to turn on your flash for outdoor portraits. As shown in Figure 4-1, the flash helps balance the lighting of the subjects with the ambient light outdoors.

While there's a lot of light available when you're shooting portraits outdoors, it isn't always coming from the angle you want. Here's a little lighting tip to keep in your back pocket: light coming from the side accentuates texture, and light coming from the front flattens it.

Figure 4-1. An outdoor portrait, brightened by fill flash

So, keeping this in mind, what type of light do you think your mother would like you to use when taking her portrait? Side lighting with lots of texture? Most likely not. How about some front lighting that softens the appearance of wrinkles and pores, please?

For outdoor portraits, many photographers take this pearl of wisdom and position the model so that the sun is shining directly in her face. Hmmm...Mom's not going to like that much, is she? So, how do you get around this apparent photographic paradox?

The answer is to find a comfortable spot for her to stand in the open shade—under a tree is lovely—with a complementary background that doesn't include any distracting elements. Now, turn on your flash. With most cameras, you do this by looking for the button with a little lightning bolt on it. As you press the button, you will cycle through all the available flash settings. Use the setting called Fill Flash or Manual On.

Make sure you're standing within eight feet of Mom. That distance is the range for those convenient, yet somewhat wimpy built-in camera flashes. If you stand too far away, the light will peter out before it ever reaches your beloved, and you won't reap the benefits of this technique.

Now, fire at will. Your camera will balance the background lighting with that of the flash, rendering a perfectly exposed portrait. And what direction is the main light coming from? You got it: the front. Dear Mom will immediately designate you as her favorite child (but please don't tell the others).

If you want to fiddle with this technique, here are a few more hot tips:

- Extend the range of your built-in camera flash another few feet by increasing your ISO setting from 100 to 200.

- Add an external flash unit, if your camera accepts one, for even more distance.

- Use the Flash Exposure Compensation control to increase or decrease the amount of light the flash emits at exposure. This control is often set to −1 to downplay the appearance of fill flash, resulting in a more natural portrait. If your camera has this option, you will find it in the menu of controls.

- Leave your fill flash on for outdoor events, such as birthday parties and family reunions. Stay close to your subjects when taking their picture. You'll be amazed at how bright and colorful your images will be.

- Bring an extra battery. Fill flash does drain your camera's battery faster, so have an extra on hand for the homestretch of the event.

Using your flash outdoors might be counterintuitive, but the results are smashing. You just have to give it a try.

HACK #40 Prevent Red Eye

The plague of point-and-shoot flash photography, red eye, can turn your children into demons and your pets into monsters. Here's how to exorcise this curse from your life.

Red eye is caused by one of those laws of physics that's difficult for point-and-shoot cameras to overcome. When the flash is located close to the camera lens and the subject's iris is dilated in low, ambient room light, the flash sends a beam of light into the eye that's reflected off the retina and beamed right back into the camera lens. Presto! You now have red eye.

Wedding photographers figured out a long time ago that if you move the flash away from the camera lens, preferably above it, you change the angle of reflection off the retina, so your camera lens doesn't notice it. But adding an external flash isn't always practical for many digicam-toting amateurs. So what are the alternatives?

I can tell you what the first alternative *isn't*: the Red Eye Reduction mode on your camera. Most of these controls are based on the theory that if they can

somehow constrict the irises of the subject's eyes, red eye will be eliminated. As you know from your own experience, this doesn't work very well. And you usually end up annoying your subjects by pelting them with strobes of light before the actual exposure.

But the concept of constricting the irises is viable. Instead of using Red Eye Reduction mode, however, try turning up the room lights, as shown in Figure 4-2. Also, if a lamp or other bright source is nearby, have the subject stare at that for a few seconds, then turn back to you for the picture. Both of these methods better achieve what Red Eye Reduction mode is trying to do, and with far less aggravation for everyone concerned.

Figure 4-2. Brightening room lights can help prevent red eye

Another trick is to have the subject look off to the side slightly and not gaze directly into the camera lens. This changes the angle of reflection and works most of the time.

If your camera accepts an external flash, then consider getting a dedicated flash cord (see Figure 4-3) so that you can raise the flash above the lens. This is far and away the most effective method for preventing red eye. You can simply hold the flash above the camera and shoot, but over the course of the evening, you will be much more comfortable by mounting the flash on a bracket.

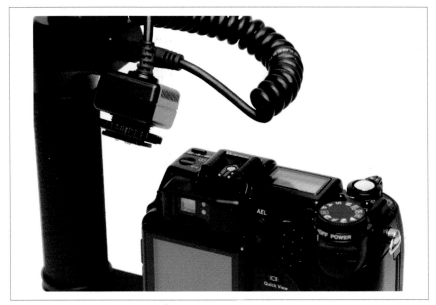

Figure 4-3. Hot shoe and dedicated flash cord

You'll also enjoy the added benefit of lowering those unsightly shadows cast by your subjects so they don't appear on nearby walls. Extension-cord flash photography is one of the easiest ways to shoot like a pro indoors.

If your camera has a flash *hot shoe*—a holder on the camera to mount the flash, as shown in Figure 4-3—then chances are good that the manufacturer makes a flash and extension cord for your model. If not, take a look at the next hack for tips on how to add this functionality to your digicam.

It's true, red eye is a monster. But you don't have to let it terrorize your photography if you take a few easy steps to tame it.

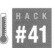

HACK #41 Add External Flash to Point and Shoots

Just because your digital point and shoot has a built-in flash, that doesn't mean you're stuck with using it exclusively.

"When two people in an organization always agree, one of them is unnecessary." You might expect to find that quote cross-stitched on a sign in the Complaint Department. But it hung prominently behind my father's desk as the editor and publisher of a weekly trade publication.

Dad's lesson is universally applicable, I've found over the years; a different perspective often provides an improvement—in life and in flash photography. I used this lesson to some effect on Mom, with more success on my

siblings, and with mixed results on various employers. One place it has never failed me, though, is flash photography.

The big problem with most flash photography is that it uses the flash on the camera. That flash takes the same angle on the subject as the camera's lens, so it throws harsh shadows, creates red eye, and generally makes *The Night of the Living Dead* look like the end result from *Extreme Makeover*. As if that isn't enough, it also eats camera battery power alive.

Flash really needs to take a different point of view than your lens. An external flash can make the single biggest improvement to the quality of your flash images. And you don't need a hot shoe or sync socket to use an external flash. Nor do you need a personal trainer to heft the gear around. All you need is a flash on your camera, although hot shoes and sync sockets are also nice to have.

In fact, there are many ways to put an external flash system together. Let's look at two variations: a simple wireless system you can use with any digicam and a professional bounce flash system.

A Simple Wireless Setup

If your digicam has only the flash it was born with, your external flash should be a *slave flash*: a flash that fires when it gets its cue (through infrared energy) from your digicam's flash.

The digicam flash becomes a *trigger* now. It goes off and tells the external flash that it is now time to fire. To ensure that this works properly, use Fill Flash or Manual Flash mode and mask your digicam flash with a piece of exposed slide film so it won't illuminate the scene. The slide film acts as an infrared filter, triggering the external slave flash.

The good news with this rig is that you now have an independent flash, triggered by the camera, that you can position anywhere you want. The bad news is that you've disabled your camera's dedicated-flash exposure system. The way dedicated flash works is that the camera initiates the sequence by firing the flash. As the light is reflected off the subject back to the camera, a sensor measures the reflected light. When the amount of light matches the camera's auto-exposure setting, the camera stops the flash.

I know this sounds truly amazing, but it works. And it all happens in a fraction of a second. The challenge is that when you add an external unit without maintaining this communication system between camera and flash, the camera can no longer control the duration of the external flash. It is either on or off. So, you'll need to experiment a bit with this setup to get good exposures. I recommend you actually take notes, marking down the distance of

the flash from your subject and all of your camera settings, so you can repeat your successes.

If your camera has a Manual Exposure mode, set the shutter speed to 1/30 of a second and set the f-stop to match the flash's power (according to its documentation). You can fiddle with the shutter speed to capture as much of the background light as you want. A faster shutter speed (say, 1/60 or 1/125 of a second) records less background in low-light conditions. Then, aim the slave at your subject and fire away.

You can use an old flash from your 35mm gear as a slave if you add an IR trigger, such as the US$20 Wein Peanut slave (*http://www.weinproducts.com/batteryfree.htm*). Or, you can buy a slave with a built-in IR trigger, such as the Zenon MagneFlash flat panel (*http://www.imaging-resource.com/ACCS/ZMF/ZMF.HTM*), shown in Figure 4-4, or SR Inc.'s Digi-Slave (*http://www.srelectronics.com*).

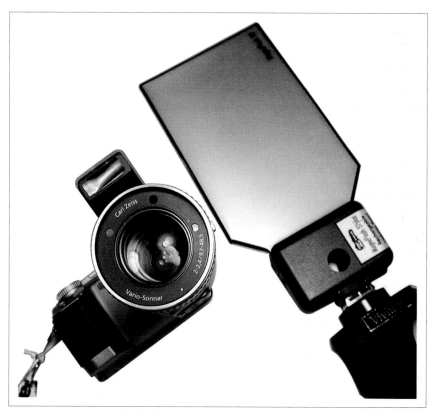

Figure 4-4. Zenon MagneFlash

If your digicam always fires a preflash (like most Olympus models do), make sure your slave features a delayed trigger. Otherwise, your slave will fire dur-

ing the preflash, before the shutter opens. Zenon makes delayed-shutter versions of the MagneFlash, and the Digi-Slave line can be configured to fire on the first or second flash from your digicam.

Final Thoughts

With any digicam, you can enjoy the advantage of an external flash. When you bring your own light to the party, you'll never see red eye, your shadows will be more natural, and your camera batteries will last longer. You might even enjoy making the shadows fall where they do no harm and perhaps flatter the subject with a softer bounce light that covers a wide area.

As the sign in my father's office suggested, a different angle on things improves the picture.

—Mike Pasini

Bounce Flash for Softer Light

HACK #42

One of the best techniques for using (and reasons for purchasing) an external flash is to bounce its light off the ceiling. This creates softer skin tones and a journalistic look.

Photographer Bill Harvey was awarded the lifetime achievement award in 1997 by the Press Photographers Association of Greater Los Angeles. He showed me the setup that I still use with unfailingly excellent results, as everyone always agrees.

Bill used a Vivitar 283, still available today, mounted on a pistol grip. With the 283, you just set the ISO, switch the removable sensor to one of several distance settings, and look up the color-coded distance setting on the illuminated dial to find the correct f-stop.

But Bill never shot the flash directly at his subject. Instead, he pointed it upward, toward a small plastic reflector like the one in Figure 4-5, made by Sto-Fen (*http://www.omni-bounce.com*). Sto-Fen makes several accessories for the 283, as well as Canon and Sunpak strobes.

Bill used Sto-Fen's Twin Panel Bounce. Its compact, clever design eliminates hot spots and covers 24mm lenses and larger. Digicam zooms generally aren't wider than 28mm (speaking in 35mm equivalents). I also like their Omni Bounce, which is a white plastic dome with a black panel on the back that sits right on top of the 283 lens. It gives an even softer shadow than the Twin Panel but doesn't have quite the range. Both bounces come with a black plastic mount that just snaps over the 283—very simple, elegant, portable, and reliable.

Figure 4-5. The Sto-Fen reflector for bounce-flash photography (photo by Mike Pasini)

If the head of your flash pivots upward, you can also bounce the light from your flash with a rubber band and the back of a business card. This disperses the illumination. Some flashes even include a bounce card built into the head.

Bounce flash gets you soft, natural shadows over a wide area and completely eliminates red eye, as shown in Figure 4-6.

The 283's removable light sensor is an important feature. You can mount the removable sensor on the camera's hot shoe but move the light around to other positions and still get good exposures. In Figure 4-7, I've rigged up a Vivitar 283 to a Nikon CoolPix 990. This isn't sophisticated dedicated flash circuitry precision, but it keeps the sensor with the camera; after all, that's where the exposure is made.

Bill would add an external battery pack to power his Vivitar, but I find that today's NiMH AA rechargeables handle the job with power to spare.

I like to move the flash an arm's length away, up high or even to the other side of the camera, depending on the subject. I know the sensor will adjust to whatever I want to do, rather than force me to do something the flash expects. I can comfortably wave the flash around, because it's mounted on a nice, molded Vivitar grip. The grip pops on and off a bracket that attaches to the camera via its tripod mount. It couldn't be simpler.

The whole rig is a bit ostentatious—it makes me look like I actually know what I'm doing—but it's actually easy and natural to use. And it's a lot of fun to be able to paint the picture with the light of the flash.

Figure 4-6. Using bounce flash to produce more natural results

One Important Catch for Digicam Users

The problem with the popular 283, apparently (it's hard to confirm this from any reliable source), is that models manufactured before 1984 use a trigger voltage of 200–300 volts. Models since then use a less titillating 10 volts, which is under the 12 volts most autofocus SLRs warn against. Digicams with hot shoes prefer things a little less exciting, generally under 6 volts. Sending more than that through your digicam's delicate circuits might eventually fry them.

To protect my digicams, I use the tiny, US$40 Wein Safe-Synch HS voltage regulator. I found mine at B&H Photo (*http://www.bhphotovideo.com*). The Wein slips into a hot shoe and is tightened safely into place with a thumb wheel. You can connect your flash to the Safe Synch's PC connector or the hot shoe to enjoy its six-volt-maximum trigger-voltage protection.

A More Modern Approach

I thought you'd enjoy Bill's story, because it shows that the bounce-flash technique has been making photographers look good for decades. Thanks to modern technology, however, this magic is easier than ever to use for your pictures.

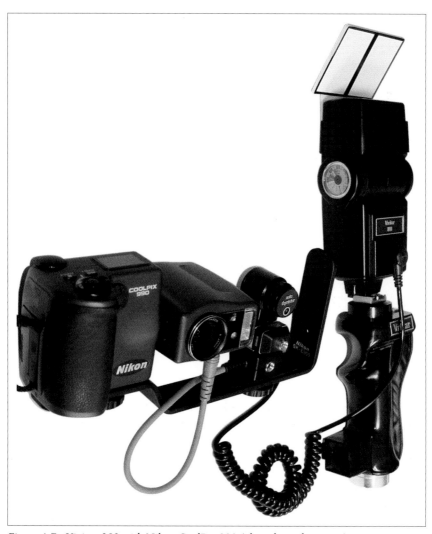

Figure 4-7. Vivitar 283 with Nikon CoolPix 990 (photo by Mike Pasini)

If your digicam accepts an external flash made by its manufacturer, you can apply the art of bounce with the brains of dedicated flash circuitry. In Figure 4-8, I've connected an Olympus C-5050 with an Olympus FL-40 flash via a dedicated remote cord. Why is this important? Because the intelligent exposure system takes all the guesswork out of getting a perfectly exposed shot. You simply put the dedicated flash in the camera's hot shoe, point the flash head up to the ceiling, compose your picture, and take the shot.

The camera opens the shutter and fires the flash. As the light bounces off the ceiling and rains down on the subject, the camera measures the light as it

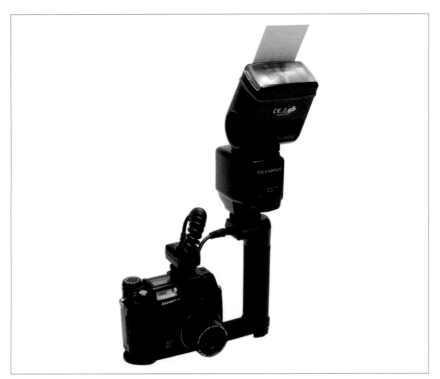

Figure 4-8. Olympus C-5050 with bounce flash

passes through the camera lens. When there's enough light for a proper exposure, the camera turns off the flash and closes the shutter. All of this magic happens in a fraction of a second, and it works beautifully.

I've successfully used this technique with a Canon G2 camera with matching Canon 420 EX Speedlite flash, and with an Olympus C5050. But Nikon, Minolta, and many other manufacturers make similar rigs, and they all work wonderfully.

No Hot Shoe, No Problem! (Well, Sort Of)

But what if your camera doesn't have a flash hot shoe? Does that mean you're doomed to harsh, unflattering indoor photography? Not at all.

First, read "Add External Flash to Point and Shoots" **[Hack #41]**. That will help you get an external flash talking to your camera. However, as mentioned in that hack, you don't have the advantage of the camera's dedicated flash circuitry controlling the light output to ensure a good exposure. You're in uncharted waters here.

As a starting point, set the external flash to its maximum output setting so you have as much light as possible to bounce off the ceiling. If your camera has a Manual Exposure mode, set the shutter on 1/30 of a second and set the aperture at f-4. Bump up your ISO setting from 100 to 200, just to make the image sensor a tad more sensitive.

Now, point your flash upward, compose the subject in the camera, and fire! Review the image in your camera's LCD monitor. If it's too bright, close down the aperture to f-5.6. If it's too dark, open up the aperture to f-2.8. If it's still too dark after you do that, you might have to increase the ISO setting to 400.

As you can see, this rig requires lots of fiddling around to get just the right combination of settings. It becomes a powerful argument for investing in a dedicated flash system for your next camera outfit purchase. But until that blessed day comes, you'll be surprised at the great images you can capture once you nail the settings.

Oh, and when you do, be sure to write them down.

A Few Bounce-Flash Tips

Unlike direct illumination, bounce flash is influenced by the surface you use to reflect the light. So there are a few things to keep in mind to improve your results:

Low ceilings are better than high ones. The farther the light has to travel (both up to the ceiling and back down again), the more challenging correct exposure becomes. High ceilings usually result in underexposure, because there just isn't enough light left after traveling all that distance. Look for low ceilings when using bounce flash.

White ceilings are better than colored. First, white ceilings reflect light better and usually result in proper exposures. Beyond that, however, remember that the light that falls on the subject will take on the tint of the ceiling. So, if the ceiling is beige instead of white, not only will it absorb more light, it will also color it and influence the tone of your picture.

Use a rubber band and business card for bright eyes. Some people who have deep-set eyes won't fare well with bounce flash. Because the light is raining down from the ceiling, their inset eyes go dark. You can solve this problem by making a *kick light* reflector with a business card attached to your flash by a rubber band. Some of the flash's light will bounce off the business card directly toward the subject, helping to keep the eyes from going too dark. The rest of the light bounces off the ceiling, giving you that pleasing bounce-flash look. Yes, you can have it both ways. (Refer back to Figure 4-8 for an example of how this setup looks.)

Angles are important. Using bounce flash is much like playing a game of pool: you need to figure the angles to make a good shot. Try to angle your flash head so the light bounces off the ceiling and lands right in front of the subject. Digicams make this process easier, because you can take a shot, review it, adjust, and then shoot again.

If you follow these tips, regardless of whether you have a sophisticated dedicated flash system or a simple external flash triggered by your camera's built-in flash, you'll be rewarded with outstanding images unlike anything you could capture with the direct illumination from your digicam's built-in flash.

—*Mike Pasini and Derrick Story*

Pro Portraits with Just Two Flashes
HACK #43 You don't need to spend thousands of dollars on expensive lighting to get professional-looking portraits.

Many amateur photographers are intimidated by studio portraiture, and for good reason. A trip to a working pro's studio reveals thousands of dollars of lighting equipment, specialized backdrops, and various posing accessories. Who can afford that?

You have to remember that working pros need all that stuff because they're required to meet the needs of a various clients. Pros often don't know who's going to walk in the door and what that person is going to want. You don't have that problem. Your mortgage isn't dependent on your ability to meet every customer's whim.

So, then, how much stuff do you need to shoot a professional-looking portrait? Your setup can be as simple as two flashes, two light stands, one photo umbrella, and a nontextured backdrop, such as butcher's paper. All of these goodies fit easily in the trunk of your car, enabling you to shoot great-looking portraits just about anywhere.

Get Your Lighting Together

For this assignment, I'm going to start by showing you what I consider the easiest way to go. Even though the investment in this equipment is far less than what pros spend, the bottom line might still be more than your budget allows (figure about US$600). If this is the case for you, I'll present some low-cost alternatives at the end of this hack. But let's start with the most desirable and go from there.

First, I strongly recommend a camera that has Manual Exposure control and accepts external flashes. A camera that has lots of flash accessories available

from the manufacturer is even better. At the moment, Nikon and Canon provide the most options.

When you're shopping for external flashes, look for models that can be triggered wirelessly by the camera. These units are perfect for the photographer on the go. I'm using two Canon Speedlite 420EXs (as shown in Figure 4-9) and a Transmitter ST-E2 for this assignment. The transmitter mounts in the camera's hot shoe and wirelessly triggers all the flashes when you trip the shutter.

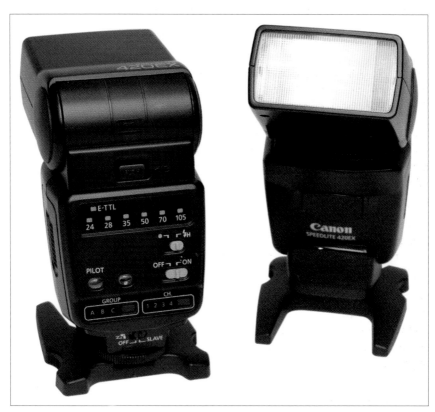

Figure 4-9. Canon 420EX flashes in slave mode

Not only does this configuration save you from the tangle of wires, but the flash units and camera also communicate during the exposure, so you get perfectly exposed shots without having to calculate guide numbers and f-stops. It's truly amazing. Nikon's offering is equally fantastic.

Now, all you need are a couple of light stands (with brackets) on which to mount your flashes and a photo umbrella to serve as a diffuser for the main light. I've had good luck with Bogen light stands, such as model 3097,

because they provide good height but fold down to a compact size and are lightweight. I add a Bogen 028 flash bracket to the top of each stand so that I can position the light at any angle. Plus, I use these brackets to hold the umbrella, as shown in Figure 4-10. Just about any type of photo umbrella will serve you well, so shop for price.

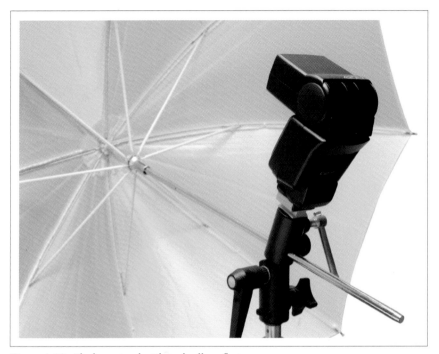

Figure 4-10. Flash on stand with umbrella reflector

I can use this lighting setup with almost any Canon camera that has a hot shoe, including both film models (the EOS series) and digicams, the "G" series, Digital Rebel, 10D, and on up the line. Figure 4-11 was shot with this lighting arrangement and a Canon 10D digital SLR. But I've recorded many successful portraits with the more affordable Canon G2 prosumer model. They all work equally well.

The Setup

Find a room that gives you at least 10'×10' of working space. Lots of natural light is helpful for accurate focusing and keeping the subject's eyes from dilating too much. Attach a 6'×6' piece of backdrop on the wall. You can use photographer's backdrop paper that comes in rolls, butcher's paper, or just about any other smooth surface. The main thing is that you don't want

Figure 4-11. Portrait taken with two-flash setup

to show wall texture, because that looks amateurish. Try to position your subject at least four feet from the backdrop. This helps soften its appearance in the final shot.

Now, mount one flash on a light stand and attach the umbrella. This will serve as your main light. Position it close to the model, within a few feet, and just off to one side. The lighting rule for this type of photography is that the larger the light source (in this case, light reflected off an umbrella) and the closer its proximity to the subject, the softer the light. Soft light is good for portraits in which light is reflected off an umbrella just a few feet from the subject, as in Figure 4-11.

Mount your second flash to a light stand and position it behind the subject but off to one side (so it doesn't show in the picture). Cover the flash head with several layers of tissue held in place with a rubber band. This will reduce the light output from the flash. Elevate the stand as high as it will go and point the flash at the top of the model's head. This will serve as the *hair light*. Lighting the hair separately is a sure sign of professional portrait photography.

Now, turn everything on, including the transmitter that you've mounted in the camera's hot shoe. Set the camera to Auto Program exposure mode and

take a few test shots. After reviewing the images in the LCD monitor, adjust your lighting accordingly. Is the hair light too strong? Then add more tissue or move it back a bit. Is the main light flattering for the model's features? If not, move it to a different position and try again. I usually take about a dozen test shots before I find a lighting combination that I like. Once I do, I shoot quickly, before my subject gets tired of posing.

You'll be amazed at how good your portraits will look.

Alternative Equipment

The wireless flash setup is far and away the most accurate, convenient, and portable arrangement you can use. But if you don't have the US$600 to invest in these tools, consider this alternative lighting arrangement.

If you already have a few older flash units available, make them wireless by purchasing so-called *slave triggers*, such as the Wein WP-HS that's available for around US$30. The slave attaches to the foot of the flash and has a hot-shoe mount and a tripod socket so that you can attach it to a light stand. Position your slave-mounted flashes, as outlined earlier in this hack, and then activate your camera's built-in flash. When it fires, it will cause the other, more powerful flashes to fire too. You might want to put a few layers of tissue or a piece of exposed slide film over your camera's built-in flash so that it doesn't adversely affect your lighting scheme. Its job is to trigger the other flashes.

Some digital cameras emit a preflash before the real exposure. This can throw off the timing of your wireless arrangement. Overcome this problem by mounting a small external flash in the camera's hot shoe. It won't emit a preflash like the built-in unit.

Now, we have to address the problem of exposure. Since there's no communication between the camera and the flashes, everything has to be set manually. You could calculate guide numbers for this arrangement, but why? You get instant feedback on your camera's LCD monitor.

Put your camera in Manual Exposure mode with the shutter speed at 1/60 of a second and the aperture at f-5.6. Set your main flash (the one reflecting off the umbrella) to its most powerful setting. If the hair-light flash has variable settings, set it to 1/4 power. Otherwise, add layers of tissue as needed. Now, make an exposure.

If the subject is too bright, stop down your aperture to f-8. Too dark? Try f-4. Once you find the magic combination of flash and aperture settings, take notes! This will save you much effort the next time you use this setup.

Final Thoughts

You can travel light and still shoot portraits like a pro. The best route is to use wireless flashes made by your camera's manufacturer. But with a little patience, you can patch together just about any assortment of flashes for fantastic results.

Eliminate Glare in Reflective Surfaces

You've probably felt the frustration of trying to take a picture of a reflective object, such as a framed painting, and getting glare. The secret is to add another flash.

Using two external flashes instead of your camera's built-in unit offers all sorts of new photographic possibilities. As discussed in "Pro Portraits with Just Two Flashes" **[Hack #43]**, you can produce great-looking portraiture with just a couple electronic flashes and light stands. Here's another use for this capability: photographing reflective surfaces without producing glare.

As you know, when you try to use your camera's built-in flash to take a flash picture of, let's say, a painting on the wall, you always get a hot spot somewhere in the image. You could turn off the flash, lug everything outside, and then use natural light, but that's not always convenient either, such as when it's night. Plus, if you're shooting a lot of different objects to sell on eBay, do you really want to be standing outside with your equipment all day?

Try this method instead and work comfortably indoors. Hang your artwork on the wall and get your flashes and light stands together **[Hack #43]**. For this assignment, you won't need the photo umbrella, but you will need both the flashes mounted on their light stands.

Raise the light stands so that the flashes are the same height as the painting. Now, position one on the left and one on the right, each at 45° angles from the painting. The flashes and painting should form a triangle.

Mount your camera on a tripod and extend the legs so that the camera is the same height as the center of the painting. Make sure the camera is level and centered between the two flashes. Now, focus and take a picture.

Both flashes will go off, but amazingly, there's no light reflection in the picture! Magically, each flash cancels out the reflection from the other (see Figure 4-12). You get an evenly illuminated image with no hot spots.

You can also apply this technique to tabletop photography for items such as flower vases and glassware. The main thing to remember is to keep your light sources at strict 45° angles from the subject, and keep the camera centered between them.

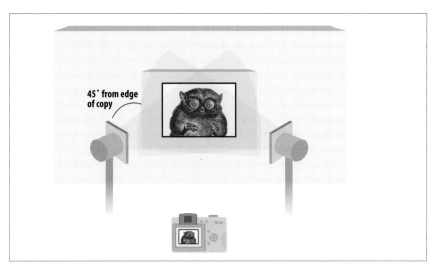

Figure 4-12. Two flashes at 45° angle for no reflection

HACK #45 Freeze Action with Electronic Flash

The hand is quicker than the eye, and your electronic flash is faster than your shutter. Use it to stop time and capture that magic moment.

The shutter on your camera can reach speeds of 1/2000 of a second or faster. The faster the shutter speed, the easier it is to *stop action*—that is, freeze your subject in its tracks or, in the case of Figure 4-13, in mid flight. The challenge with a fast shutter speed is that it also severely reduces the amount of light passing to the image sensor. So, you have to either open up the aperture all the way (f-2.8 or so), increase your ISO speed (to ISO 400 or more), or both. And even then, you still might not have enough light to capture the picture.

But there's a workaround for these limits imposed by the laws of physics. Your camera's electronic flash is an excellent tool to stop action when you don't have enough light to use a super-fast shutter speed.

In fact, even when you do have enough light, you still might want to use the flash. Why? Your camera's shutter probably tops out at 1/2000 of a second or so. But the electronic flash is just getting warmed up at that speed, and some external units can emit bursts of light as short in duration as 1/50,000 of a second. Now that's high-octane performance!

And it gets even better. Since the flash adds light to the scene, you don't have to fiddle as much with aperture and ISO settings. It's rare when you get to have it all in photography, but this is one of the few occasions where that's possible.

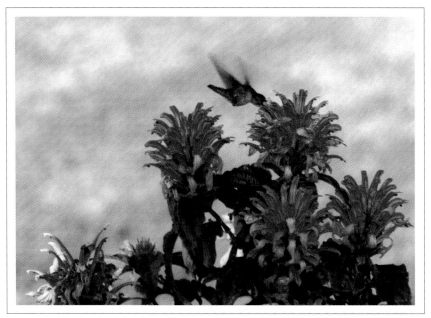

Figure 4-13. A hummingbird captured in flight with flash

To use this technique, you first have to make sure the flash fires. If you're outdoors, switch to Fill Flash or Flash On mode. Now, make sure you're within range of your flash. For most built-in units, this means eight feet or closer. You can extend this range if your camera accepts an external flash, which is more powerful.

If you're using a point-and-shoot digicam, you're still going to have to deal with *shutter lag*: the delay from the moment you press the shutter to when it actually fires. You'll have to anticipate the decisive moment and shoot accordingly. Digital SLR shooters have more responsive cameras and don't have to compensate nearly as much for lag. Get to know your camera, and go from there.

HACK #46 Second-Curtain Flash for Cool Effects

One of the most magical of all camera tricks, second-curtain flash lets you show a trail of motion behind an object that is frozen in mid flight.

Typically, you use a camera flash to add light when there's not enough ambient illumination for a well-exposed shot, or to fill in shadows for portrait subjects. In either of these scenarios, you typically have a relatively fast shutter speed (1/60 of a second or so) with the flash occurring at the beginning of the exposure, otherwise known as the *first curtain*. The term *curtain*

refers to the phases of the shutter. The first curtain occurs at the beginning of the exposure and the *second curtain* occurs at the end.

For an evening portrait, you use a much longer exposure time **[Hack #29]** to capture some background information that would otherwise be dark because the flash can't reach that far. Subjects must stand still during these long exposures; otherwise, they'll blur in the photo.

Technically, a *second-curtain flash* is just a technique in which the flash fires at the end of a long exposure rather than at the beginning of it. So, why would you ever want to have the flash fire at the end of the exposure? Well, it creates great opportunity for the best of both worlds. On one hand, you get the artistic motion trail that illustrates the movement of an object, often revealing patterns or characteristics about the movement that we can't other-wise perceive. On the other hand, you also get to *freeze* the subject at the end of the motion. By having the sharp representation of the object at the end of the motion trail, rather than at the beginning or middle, you end up with a more interesting shot that shows the history of the subject's movements.

A classic application of second-curtain flash photography is to show a dancer in motion or a moving object, such as a golf club or a bouncing ball. In the example shown in Figure 4-14, I shot a playing card flying through the air at 1/2 second at f-7.1.

How to Create the Magic

You'll need a camera with a Second Curtain flash mode or one that accepts external flashes with this option. In this hack, I used a Canon Digital Rebel with a Canon Speedlite 550EX. When shopping, you'll have to check the specs carefully, because some great digital SLRs don't have this feature, while a plain-Jane consumer digicam just might.

For your setup, mount your rig on a tripod, set the flash to Second Curtain mode (it will be there somewhere in the controls), put the camera in Manual Exposure mode, and try a beginning setting of one second at f-5.6. It's also helpful to have a remote release for this type of shot.

Now, pay some attention to your background, because you'll want one that differs in tone and/or color from the subject. Typically, these types of pho-tos are shot with a light object on a dark background.

Put the object in motion and trip the shutter. You'll hear the *click* of the shutter opening, but no flash...at least not yet. When the shutter clicks again to close, the flash will fire. That's the beauty of the second curtain. The shutter is open, capturing the object's movement, and then the flash fires

Figure 4-14. Second-curtain flash

right at the end of exposure, freezing the subject in mid flight and thereby rendering a natural-looking composition.

You'll need to take many test shots to perfect the composition, the lighting of the scene, and the motion of the object. The length of the trail is determined solely by the length of the exposure time (given that you don't have any control over the speed of the subject). The intensity of the motion trail is determined by the strength of the ambient light on the subject, as well as the camera's ISO and aperture settings. The intensity of the frozen image at the end of the exposure is determined by the flash strength. To maintain the most control, put the flash strength on manual control; this feature typically requires an external flash.

If you are shooting a light object on a dark background, the goal is to light the subject but not the background. There are a number of things you can do to achieve this. For starters, move the background as far away as possible. In my example, I used a large black sheet as the background and moved the camera as far away as the size of the sheet would permit.

Another tip is to place the ambient light source (such as a desk lamp) and the flash off to one side and light the subject at an angle. The goal is to place the lights so that their illumination doesn't hit the background.

So, how do you move the flash off the camera but still retain communication? One trick is to buy a relatively inexpensive coiled cable that connects to the flash on one end and the hot shoe on the other [Hack #42]. A more expensive approach is to use a wireless flash system [Hack #43]. A homemade approach is to aim the flash off to the side or directly up and bounce it off a reflective surface, such as a piece of white cardboard. Also, keep in mind that the less reflective your dark background is, the easier it will be to control the lighting.

Choosing to tackle a shot with a dark object on a light background will make your work harder, because you will have to light the background but light the subject only minimally. If you have too much ambient light, the motion trail will be blown out in the background.

If your shot involves throwing an object across the frame, keep in mind that you probably won't get the perfect throw on your first shot. It might take a hundred or more attempts. That's okay; it's not like you're burning film. In fact, many of your best shots come from unexpected results.

If you're shooting a scene that you can't test over and over and you don't know how long it will take the subject to run through the composition, you can set the camera to Bulb mode and hold down the shutter as long as you want, which ideally should be until just before the subject exits the end of the scene.

Keep in mind, however, that with digital SLRs the viewfinder is blocked during these long exposures because the mirror is flipped up, allowing light to pass through to the sensor. You can get around this problem by looking for a reference point on the background where your composition ends—perhaps a distant tree or building. While you're shooting, observe the scene with your eye over the top of the camera and judge the end of the frame based on the reference point. You don't want to ruin a good shot by having it run off the scene, so frame a little wider and crop on the computer later if necessary.

Try second-curtain flash with a variety of subjects. You can combine this technique with others mentioned in this book (such as "Auto Headlamps and Other Streaming Lights" [Hack #33]) for some truly impressive results. Let your imagination run wild.

—*David Goldwasser*

The Computer Connection
Hacks 47-61

To really appreciate the power of your digital camera, you have to plug it into a computer. This is where you turn average photos into a great ones, create glorious prints that used to take days to return from the photo lab, make digital slideshows that rival professional presentations, paste together video snippets into short movies, and even add voice and music to your images.

In this chapter, you will learn how to harness the creative power that flows from camera to computer via the USB cable connected to your PC.

HACK #47 Judge Image Sharpness by File Size
With a series of photographs of the same subject in hand, you can judge which shot is sharper without ever opening a file.

Figuring out which photo in a series is the sharpest can be a laborious task. If you have five shots of the same subject, you typically open each in turn in the image editor, examine them all closely, and then make a judgment call as to which one is the keeper.

If you have to work quickly, this approach can be quite frustrating, not to mention time-consuming. There's got to be an easier way! And indeed there is.

You can make solid judgments about image sharpness without ever opening the file. Both Windows and Macintosh computers provide you with all the information you need by simply opening the folder that contains your pictures and viewing some of their basic data. Eyeballing sharpness is all a matter of size—file size, that is. The larger the file, the sharper the picture.

When you're shooting in JPEG mode with your digital camera (which you usually are, unless you explicitly switch to TIFF or RAW), the files are

compressed in the camera so that they don't take up too much room on your memory card. Fine, sharp detail is harder to compress than softer, duller images. So, the resulting file for a slightly sharper image will be a little bigger.

Under Windows, open the folder of images and choose the Details view, as shown in Figure 5-1. In the Size column, you'll see how big each image is. In this example, *IMG_1005* and *IMG_1006* are of the same subject, but *IMG_1006* (1,803 KB) is a little sharper than *IMG_1005* (1,775 KB). Windows enables you to preview the image in the Details box in the left column. All you have to do is click once on the filename, and the preview for that file appears. This makes it easy to make sure you're comparing pictures of the same subject.

Figure 5-1. The Details view in Windows

This process on Mac OS X isn't much different. Choose Column View, as shown in Figure 5-2, and click the image you want to examine. Finder will generate a thumbnail, along with the image's file size and other details. Click

another image to compare. Again, file size should inform you which shot in the series is sharper.

Figure 5-2. Column View in Mac OS X

This hack assumes that you usually shoot more than one frame for each subject; I highly recommend this. For people shots, I always shoot at least two frames, just in case someone looks away, closes her eyes, or otherwise contorts her face in one of the shots. But even for landscape and other non-people compositions, I shoot more than one frame and then choose the absolute best version of any subject. I don't hold the camera as steady for every shot. And sometimes, things happen in the background that I don't notice in the camera's small LCD monitor.

Multiple shots ensure that I come away with the best picture possible. And if you can get away with finding the sharpest version without opening a single file, why not do so?

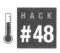

HACK
#48

Unerase the Lost

Nothing wrenches the heart like accidentally erasing a memory card full of images. But all is not necessarily lost.

A few years ago, a buddy of mine's mother was approaching her 100th birthday. She didn't get out much any more, but she'd been to the hairdresser and had her hair Cool Whipped to perfection. She even went to the dry cleaner to get her Queen Bee formal gown pressed. The tiara she always kept gleaming.

She enlisted her friend to pick her up at her summer residence to drive her to her son's newly remodeled home. His dinky two-bedroom gardener's shack

had been magically rebuilt into a four-bedroom palace with closets the size of shoe stores.

And her son even got a haircut. She'd been begging him to do that for 32 years. "Danny, why don't you get a haircut? Take the money from my purse. Go on."

I'd recently been out to shoot the new baseball stadium in town, so I brought along the shots on the Compact Flash I'd used. While we were waiting for the Queen Mum, I plugged my digicam into their television and wowed the kids with delusions of a World Series to come.

Naturally, I also brought a blank card to shoot the festivities. And, as luck would have it, I got a once-in-a-lifetime shot of mother and son—yep, a rare simultaneous smiling.

The next morning, before any cup of anything could clear the cobwebs from my head, I deleted the wrong card. "No," I said. "I didn't."

Oh, yeah, I did. But I was confident I could recover the data from the card. I'd done it with floppies, why not with a card? So, I spent the next few weeks trying every trick in the book to undelete the files on the card. But they were lost.

I consoled myself with the thought that I'd get that portrait again one day, but the dear matriarch never lived to see her 101st birthday. And her son was so distraught, he let his hair grow out again.

It's a sad story. But there's no reason it should ever happen again.

These days, even one of the kids could salvage that image while waiting for a World Series. All the little gotchas that defeated me years ago have themselves been defeated by modern utilities designed especially for just this sort of thing.

How They Don't Work

The first thing to know is that—whether you are using a Macintosh or a Windows PC—your storage device is formatted for MS-DOS.

Macintoshes have no trouble reading and writing MS-DOS media (and PCs can handle Macintosh media with third-party software). But neither of them is any good at running disk utilities on the other's media. Norton knows your native filesystem, period. So, recovery of a DOS-formatted card is a generally a Windows task.

Unfortunately, Windows might see your card only as a network drive (where, as with floppies, deletions are not safely buffered in the Recycle

Bin). And it's rude to reorganize the directories of network drives, so your usually reliable unerase utility might not go there.

The size of your card is also a factor. The file allocation table for a 16 MB card is not quite the same beast as for a 256 MB card, which is also why some larger-capacity cards don't work in some cameras.

The complications build from there.

You might have success using freeware to unerase your card. I report every success story I hear in the letters column of the Imaging Resource Newsletter (*http://www.imaging-resource.com/IRNEWS*). But the free utilities run primarily on Windows (the exception is Carsten Blüm's Exif Untrasher: *http://q41.de/downloads/exif-untrasher_en*).

But this job is a lot more difficult than it might seem. I prefer to rely on a utility that will do everything possible to restore the data, rather than pat myself on the back for saving US$30 and not recovering two or three images every time I run it.

The Secret to Unerasing

All of these utilities know a little secret: the data on the card is not actually erased. It isn't really lost until it is written over the next time you save information to its formerly protected sectors.

An erase operation simply frees the file's disk space, overwriting the filename's first character in the card's directory with the Greek character sigma. It's faster than zeroing all the data and just as effective, if not as secure. To actually erase the file, you have to write over every byte. And you have to do so more than once, if you believe certain U.S. government specs. That's what the Norton Utilities Wipe command is all about.

To the Rescue

After my traumatic experience, I wanted the best utility for recovering images. I came up with DataRescue's PhotoRescue (*http://www.datarescue. com*). It runs on Windows 98 or higher and Mac OS X. The basic version, shown in Figure 5-3, costs US$29 (or US$45 for both platforms). An expert version, offering even more harrowing measures to restore the past, costs US$39.

PhotoRescue uses a proprietary data-recovery engine, optimized for image files, that dynamically switches between up to 12 data-recovery algorithms to apply a recovery strategy that is optimized for each image.

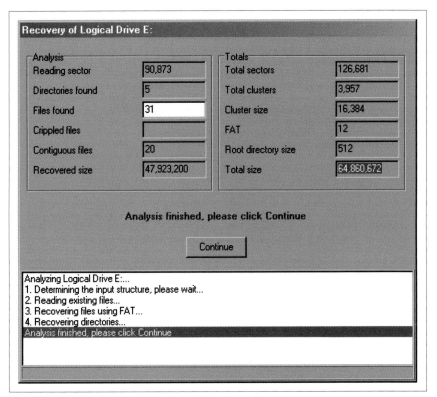

Figure 5-3. Windows version of PhotoRescue's analysis of a Memory Stick

It can also create a disk image of your card, a file on your hard disk that mirrors the data on your card. This is a pretty interesting capability, because it means you can duplicate the card data any number of times to try different recovery strategies and diagnostics. When PhotoRescue finds all the files hiding on your memory card, it displays the directory tree, a thumbnail, and the filename for each recovered item, as shown in Figure 5-4.

What Can and Can't Be Done

PhotoRescue has recovered every image I erased and every card I reformatted. But to be retrieved, the data has to reside on the card. And that isn't always the case. Let's look at what can and can't be done:

- If you simply erased files on your card from your camera, PhotoRescue can retrieve them by uncovering all the information that's still lingering on the memory card. You can't see it, but it's still there.

- If you used the card to capture more images after erasing, you are overwriting whatever PhotoRescue might be able to recover. Something

Figure 5-4. Formerly lost files recovered by PhotoRescue

might be recoverable (from the part of the card not yet reused), but not everything.

- If your camera can't read your card, PhotoRescue might still be able to recover your images by reading the card in physical (rather than logical) mode.

- Because IBM Microdrives can suffer mechanical failures, data retrieval by software alone might be impossible. But you can still try a disk-recovery firm, such as Drive Savers (*http://www.drivesavers.com*), that actually pulls data blocks off damaged drive platters and puts the information on other media for you.

- Using your camera or computer to reformat your card might make recovery impossible. According to DataRescue, "Nikon and Canon digicams usually do not fully erase cards. Olympus digicams may or may not fully erase cards during a format. Sony digicams always seem to do a complete wipe."

After reformatting your card, to see if you have recoverable data, use Photo-Rescue's "Image the Input" command to create a disk image. Compress that disk image with a utility such as WinZip or StuffIt. If the resulting archive file is small, it means that there wasn't any data to compress.

After an in-camera reformat of my card, PhotoRescue recovered exactly what I had recovered after merely erasing the card.

Safe Practices

Naturally, the best approach is not to erase your card until you've copied your images. One copy is not enough. Two copies on different media is the minimum. The copies should be created with as few shared variables as possible. If something goes wrong with one scheme, the other should not suffer the same fate.

Then, use your camera, not your computer, to erase the images. Once in a while, feel free to reformat the card, but that's not really necessary. If you make sure never to erase files or format your card on your computer, your camera will always be able to make sense of your card. If you use your computer, your camera might not. Cameras aren't as smart as computers.

Final Thoughts

Before you make the tragic mistake I made, find a flash-card unerase utility you can live with. The next time you erase a card, use your utility to try to recover the images that were on it. Try it after a reformat, too. If you don't get them all back, try another utility.

Rehearsing for disaster might seem silly, but I know at least two people who wish I'd done it. It's a tragedy, yes, but it's entirely preventable. Don't let it happen to you.

—*Mike Pasini*

HACK #49 Name Folders to Organize Your Images

You have many digital-shoebox applications to choose from to help you organize your photos. Or, you could simply use the built-in tools that come with your operating system.

Of all the places I've been, the most amazing one I've seen remains my grandfather's basement. It was *organized*.

He had, perhaps, an unfair advantage over the rest of us. As a pharmacist in the days when all pills were white, being disorganized could have been fatal. The discipline of being organized was part of his daily routine.

But he also enjoyed the advantage of organizing things, which is simply being able to find just what you need without the frustration of looking for it. The screws were on these shelves, the nails there, the adhesives right here, the rubber bands (sorted by size) over there, and on and on. His basement was as neatly organized as Noah's ark.

Fortunately, he passed that gene on to me, so when I started collecting digital images, I quickly established a scheme so that I'd never have to look for them or remember where they were.

This was long before asset-management programs such as Adobe Photoshop Album (Windows), Canto Cumulus (Mac/Win), Extensis Portfolio (Mac/Win), iPhoto (Mac), iView MediaPro (Mac/Win), Kodak EasyShare (Mac/Win), Picasa (Windows), QPict (Mac), and others were available. I had to rely on the only thing available: the filesystem.

Filenames

When I was the computer guy at the office, I used to have a standing offer of US$100 to anyone whose problem could not be resolved by a clear understanding of the four parts of a filename. In the days of MS-DOS business systems, I never had to pay out.

Here are the four parts of a filename:

- The volume name (e.g., *C:* or *Macintosh HD:*)
- The directory and subdirectories, if any (e.g., *DOS* or *Documents:*)
- The root name (e.g., *AUTOEXEC* or *Read Me*)
- The extension (e.g., *.BAT* or *.txt*)

As you can see from the examples, this tends to be true for all operating systems. In Windows, you might see *C:\DOS\AUTOEXEC.BAT*, and on the Mac you might see *Macintosh HD:Documents:Read Me.txt*, but all four parts are there in each filename.

Each part does a different job:

Volume name
> Tells us where the file can be found. The volume can be the internal hard drive (as in our previous example), an external storage device, a CD, or a floppy.

Directory and subdirectories
> Together with the volume, these give us the pathname of the file. The pathname in our example is *C:\DOS* or *Macintosh HD:Documents:*.

Root name

> Pretty much what we call a filename, period. It's the basic name of the file. Without the root name, we don't have anything.

Extension

> Often, our only clue to what kind of data the file contains The extension *.jpg* indicates a JPEG image, *.tif* a TIFF image, *.txt* an ASCII text file, *.doc* a Microsoft Word document, and so on. So, we don't want to mangle our extensions (even if modern operating systems sometimes hide them from view). Tread carefully here.

Organizing by Filename

To use this information to organize thousands of images, first think about your images and the way you shoot. Do you shoot business separately from pleasure? Do you shoot more than one event at a time, storing them all together?

Then, work out a naming system for your volumes. Give meaningful family names to your external (and infinitely extendable) storage media, such as CDs and DVDs. You might name the volumes by year, season, location, or client, depending on how you work.

The volumes represent your permanent collection or archive. Your internal hard disk should only be a waiting room for your images until they find a permanent place on a removable disc. And that disc should be copied so that your collection can exist in two places: one at hand, and one offsite for insurance. That way, when your smoke alarm goes off, you won't have to grab the photo albums on your way out. You can grab clean underwear.

By using well-named directories and subdirectories (or folders), these broad categories can be organized into smaller collections. Just don't overdo it. Remember, you don't want to have to remember anything. A hierarchy of one or two levels is deep enough.

Real-World Example

I originally used a scheme much like the one used by iPhoto: a folder name for the year, another for the month, another for the day. That buried my images a little too deeply to see what I had quickly.

Gramps wouldn't have approved of a system that put everything in boxes that were stored in drawers behind cabinet doors. Everything has to be out there on shelves or in cubbyholes, where you can see it.

So, I simplified my system by creating long folder names that said it all. Of course, I wasn't restricted by the eight-character root MS-DOS filename

limit anymore. Modern Macintosh, Unix, and Windows systems all support my new scheme, which is simply the year, the month, and the day (in numerals), followed by a short description (a slug, really) of the event.

For example, *2003.12.25-Christmas* works on any operating system. You can use more than one period, and hyphens are fine. Not every character is legal, though. Beware of slashes and colons especially, but every operating system has its taboo characters.

Folders named this way will sort naturally by date in any alphabetical directory listing. So, you can quickly scan nothing more than the default directory listing to find someone's birthday, a client shoot, or anything at all. You can even use your operating system's search utility to limit results to just those events.

In the real world, we don't just shoot images; we edit them. But that doesn't make the originals indispensable.

As soon as I copy the images to my hard disk from the flash memory card, I copy them to a second device. Only then do I return the card to service, wiping it clean only in the camera. I make two CDs of the original images and leave them on my internal hard disk for a few months to edit, print, and share as I see fit.

I save the new versions in a folder with the same name as the originals but with a little appendage, such as *-r* for *retouched*. So, our Christmas images in *2003.12.25-Christmas* might have slightly improved versions in *2003.12.25-Christmas-r*.

Auto Keywords

There's another advantage of using an explicit pathname. If you do one day decide to use a program such as Photoshop Album or Portfolio to catalog your collection, the pathnames can automatically be parsed on import to create keywords for each image in the directory—very cool.

Keywords make it easy to find images with a greater degree of precision than our shoot-oriented system. With date and event keywords automatically added, you can spend your time adding specific keywords to each image to identify them further. Nothing else will do when it's time to find pictures of *Dad* or *My First Girlfriend* or *My Last Husband*.

Image Root Names

Many programs let you change the root name of your image file from a non-descript *DSC2345.JPG* to something meaningful. That strikes me as too

much work. Your camera names each image. Let it and forget it. This system thrives on not remembering anything.

If you simply put the description of your shoot in the folder name, you don't have to change the root names of all your image files. And you can change any particular ones you want without disorganizing the collection.

Final Thoughts

Gramps didn't organize his basement just for the pleasure of it. He was an avid amateur golfer who played in tournaments all over the state. Keeping the basement in shape gave him more time to hone his game.

Keeping your image collection in shape will, at the very least, let you spend more time taking and editing pictures. And you don't need to spend a penny to do it!

—*Mike Pasini*

Create a Web Photo Gallery

#50 A great way to share your pictures is to post them on the Web. Here's an easy way for photographers to leverage the greatest publishing tool of all: the Internet.

Creating a web site is a cumbersome task, even for people with quite a bit of web design experience. So, what if you just want to get some images up for friends, family, or a client to review and comment on? This hack will get you on your way quickly, using a built-in feature of Adobe Photoshop. That's right, by using a powerful tool called Web Photo Gallery, you will have a professional-looking site up in no time.

All you need for this hack is a copy of Adobe Photoshop or Photoshop Elements. Before I go further, let me clarify the difference between the two applications. The professional offering from Adobe is called Photoshop CS (*http://www. adobe.com/products/photoshop*). It costs about US$650, runs on both Windows and Mac, and has many high-level tools, such as advanced batch processing that working designers need. Adobe also offers Photoshop Elements (*http://www. adobe.com/products/photoshopel*), which is available for about US$85 and has most of the tools that CS offers. Elements also runs on both Windows and Mac. For this hack, you can use either Photoshop CS or Elements. I refer to them both simply as *Photoshop*. The screenshots are from Photoshop CS.

When you have all your software together, you'll need access to web space for hosting your photo album. Check with your Internet service provider (ISP) to see if you have free web space (you almost always do!) and find out how to upload your files.

Most likely, your ISP will tell you to use an FTP application to move your files from your computer to their web servers. There are a number of good freeware or shareware FTP applications out there, and Mac OS X users have FTP built right into the operating system.

Okay, enough network stuff; let's start building a great-looking photo web site!

Open Photoshop and figure out which digital images you want to publish. They can be in any format Photoshop can open, and they can be as large as you want; Photoshop will take care of resizing them for the Web. You do need to make sure they are large enough to display in the larger size on your web page. A 200 KB JPEG is a good guide for a minimum size.

Go to the File menu and select Automate → Web Photo Gallery. This will open a Web Photo Gallery dialog box, as shown in Figure 5-5.

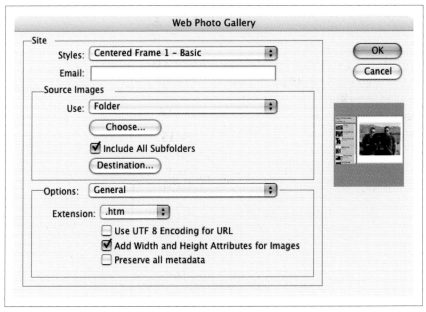

Figure 5-5. Web Photo Gallery dialog box

The first thing you'll need to do is select the style of web page you want from the drop-down Styles menu. There are many styles available, and each will load a preview thumbnail in the right side of the window.

Pick the style you want and move onto the next step: entering your email address. You don't have to have an email address on your site, but it is a great way to solicit feedback.

Next, you need to tell Photoshop which folder to use as a source so that it knows where to access the photos from when it runs the script. Notice that you can also tell Photoshop to include all the subfolders in the source folder. This is handy if you keep all your digital photos in a folder with nested folders for different photo shoots [Hack #49].

The destination folder is the folder where your HTML file and images will go. It cannot be the same folder as your source folder. The destination folder is the one you will post to the web server; it will contain all of your web photos and the HTML files that organize them.

There are a number of options available to you on the Options menu, as shown in Figure 5-6.

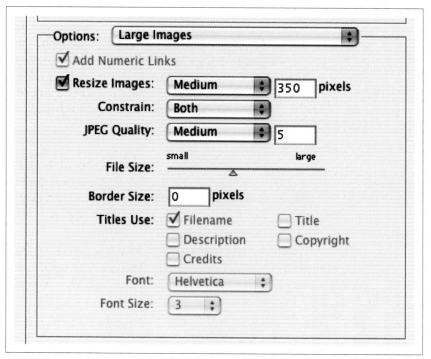

Figure 5-6. The Large Images dialog box of the Options menu

Let's take a gander at each option:

Banner

Title your site, include your name and contact information, and, if you want, have the date show up on your web site.

Large Images and Thumbnails

Set the size of the large images and thumbnails for your web site. The majority of web surfers still have a monitor resolution of 800×600 pixels, so keep this in mind when you size your images. When shooting images in JPEG mode, it is best to store them in the highest quality setting. However, for displaying images on the Web, these images will be too large to download in a reasonable amount of time, which could lead to people tapping their fingers while they wait for your images to load. Not good! I recommend a setting for JPEG quality of 5–7.

Next, if you want your images to have a border, enter a pixel value in the field to determine the width of the border. Web Photo Gallery can use the filename as a title, but it can also use a variety of other data that you can ascribe to an image in Photoshop. To ascribe additional data to your images before making a web photo gallery, open up your images and select File/File Info.

Don't forget that you can show different information in your thumbnails than you show in the large images. For example, you might want to show the title of the image in the thumbnail and the description in the large image. Make sure to experiment; one of the great things about this hack is that it takes just minutes for Photoshop to spit out your site. Don't like it? Just make a change and create your site again. Voilà! On to the next option.

Custom Colors

You can have custom colors for the background and more. Click on the color boxes and pick a new color in the Photoshop color picker. Remember, though, that web usability experts often recommend using the default bright blue for links; it's easier for users to recognize.

Security

You might want to have a copyright watermark on your images to prevent them from being downloaded and used without your permission. The Security window lets you create a watermark with the copyright symbol, filename, description, and more. You can choose the size, color, and opacity of the type, and Photoshop will automatically add the watermark to your large image. Neat.

After you click OK, Photoshop goes to work. Depending on the number of images you have, their size, and the speed of your computer, this could take seconds or a few minutes. Photoshop will open each of your images, save them in the thumbnail and large image size, and create the required HTML code.

When Photoshop has finished grinding away, visit your destination folder. Open the *index.html* file in your favorite web browser and examine the output, as displayed in Figure 5-7.

Figure 5-7. A web gallery created with Photoshop

The next step is to upload the HTML and images to your web server.

The Web Photo Gallery included in Photoshop is a powerful utility that can help you present your images on the Web or your company intranet, or even burn your collections to CD. Since almost anyone with a computer can navigate a web page, viewers will feel right at home with the photo CDs you create using this technique.

—*Hadley Stern*

HACK #51 Amazing B&W Prints from Your Inkjet Printer

For a couple hundred bucks you can convert your Epson or Canon printer into a high-end black-and-white darkroom.

Digital photography is based on a long history of techniques and tricks hammered out over a hundred years of film photography. The metaphors used by Photoshop are rooted in the lexicon of film photography. Filters, contrast, burning and dodging, color balance—all these terms come directly from analog photography.

This hack takes a sacred part of traditional photography, the *silver halide print*, and turns it on its head. How? By using the traditions of offset printing, in which different shades of black are applied in layers to create super-rich B&W prints. Go to one of your favorite bookstores and pick up a book by a photographer that has black-and-white photographs. That book is printed on an offset printer and the image is made up of thousands of tiny dots to trick your eye into seeing continuous tone.

Silver halide prints, on the other hand, *are* continuous tone and, because of this, are incredibly rich. A higher-quality black-and-white photography book will try to mimic this quality by printing *duotones* that use two layers of ink to create richness that can't be accomplished with just one layer of black ink. This results in a higher-quality image that looks closer to its continuous-tone original: the silver halide print. Many books are printed using *tritones* (three shades of black) or even *quadtones* (you guessed it, four shades of black). Quadtones will generally be richer than duotones.

So how in the heck does this apply to digital photography? Well, some pretty clever people out there have figured out how to turn your Epson printer into a quadtone black-and-white printer. That's right—you can take the cyan, magenta, yellow, and black cartridges out of your printer and replace them with cartridges that are four shades of black, as shown in Figure 5-8.

Printing quadtone images is complicated, because it requires both a software and a hardware solution. Someone (or something) has to figure out which parts of the image should be printed in which tone. Then, that software needs to communicate with the printer to lay down the different shades of color correctly. Don't worry; you don't have to start draining your cartridges and putting in custom shades of gray, and you don't need to start writing software yourself. *Piezography* has done all of this for you by devising a system by which different shades of black ink are carefully controlled by your computer to create stunning B&W prints.

small format

PiezographyBW ICC (released Nov 17, 2003) pre-filled ink cartridges for the EPSON® 860, 1160, 1200, 1270, 1280, 1290, 2000P <u>are now found here</u>.

PiezographyBW plug-in and PiezographyBW Pro Ink cartridges for the EPSON 860, 1160 <u>are now found here</u>.

PiezographyBW plug-in and PiezographyBW Pro Ink cartridges for the EPSON 1200, 1280, 1290 <u>are now found here</u>.

click <u>here</u> to see why PiezographyBW plug-in and PiezographyBW ICC use different ink cartridges in 6-ink printers.

Click <u>here</u> to upgrade.

Figure 5-8. Replace color cartridges with special black ones for quadtone printing

Piezography is a combination of ink cartridges and International Color Consortium (ICC) profiles that together will have you creating incredible digital black-and-white prints pretty quickly. The International Color Consortium created ICC profiles as a way to manage color across all computer platforms. ICC profiles that work on both Macs and PCs (all Macs and most versions of Windows—check the tech specs for more details) are available for most Epson inkjet printers and some Canon printers.

> You can pick yourself up ink cartridges and a profile for your printer at *http://www.inkjetmall.com*.

The ICC profile is specific to your printer and the kind of paper you are going to print on. Piezography can be performed on a surprisingly wide array of Epson inkjet printers, from the lowly Epson 8.5×11 photo printers all the way up to the super-large-format Epson 10000.

To start out, you should purchase a starter kit to see if Piezography is for you. The kit includes Piezography ICC media profiles, a set of piezotone ink cartridges, a set of flush cartridges, a manual, and 10 sheets of assorted sample

papers. Expect to spend anywhere from US$200 to $400 for this kit, depending on which printer you own.

You can also purchase a bulk ink kit. This is cool, because it lets you run your printer for long periods of time without having to change cartridges. Instead, you have ink bottles that sit next to the printer and are connected, via small tubes, to the ink cartridges in your printer, feeding them ink. This also results in a significant cost savings over all those cartridges you end up buying and throwing out. Remember that bulk ink kits are simply a function of economics: the more you print, the more they make sense. Since you probably want to see how well Piezography works for you before investing in a bulk ink kit, you should probably try the cartridges first.

Since these inks are going to replace your current ink set, the first thing you need to do is thoroughly clean your printer so that there is no old ink to mix with the new. Piezography inks are purely pigment-based, which allows for a greater dynamic range and the creation of truly archival prints. Making sure that your old Epson ink is clear so that the Piezography inks can work properly is an important first step. Install the flushing cartridges and print an image provided on the included CD a few times. This will ensure that your inkjet heads are clean and ready for the new Piezography inks. Some of the larger printers have slightly different flushing procedures, so make sure you read the manual.

Now that your printer is ready to print with pigment-based, archival, black-and-white inks, you need to get your monitor ready. To get the best results, make sure your monitor is calibrated. Then, load up the ICC profiles included with your starter kit. What you see on your screen in Photoshop will match what you see when you print using Piezography inks. It's that easy.

The system works best when you calibrate your monitor (whether Mac or PC) to Gamma 1.8. You do all your work in the grayscale color space. Don't worry; you don't have to shoot your digital images in color. You can pick and convert your color images to grayscale.

When you are ready to print, you can soft-proof. This will display an image on your screen that is unbelievably close to how it will print. One important thing to remember, however, is that the ICC profiles take into consideration the kind of ink set you are using, the model of printer you are using, and the type of paper you are printing on. Therefore, if you want to try different types of paper, you need to buy and use the ICC profile for that particular paper. This allows for the soft-proofing feature, on a color-calibrated monitor, to be accurate. Once the image is where you want it and you have made

the adjustments you need in Photoshop, it is time to print. Depending on your printer, expect the print job to take 2 to 10 minutes.

Print speeds vary depending on your printer. The Piezography print system is a true replacement for a traditional black-and-white darkroom. For a couple hundred bucks, this hack will turn you into a master printer of digital black-and-white photos.

—Hadley Stern

HACK #52 Great Color Prints from Your Inkjet Printer

The battle cry for his hack is "go forth and calibrate!" That's about the only way you're going to get consistently accurate prints from your inkjet printer.

One of the promises of digital printing is that you can produce images in your own digital darkroom without the mess of mixing chemicals. However, while there is no water involved in digital printing, your prints might still get wet from the sweat of frustration.

If you've ever tried to print color photos by just plugging your camera into the computer, opening your image, and printing, you know where this frustration comes from. Consistent color out of the box is almost impossible without a little upfront work. But, if you follow the techniques outlined in this hack, what you see on your monitor will look very much like what you print out.

The solution starts with your monitor. Monitors are made by a wide variety of manufacturers. This results in a surprising array of color variance between your monitor and another brand. Even the age of a monitor affects its color. This means that the perfectly color-correct image on your monitor might not really be color-correct. The only real way to ensure that the color on your monitor is consistent with the color on your printer is for them to work off the same protocol. The industry-standard software for this protocol is documented by the International Color Consortium (ICC), a group founded by Apple and seven other vendors in 1993. The most popular and mature implementation of the ICC system is Apple's own ColorSync (*http://www.apple.com/macosx/features/colorsync/*). Using ColorSync, you can match what you see on your screen to what you see on paper with uncanny accuracy.

ColorSync is built into the Macintosh operating system (including Mac OS X, 9, and older versions) in a seamless way. If you have a PC, don't fret. While the ICC system is not as well integrated into Windows as it is on the Mac, it's still possible to utilize a color-management workflow.

Measure Me

For this hack, you need to purchase a *colorimeter*, which measures color densities and enables you to calibrate your monitor. There is really no way around using a colorimeter if you want truly accurate color on your monitor. Popular brands start at US$150 and include the Pantone Spyder, Monaco Sensor, and the Gretag Eye-One Photo. You can find many models at Amazon.com (*http://www.amazon.com*). Some colorimeters can calibrate only CRT monitors, so if you have an LCD monitor, make sure to purchase a colorimeter than works for you.

You could use the Adobe Gamma tool that comes with Adobe Photoshop, but because this is entirely a software tool, your results will be mixed at best. A colorimeter is a little camera that you place on top of your monitor and plug into your computer. You then run an application that comes with the colorimeter. Depending on the software included, your monitor will go through a series of routines, flashing different screens of color and making what might seem like strange patterns. The colorimeter reads these colors and, using software, creates an ICC profile for your monitor. By having your monitor calibrated to an ICC profile, you've taken an important step toward output that looks like what you view on the screen.

The implications of calibrating your monitor are fantastic. Now, when an image has too much yellow in it, you know that it really has too much yellow in it. Calibration will not automatically fix your images, but it will give you the ultimate control to see what needs to be fixed. And when you begin using levels or curves to makes adjustments, you will be doing so with the utmost accuracy. Yes, a more expensive monitor will give you even more accuracy, but even a relatively cheap monitor that is calibrated using a colorimeter provides a quantum leap in accuracy.

Print Me

With your monitor calibrated accurately, the next step is to get whatever you print to match, as closely as possible, what you see on your screen. You could go out and buy a colorimeter that will accurately match your printed output, as described in the previous section. However, because printers have much tighter tolerances than monitors, this isn't necessary. (But if you have money to burn, or if you want to take your color accuracy to the next level, go for it.)

Printer manufacturers include ICC profiles with their printers, as shown in Figure 5-9. Many manufacturers even include different profiles for different papers. For example, my Epson printer comes with profiles for matte paper, glossy paper, and a number of different varieties in between. This is because,

depending on the actual paper's substrate on the color gamut (or amount of colors), your print output can vary from paper surface to paper surface.

Figure 5-9. Available ICC profiles for a few Epson printers

When working with images in Photoshop, make sure to work within the RGB (red, green, and blue) color space, and don't convert your images yourself to CMYK (cyan, magenta, yellow, and black). Yes, most inkjet printers use CMYK to print (some use additional tints to achieve even more colors), but believe it or not, the software that runs these printers works in the RGB color space. Also, when you convert your image to CMYK, you are not converting it to a generic version of CMYK; you are converting it to a specific color space (the default version in Photoshop is US Web Coated, Web—in this case, meaning web offset printing).

Using profiles and the soft-proofing feature built into Photoshop, you can simulate how your image will look when printed, without ever having to

actually change the color space of the image. You can access these profiles right within Photoshop to preview how your photo will print. Go to View → Proof Setup → Custom and select your printer/paper combination from the drop-down menu, as shown in Figure 5-10. Click OK. The colors in your image will change either subtly or dramatically, depending on your image and the profile used.

Figure 5-10. Previewing how your image will print in Photoshop

Because your monitor is accurately calibrated, you can be certain that the yellowish cast in your image will appear yellowish when you print. Now, you can accurately adjust the yellow cast on your monitor before printing. When you do print, make sure you select "No color correction" from the Epson printer setup window. If you don't select that option, Epson's own color-management feature will kick in, ostensibly color-managing your already color-managed image.

Lighting

Walk into any gallery or museum and you'll immediately notice the quality of the light. These institutions spend plenty of money and time to make sure their color cast is as neutral as possible. That way, a Monet in Paris will look the same in New York. You need to do the same thing with your photos; otherwise, all the work you have done to get good color will be lost when you look at them under that tungsten light bulb.

You can neutralize your color cast either by purchasing a viewing booth with neutral lighting or by putting together your own rudimentary, but pretty accurate, viewing environment. A neutralized workspace is achieved by combining tungsten lighting with fluorescent lighting. Local art stores sell desk lamps that incorporate both tungsten and fluorescent bulbs, but you can also make your own viewing area by having two lights: one fluorescent

and the other tungsten of equal wattage. Make sure to view your prints in this light and make any color decisions here.

Now that your monitor, printer, and desk space are color-calibrated, you can now make adjustments in Photoshop confidently.

—Hadley Stern

HACK #53 Pro-Quality Prints from Your Digicam

Home printing solutions have their advantages, but working with a commercial printer can elevate your images and help them last for a very long time.

Two of the premises of digital photography are that things are easier and cheaper. When it comes to printing digital photos, however, neither of these premises is necessarily true. While having an inkjet printer at home affords you the ability to print when you want, the digital darkroom, as many of us have discovered, takes a lot of time and money. Between buying the printer, expensive refills, photo-quality paper, and color calibration, home printing can be a pain. This hack will explore the many alternatives to home printing.

The first place to look is your local pharmacy or photo store. You can take in your flash cards and plug them into kiosks that allow you a lot of variation and control over the final output. Many of the kiosks let you remove red eye and adjust color right before you print. The printing mechanism that is used is usually *dye sublimation*, which strongly resembles the look of a traditional photo print and lasts about as long. You can take your flash cards in, plug them into the kiosk, and be on your way. Some photo stores even let you upload your images and pick them up later.

Professional Photofinishers for Fine-Art Photography

But what if you want larger prints for fine-art photography? To take things to the next level, there are a number of options for larger output from your digital files. These options include inkjet printers (similar in technology to the ones we have at home), Iris prints (fine-art inkjet printing using a large drum to apply the ink), and Lambda/lightjet/chromira prints (using lasers to transfer the image to photographic paper).

To access these options, you should look up professional photofinishers in your area or check out *http://www.westcoastimaging.com* and *http://www. singereditions.com*. Because digital photography is the confluence of many technologies and disciplines, you might find large-format printing available at a variety of businesses; look up digital prepress, print makers, and photofinishers to find someone who provides large-format digital output.

Print resolution requirements are similar regardless of the specific output you choose. Your image usually needs to be at least 200 dpi at its 100% size [Hack #62]. I say *usually* because some service bureaus might require higher or lower resolution and some might use proprietary tools to get more out of your image. Also, resolution is always a subjective thing. Someone might be perfectly happy with a 16×20 print from a three-megapixel camera, while another person might be mortified by the results.

One of the major benefits of working with a service bureau, apart from getting access to super-large printers, is working with people. That's right, people! Even in this digital day and age, working with someone who works with digital images day in and day out is a significant advantage. At its best, working with a service bureau should be a collaborative process. You bring your artistic vision to the table, and the person at the service bureau brings his technical knowledge of what is possible. Often, professional photofinishers provide a proof print (which usually costs extra, but not as much as the final print). This lets you do some color correction before the final print is made—very handy indeed.

Different Types of Output

Now, let's take a look at the differences between inkjet, Iris, and Lambda/lightjet/chromira printers:

Inkjet
> Large-format inkjet printers are simply larger versions of the ones we have on our desks at home. Epson is the market leader in this space, but other manufacturers also offer printers capable of making great prints. The larger inkjet printers can give a look and feel that is similar to a traditional photographic print. There are a number of options for common paper types, including glossy, matte, and watercolor. Ask the photofinisher for samples.

Iris
> Iris printers have less of a traditional photographic look and feel and more of a lithographic look and feel. They are popular in graphic design prepress work because of their ability to match color closely. Iris prints can also be made on a wide variety of stock and can give your photographs a unique, painterly look. If you want to experiment with printing your photographs on thick, watercolor stock, Iris prints can't be beat.

Lambda/lightjet/chromira
> The next category of printers is what I call Lambda/lightjet/chromira. Why so many names? Well, because the marketplace is continually shifting in this space, and the differences between the three are quite

minimal. However, you will see this kind of technology offered under a variety of names. Lambda/lightjet/chromira prints are interesting because they use the same chemicals and paper as the traditional C41 process. Your digital print is literally a photograph. Instead of using the light from an enlarger to expose the image, a Lambda/lightjet/chromira printer projects your digital file onto the paper. Combine this with the popular Fuji-Crystal archive paper and you'll have a print that can be hung on any museum or gallery wall.

Speaking of archival images, one of the reasons photographers get their prints printed professionally is the potential archival limitations of home printing. Done correctly, professional inkjet, Iris, and Lambda/lightjet/ chromira prints can provide archival images. See Wilhelm Imaging Research's excellent web site (*http://www.wilhelm-research.com*) for information on the longevity of the various digital printing methods.

Professional digital output is a great way to print your digital images, and many film photographers are now using it to print negatives and slide film. You read that right; because of the advanced optics of scanners and the fact that the image is digitally exposed directly to paper, film photographers are discovering that their images can be sharper and clearer, even though the source is film. Another advantage of digital printing for film photographers is that they have access to Photoshop, a far more capable editing tool than your typical analog enlarger. So, you too can consider using digital printing for your negatives and chromes.

Final Thoughts

Using either scanned film or digital camera files, a service bureau can take your images to the next level in professional presentation. Ask photographers in your town for recommendations on bureaus they use, and start building a relationship with a service bureau. Your prints will thank you.

—*Hadley Stern*

H A C K **Take Your Slideshow on the Road**
#54
If you go to all the trouble to make a digital slideshow, how are you going to share it with others who are far away? Are you going to lug your computer to every family member you know? Here's how to take your show on the road, while leaving the computer at home.

Nearly every digital-imaging application on the market enables you to make slideshows, and for good reason. Digital slideshows are much more interesting than their lumbering predecessor: the Kodak Carousel projector snooze-

a-thon. Today's version of this ancient art of vacation debriefing is more tightly constructed and capable of including special effects, music, and voiceovers.

The problem with digital slideshows is that people don't know how to share them easily with others, especially with audiences who use a different computer operating system. Yes, you could cart your computer to the far corners of the planet in search of audiences for your presentations. Or, you could build slideshows that are so portable they could be attached to an email and sent to family members on the other coast. I'm going to show you how to do the latter.

The key to this portability is tapping the power of QuickTime, that venerable collection of multimedia tools that work equally well on Windows and Macintosh computers. Anyone can play QuickTime content by using a free player. This technology has become so ubiquitous that your camera even uses it to handle its movie-making function.

If, perchance, you don't already have the QuickTime Player on your computer, look on the software disc that came bundled with your camera and load it up. Or, you can download the latest version at *http://www.apple.com/ quicktime/*.

Since you'll also be authoring content instead of just viewing it, I recommend you upgrade to the Pro version for US$30. This takes only a couple minutes at the QuickTime web site. You'll receive a registration key that unlocks the editing capabilities of the application. Now, you're ready to dive into this hack, as well as many more that follow later in this chapter.

Okay, back to slideshows. If you really like the authoring tool you have now, take a look to see if it has an Export to QuickTime option. If it does, you're in business. Figure 5-11 shows this option in iPhoto on Mac OS X. Build your slideshow as usual, and then export it to QuickTime. All your images and music (if you've added any) will be bundled into one file. You can play that file on your computer by simply double-clicking it, attach it to an email and send it to your friends, or post it on your personal web site. It is now extremely mobile.

If your existing authoring program lacks the functionality you need, take a look at LiveSlideShow (*http://www.liveslideshow.com*) by Totally Hip Software. It comes in both Mac and Windows versions and allows precise control over every aspect of the presentation. LiveSlideShow includes a variety of professional transitions and the ability to add music and other effects. You can buy the boxed version for US$50 or download it for the same price.

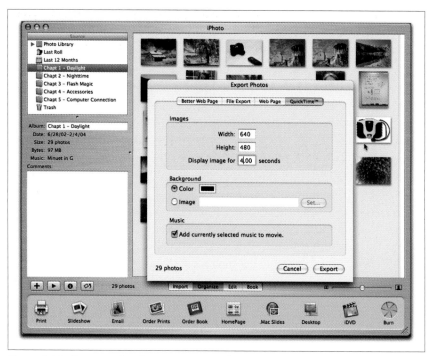

Figure 5-11. Export to QuickTime option in iPhoto

You can also build your slideshow directly in QuickTime Pro in just four easy steps:

1. *Assemble your images.* Choose the pictures you want and give them a common name followed by a number—for example, *vacation01*, *vacation02*, and so on. Put them in a folder. QuickTime will read these images in the order in which they are numbered. Be careful at this stage, especially if you're a Windows user. Because QuickTime for Windows is picky about file naming, if you don't follow this format, QuickTime won't generate the slideshow. Make sure all of the file dimensions are the same—I recommend 640 × 480 pixels—and that your file labeling is consistent.

2. *Use the Image Sequence command.* Launch QuickTime Pro and select Open Image Sequence from the File drop-down menu. You'll be greeted by a dialog box that lets you navigate to the folder that contains your pictures. Open the folder, click on the first image in the folder—for example, *sample01*—and click on the Open button, as shown in Figure 5-12.

3. *Choose the frame rate.* A second dialog box appears, providing you with the option to choose how long each image will appear on the screen. I recommend four seconds per frame as a starting point.

4. *Save as self-contained.* QuickTime will build your slideshow and present you with a final dialog box that asks you to give your slideshow a name. Enter the name and click the "Make movie self-contained" button.

Figure 5-12. Using the Image Sequence command in QuickTime for Windows

You're now ready to play, share, or continue to mess with your slideshow. If you want, you can add music [Hack #59] or voiceover [Hack #60].

Virtual-Reality Movies from Your Digicam

HACK #55

You can create a virtual-reality (VR) movie with the most basic of digicams. You just need to know how to stitch things together.

"Get the Big Picture with a Panorama" [Hack #19] showed how to stitch together a series of images to make a wide panorama of a scene. This technique conveys the grandeur of impressive sites such as the Grand Canyon much better than a single snapshot. With panoramas, you can make prints or simply view the wide pictures on your computer screen.

But there's more treasure to mine here. One of the most exciting byproducts of digital photography is a technique called *virtual reality* (VR). In its

simplest form, a photographer puts his camera on a tripod and takes a series of pictures in a complete 360° circle around him. You use the same technique for capturing these images **[Hack #19]**, but instead of stopping at 120° or 180°, you keep taking pictures until you've completed a full circle.

For a gallery of examples to play with, go to the Cubic VR Gallery (*http://www.apple.com/quicktime/gallery/cubicvr/*). You'll need QuickTime installed on your computer. Chances are, you already have it. If not, you can download it for free at *http://www.apple.com/quicktime/download/*.

Creating Your Own VR

Many cameras include bundled software to stitch your panoramas together. For example, Canon cameras come with PhotoStitch. Not only can you stitch your images together for a beautiful wide photo, but if you shoot a complete circle of images, you can also export your panorama to a Quick-Time VR movie, as shown in Figure 5-13.

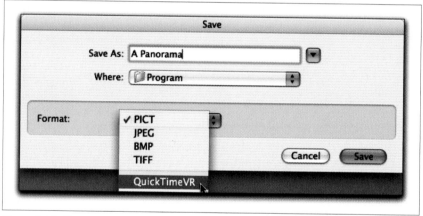

Figure 5-13. Exporting a panorama to a QuickTime VR movie

After the images have been converted to a VR movie, you no longer view them in a traditional image editor such as Photoshop Elements. Your movies are now "played" in the QuickTime Player, where you can spin around in a circle just as if you were standing there in real life, looking around at the scenery.

You can send these movies to friends as email attachments (be sure your friends have enough bandwidth to download them), or you can post them on your web site for everyone to enjoy. They are truly spectacular.

If your camera didn't come with software for saving your 360° panoramas as QuickTime VR movies, there are some affordable third-party solutions out there. For example, ArcSoft makes a lovely tool called PanoramaMaker (*http://www.arcsoft.com/en/products/panoramamaker/*) that is effective and easy to use. It runs on both Mac and Windows and sells for US$40. You can download a demo version and give it a spin, so to speak.

When you first launch the application, select which type of panorama you want to make. Choose 360°, as shown in Figure 5-14. This tells the program to prepare your series of images in such a manner that they will export easily to the VR format. Now click the Next arrow, which takes you to a screen where you add the series of photos that will comprise the VR movie. Make sure your photos are in the proper sequence, add them to the time-line, and then hit the Next arrow to stitch them together and build the sequence. Now, all you have to do is click the Export button, and PanoramaMaker will build your VR movie and save it for you. Amazing!

Figure 5-14. Creating a QuickTime VR movie in PanoramaMaker

If you've been using the PhotoMerge function in Photoshop Elements to create your traditional panoramas, you'll be disappointed to discover that it does not have an option to export to QuickTime VR. I looked at some Photoshop plug-ins that might solve this problem, but I didn't find anything as

effective, cheap, or easy to use as ArcSoft's PanoramaMaker or the software bundled with your camera.

Virtual-reality movies are truly impressive, and possible, with any digital camera. Just apply a little computer magic, and take the world for a spin.

HACK #56 Digicam Movie Editing Made Easy

Almost all point-and-shoot digicams capture video footage in addition to still photos. But how do you turn those short snippets into your own personal movie?

If it comes down to a choice between bringing along a camcorder or a digital camera, I'm going to choose the camera. Even though I enjoy shooting video, I like still photos even more. Plus, digital cameras are smaller, and managing pictures is easier than dealing with hours of video.

But there are times when I also want to capture a few snippets of video. Certain special events—such as a speech at a wedding, a greeting from an old friend, or a child's first steps—are communicated better with moving pictures and sound. Fortunately for us, most digital cameras have a respectable Movie mode, and some even have great ones.

The problem is, once you have captured the footage in your camera, what do you do with it? Before I answer that question outright—and I will—let me explain the difference between the video your digicam captures and the footage from a digital camcorder.

These days, most people shoot video with a digital video (DV) camcorder. DV is becoming the format of choice. Once you record your movie clips, you can plug the camcorder into your personal computer and an application on your computer launches, ready to download and edit your footage. On the Windows platform, you might use Microsoft's MovieMaker; on the Mac, you could use Apple's iMovie or Final Cut Express.

But when you plug in your digital still camera, these applications don't seem to recognize it, even when it's full of video. One of the reasons for this is that you're probably plugging your still camera into a USB port, while your camcorder uses the FireWire port. Most video-editing applications look for devices connected via FireWire. But that's not the only difference.

Digital camcorders typically record in the DV format. Your digital still camera is using a completely different format, such as Motion JPEG OpenDML, which is an extension of the AVI file format. You can play these files on your computer by using QuickTime Player; in fact, this format is part of the QuickTime media layer. That's why almost every digicam under the sun provides you with QuickTime on its bundled CD.

Playing the files is one thing, but hooking them together and editing them is another altogether. If you can't use the DV-editing software that came with your computer, then what do you do?

In this hack, the answer is QuickTime—the Pro version, that is. Sure, the free QuickTime Player you download from Apple lets you *watch* the movies. But the Pro version you buy online lets you *edit* them too, plus do a lot more. QuickTime Pro is an extremely versatile digital-media application. But for the moment, we'll focus on editing, stitching, and trimming.

The first thing you need to do is transfer the movie files from your camera to your computer. If you don't know how to do this already, you'll have to crack open your owner's manual. Every camera/computer combination is a little different. If you're lucky, your camera has what is referred to as *Mass Storage Device connectivity*. That means it appears on your computer like a regular hard drive. Nikon, Olympus, and Kyocera cameras usually have this feature. In those cases, you simply open the "hard drive," drag the movie files out, and save them on your computer. In case you don't know which ones are the movie files, they will usually have an *.AVI* extension.

Now you need to purchase the Pro version of QuickTime. Go to *http://www.apple.com/quicktime/* and click Upgrade to QuickTime Pro. You'll receive a software key that unlocks the Pro features in the Player version of Quick-Time.

Now you're in business. You need to learn only three commands in Quick-Time Pro to edit your movies:

Trim

> This command enables you to snip off the yucky stuff on either end of your movie. Simply move the bottom triangles on the scrubber bar to the endpoints of the content you want to keep, as shown in Figure 5-15. When you then go to the Edit drop-down menu and select Trim, the gray area will be kept and the white area will be trimmed away. You've successfully snipped off the content you didn't want to keep.

Add

> Most digital cameras allow you to shoot only a few minutes of video at a time. So, to construct your movie, you have to combine these short clips into a longer presentation. Use the Add command for this purpose.
>
> The procedure is similar to copying and pasting in a text document. First, move the bottom triangles to select the section of the video you want to copy. Then, go to the Edit drop-down menu and select Copy. That will put the snippet on the clipboard.

Figure 5-15. Editing in QuickTime Pro

Now, open the snippet to which you want to add the copied content. Move the top triangle on the scrubber bar to the end of that clip; then, go to the Edit menu and select Add. The video you copied to the clipboard is now added to the second snippet, including the sound that was recorded with it.

Make Movie Self-Contained

Once you've built your movie from the snippets you captured with your camera, choose the Save As command from the File drop-down menu. Give your movie a name, and be sure to click on the Make Movie Self-Contained button. This will *flatten* all the layers you've added into one movie, without any dependencies.

Congratulations! You've now made your first featurette from short clips captured with your digital still camera. Regardless of the platform on which you created the movie, you can play the movie on both Mac and Windows. If you want, you can even burn it to CD and share with friends.

To help you make the best minimovies possible, here are a few shooting tips:

- Capture all your video at the same frame rate, preferably 15 fps (frames per second) if possible.

- Hold the camera steady and don't pan. Since you can't lock in the exposure when shooting video with most digicams, you don't want lighting changes in your shots. The camera will try to adjust, creating annoying lighting shifts. Instead, focus on your subject, shoot 15 to 60 seconds of video, and then pause. Set up your next shot and go from there.

- Don't use Automatic White Balance. You could get color shifts in the middle of your clip, which you will find most annoying. Instead, choose one of the presets, such as Cloudy, to lock in the white-balance setting.

- Frame your subjects tightly, as shown in Figure 5-15. Digicam movies are usually only 320×240 pixels in dimension, so you can't afford to stand back too far; if your frame is too wide, your viewers won't recognize the subject.

- Beware of the microphone port. It's usually close to your fingers. Don't cover it up or run your hand across it while recording.

Now it's time to go shoot something and combine those clips into a movie. Look out, Martin Scorscese!

HACK #57 Rotate Your Movie from Horizontal to Vertical

Who says you have to shoot all your movies horizontally? Just as with stills, sometimes it's fun to turn the camera on its side. But when you upload your movies to your computer, they're turned the wrong way! Here's how to fix that.

When making movies with your digicam, you don't want your compositions limited any more than you do when shooting stills. Imagine if someone told you that you could shoot only horizontal pictures for the rest of your life. You'd tell them where to go stick their memory card.

The problem with movie making is, you might shoot your video with a vertical orientation, but when you upload the snippets to your computer, everything is horizontal. And 9 out of 10 chiropractors will tell you not to crane your neck sideways to watch these movies.

Fortunately for the health of your entire viewing audience, there's a simple fix. After you upload the video to your computer, open a snippet in Quick-Time Pro, the versatile movie viewing/editing application [Hack #56]. It doesn't make any difference whether you're working in Windows or on a Mac; the procedure is the same.

From the Movie drop-down menu, choose Get Movie Properties. You've just tapped into one of the most powerful areas of QuickTime Pro. There are two drop-down menus at the top of this dialog box. From the left one, choose Video Track, and from the right one, select Size, as shown in Figure 5-16.

Figure 5-16. Making selections in the QuickTime Movie Properties dialog box

You'll see that the dialog box changes content and options as you choose different items from the drop-down menus. In this case, two of the goodies you can access are found in those rotation arrows in the lower-right corner. Click on the one that rotates your movie in the desired direction, as shown in Figure 5-17. Like magic, your movie and its controls are now oriented the way you originally intended.

You can now edit, trim, and stitch together movie clips [Hack #56]. Of course, all of your movies have to be oriented the same way; otherwise, you'll get some strange-looking results.

There's something inherently interesting about a vertically framed movie. And it's an option I encourage you to try as appropriate subjects present themselves.

Figure 5-17. Rotating a movie in the QuickTime Movie Properties dialog box

Create a Rolling Movie Title

A cake isn't really dessert without icing, and a movie isn't complete without titles. Here's a simple way to create tasty Hollywood-style rolling credits.

We've been working in QuickTime Pro for the previous movie-editing hacks [Hacks #56, #57]. QuickTime is featured in this book for a number of reasons. First, it's cross-platform, so Mac and Windows users are on equal footing. Second, it's extremely powerful for its cost (US$30). Third, it's essentially the native format that your digital camera uses to record movies, so why go through nasty conversions when you don't have to? But finally, and just as importantly, QuickTime is very hackable. This hack illustrates that point beautifully.

Rolling credits and titles are a Hollywood tradition. They have graced movies made by Charlie Chaplin to Woody Allen. And they can add a professional touch to your digicam videos just as well.

I'm not going to get into the various movie-editing applications that require you to convert your QuickTime footage just so you can add rolling titles. Instead, I'm just going to use QuickTime Pro and your favorite text editor.

Using Text Tracks

Text tracks are low-bandwidth, vector titles you can add to your movies. The QuickTime web site (*http://www.apple.com/quicktime/tools_tips/ tutorials/texttracks.html*) explains how to add text to your movies. The problem is, you can't easily control how the text looks by using the basic method that most tutorials describe.

But if you get into a wonderful, hackable, hidden feature in QuickTime called *text descriptors*, you can create just about any type of title your imagination can conceive. Think of text descriptors as tags that tell QuickTime how your title should look. You can see the entire list of these tags at Apple's web site (*http://www.apple.com/quicktime/tools_tips/tutorials/ textdescriptors.html*).

To put them to work for you, open Notepad, TextEdit, or your favorite text editor. Then, enter the following text:

```
{QTtext} {font:Arial Black} {bold} {anti-alias:on} {size:18} {textColor:
65535, 65535, 65535} {backColor: 0, 0, 0} {justify:center} {timeScale:300}
{width:320}{height:240} {language:0} {textEncoding:0} {scrollin:on}
{continousScroll:on} {scrollOut:on}
[00:00:00.000]
[00:00:02.000]
A Simple Movie Title
[00:00:08.000]
```

You'll only have to do this once. From then on, all you have to do is use Save As to create different rolling titles.

Once you've entered this information, save it as a *.txt* file. Then, open QuickTime and select Import from the File drop-down menu, as shown in Figure 5-18.

If you're working in Windows, you'll be greeted with a dialog box that allows you to navigate to your text file. Once you do, highlight it and click the Convert button. You'll be greeted with another dialog box. All you have to do is provide a new filename (it can be anything) and click Save. QuickTime will build the rolling title for you.

Mac OS X users follow a similar procedure. Select Import from the File drop-down menu, navigate to your text file, and click on the Open button. Figure 5-19 shows the complete title in QuickTime on Mac OS X.

Your rolling title is now ready to view. When you click the Play button on the viewer, you'll see "A Simple Movie Title" scroll upward. You can use the title as is, or you can trim off parts of it to shorten it [Hack #57]. Once you have the title edited to your tastes, copy it to the clipboard by choosing Copy from the Edit drop-down menu. Then, open the movie to which you want to

Figure 5-18. Using the Import command in QuickTime for Windows

add the rolling title. If this is an opening title, make sure the *receiving* movie is set at the beginning. Select the Paste command, and your title will now be placed at the beginning of the movie.

Customizing Your Title

If you want a different look, all you have to do is change the appropriate text descriptors, do a Save As, and import in QuickTime. For instance, if you want to add a credit line to your rolling title, it might look like this:

```
{QTtext} {font:Arial Black} {bold} {anti-alias:on} {size:18} {textColor:
65535, 65535, 65535} {backColor: 0, 0, 0} {justify:center} {timeScale:30}
{width:320}{height:240} {language:0} {textEncoding:0} {scrollin:on}
{continousScroll:on} {scrollOut:on}
[00:00:00.000]
[00:00:02.000]
```

Figure 5-19. The complete title, as shown in QuickTime on Mac OS X

```
A Simple Movie Title
[00:00:08.000]
by Derrick Story
[00:00:14.000]
```

The timestamp numbers that follow the text determine how fast the text scrolls. If you want to slow down the movement, make the timestamp longer. For example, go from [00:00:04.000] to [00:00:08.000].

If you prefer to have blue text on a white background, use these descriptors:

```
{textColor: 0, 0, 65535}{backColor: 65535, 65535, 65535}
```

Or, for black on a white background, use these:

```
{textColor: 16448, 0, 16448}{backColor: 65535, 65535, 65535}
```

You can also change font size, font type, and the width and height of the frame. It's amazingly easy and fast. Who needs a cumbersome user interface when you can author with a simple text editor? You can also add more descriptors. The complete list is online at *http://www.apple.com/quicktime/tools_tips/tutorials/textdescriptors.html*.

Final Thoughts

I usually make my rolling title and then trim it before adding it to my movie. One of my favorite tricks is to trim the title so that it stops in the middle of the screen instead of rolling off the top edge.

If you plan on putting your movie on DVD and playing it on a TV, be sure to leave plenty of elbow room on the outer edges of the letters. Televisions often show less viewing area, and your titles might be missing a few digits if they span the width of the frame.

Finally, keep your titles simple and brief. You certainly don't want the credits to last longer than the movie itself!

HACK #59 Add Music to Movies and Slideshows

Music makes everything better, especially in the background of your digital movies and slideshows.

If you don't think music makes a big difference in media presentations, just turn off the sound during a movie and see how interesting it isn't. "Sound is half the picture" is an old saying in Hollywood . This is just as true for your digicam movies and slideshows.

QuickTime Pro allows you to add as many soundtracks as you have the patience to manage. Generally speaking, movies have two soundtracks—dialog and background music—and slideshows have just one—background music. This isn't a hard-and-fast rule, however. You could, for example, add a voiceover to your slideshow **[Hack #60]**. But let's focus on background music at the moment. I'll use a slideshow as an example project.

After you create a digital slideshow **[Hack #54]**, you need to find some music to go with it. Just about everyone these days has a digital music collection on their computer, usually in the MP3 or AAC format. You can open any of these tracks in QuickTime Pro. If you don't have any music on your computer, it's easy enough to convert a CD you have in your collection by using a number of free digital jukeboxes available for download. I like iTunes, for both Mac and Windows, and you can download it (free!) at *http://www. apple.com/itunes/download*.

Once you've found the music you want to use, launch QuickTime and open your slideshow. Then, open your music in a second player, as shown in Figure 5-20.

See how long your slideshow is by playing it to the end and checking the timestamp to the left of the scrubber bar. Then, drag the bottom-right triangle on the scrubber bar for the music until the time reads the same, or perhaps one second less.

Figure 5-20. Selecting music to accompany a slideshow

Choose Copy from the Edit drop-down menu to copy the snippet of music to the clipboard. Then, click on your slideshow to bring it forward, move the top triangle on the scrubber bar to the beginning of the slideshow, and select Add from the Edit drop-down menu. That's all there is to it. Now, play your slideshow and enjoy the beautiful marriage of music and pictures.

If you later decide you want to remove your soundtrack and use another instead, simply go back to the Edit drop-down menu and choose Delete Tracks, as shown in Figure 5-21. You will be greeted with a dialog box that lists all the video and soundtracks that make up your presentation. Highlight the Sound Track selection and click the Delete button. Your music is now removed.

Delete Tracks is also handy for removing the ambient sound that you recorded with your digicam in Movie mode. Sometimes, you want to get rid of those scratchy sounds and replace them with music.

You can add as much music as you want. Your music will be added wherever the insertion point (the big top triangle) is positioned on the scrubber bar. If you make a mistake, don't worry. Just Undo or use the Delete Tracks command.

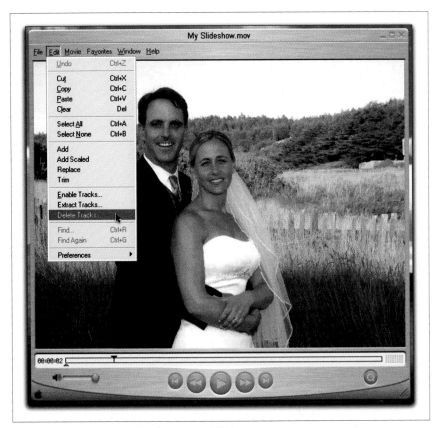

Figure 5-21. Removing audio from your slideshow

Here are a few hints to put you in the musical editor's driver seat:

Add music last. The soundtrack is usually the final step of production. Create and add your titles, credits, and other elements first, and then add the music so that it can span the entire length of the presentation.

Adjust the volume. If your music is too loud or too soft, simply select Get Movie Properties from the Movie drop-down menu. In the top-left menu, select Sound Track, and in the top-right menu, choose Volume, as shown in Figure 5-22. You can now increase or decrease volume, bass, and treble by simply dragging on the colored areas.

Choose music in rhythm with the pictures. Slideshows that change images every four seconds closely approximate a 4/4 beat in music. Try to pick music that moves at the same rate as your pictures. It gives your presentation that extra professional touch.

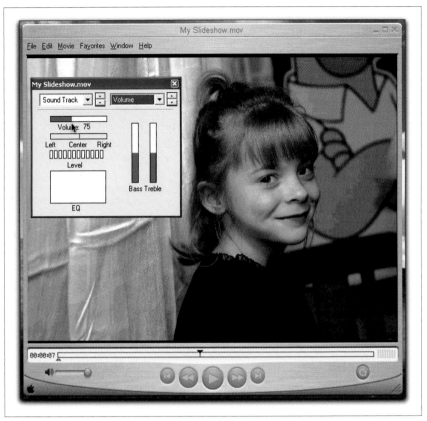

Figure 5-22. Adjusting the volume of your soundtrack

One final note: if you created a slideshow or movie in another application, then exported it to QuickTime, you can edit that presentation directly in QuickTime Pro. You don't have to go back and recreate the work in the original application. Quite handy, isn't it?

HACK
#60 Voiceovers for That Professional Touch

A picture is worth a thousand words. But sometimes, you need 1,020 words to communicate what's going on. That's when it's time to step up to the mic and create a voiceover track.

A *voiceover* is simply an additional audio track for your digital slideshow or movie, in which the narrator speaks directly to the audience. If you've ever watched a nature show on public television, you know what a voiceover is.

Creating the Voiceover

Voiceovers can add a professional touch to your presentations and, believe it or not, they're not that difficult to create. The first step is to find a way to record your monologue. One route is to use digital recording software for your computer. All you do is talk into your computer's microphone, and the software records your voice and saves it to the hard drive as an audio file.

You don't have to spend much money for this software. For Windows, take a look at Easy Recorder (*http://www.sell-shareware.com/easyrecorder/*). I like QuickVoice (*http://www.quick-voice.com/quickvoice/*) for Mac OS X users. Each application sells for US$20. Save the files in either QuickTime or MP3 format, which will enable you to assemble the presentation in QuickTime Pro [Hack #59].

You can also use a standalone voice recorder, which I like a little better, actually. I have the best luck creating accurate voiceovers that synchronize with the presentation when I can play the slideshow or movie on the computer (with the audio turned off) and simultaneously talk into the microphone of the digital voice recorder to describe what's going on. Then, I simply upload the digital audio file to the computer, add it to the presentation, and everything is in sync.

If you have a powerful enough computer, you can use this same technique by having the presentation play in one window with the voice recorder software turned on in another. Or you can use two computers.

I've had good luck using an Apple iPod (not the mini version) with a Belkin iPod Voice Recorder. I just talk into the iPod while in the field or while watching the presentation on the computer, and then add the digital audio file to the pictures.

Adding the Voiceover to the Presentation

Once you've captured your monologue, adding it is easy. If you've read the other hacks on building slideshows [Hack #54], editing movies [Hack #56], and adding music tracks [Hack #59], you know that I'm using QuickTime Pro for these projects. QuickTime also makes quick work of adding voiceovers.

Open your slideshow or movie and drag the insertion pointer on the scrubber bar to the point in the presentation where you want the voiceover to begin. For this example, I want to describe a series of shots inside Grand Central Station in New York City. I drag the insertion point to the first slide in that series. I then open my voiceover track and move the two bottom triangles on the scrubber bar to select the portion that talks about Grand Central Station, as shown in Figure 5-23.

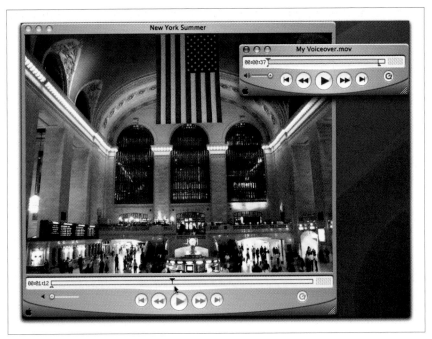

Figure 5-23. Adding voiceover to a digital slideshow

Then, I simply go to the Edit drop-down menu and choose Copy to put the voiceover track on the clipboard. I then click on the slideshow to bring it forward, go to Edit, and choose Add. QuickTime will add the additional audio track, beginning at the location of the insertion point.

If you already have a music track added to your slideshow, you might want to adjust the relative volumes between the music and the voiceover. Generally speaking, you want to lower the volume of the music and increase the presence of the voiceover. This is easily handled in QuickTime Pro.

Select Get Movie Properties from the Movie drop-down menu. In the top-left menu, select Soundtrack 1 or Soundtrack 2. In the top-right menu, choose Volume, as shown back in Figure 5-22. You can now increase or decrease volume, bass, and treble by simply dragging on the colored areas. Most likely, Soundtrack 1 will be your background music, because you added it first.

Lower the volume on the music and increase it for the voiceover, if necessary, until you get the balance you want. Then, use the Save As command to save your new presentation as a *self-contained movie*, which adds all of your various audio and video tracks to one self-contained QuickTime file that can be played on any Windows or Mac computer.

Your presentation might not turn out like an edition of Animal Kingdom, but I guarantee you that your audience will be impressed.

Store Pictures and Movies on an iPod

Yes, iPods make terrific digital music players. They're also not so bad for storing movies and pictures from your digicam.

When I hit the pavement for street shooting or the trail for an afternoon hike, I usually have my digital camera and iPod tucked away in my backpack. I bring the camera for obvious reasons, but recently, the iPod has become just as important.

Yes, a little music is sometimes the perfect antidote to the relentless din of street noise, not to mention the fact that when I have my ear buds in place, fewer oddballs bother me. The iPod also stores all of my calendar information, in case I run into a friend who wants to schedule a lunch. It also holds handy reference notes, such as important restaurant locations and other vital statistics. Just about anything I can read on my computer can be transferred to my iPod. In fact, I recently read an article that reported that the dailies for the *Lord of the Rings* trilogy were whisked around the globe on an iPod.

The 40 GB hard drive in my iPod is as big as the drive in my laptop. I have quite a bit of music, but that's not why I bought an iPod with such a big drive. The real reason is that I can upload movies and photos from my camera's memory card directly to the iPod. That means that as long as I have batteries to power my camera and two memory cards with me, I can shoot until my shutter finger cramps up in lactic-acid misery.

This scenario became particularly appealing when I got hooked on shooting movies with a Contax SL300R T* pocket digicam (*http://www.kyoceraimaging.com*), shown in Figure 5-24. Even though it weighs just a tad more than four ounces and fits in the palm of my hand, it can record full-frame (640×480) movies at up to 30 frames per second (fps); that's the same frame rate as a dedicated digital camcorder. If you're interested in this amazing functionality but want to save a few bucks, check out the Kyocera Fine-Cam SL300R, which uses the same technology but costs less than the Contax.

This bit of movie magic is enabled by RTUNE™ technology that allows the camera to write directly to a high-speed Secure Digital (SD) memory card until the card is full.

The Contax also shoots still images at three frames per second until the memory card fills up.

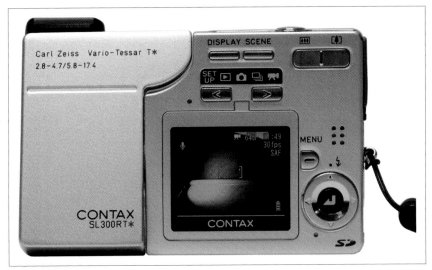

*Figure 5-24. The Contax SL300R T**

Needless to say, at 30 fps, or even 15 fps, it doesn't take long to fill an SD card. So, I either had to invest a small fortune in memory cards, or find another solution if I wanted to continue my obsession with digicam movies.

The other solution turned out to be the Belkin iPod Memory Reader (*http://www.belkin.com*), shown in Figure 5-25. This device plugs into the iPod's Dock Connector (but not the iPod mini) and can accommodate five different types of media: CompactFlash (types 1 and 2), SmartMedia, Secure Digital, Memory Stick, and MultiMediaCard. You take the media out of the camera and upload its contents to the iPod while you insert your second memory card into the digicam and keep shooting. When the day is done, plug the iPod into your computer and upload all those photos and movies via the fast FireWire connection.

At the time of this writing, 256 MB high-speed SD cards cost about US$90. The Belkin reader runs US$100. So, for about the price of one memory card, I can add gigabytes of storage to my digital camera.

You might be wondering why I carry two memory cards instead of just one. Unless you want to hang out and have a cup of coffee during the upload process, you'll need that second card to keep shooting. The Belkin might be convenient, but it isn't fast. I tested its speed by shooting a full-frame video at 30 fps with the Contax using a SanDisk Ultra II 256 MB SD card. I kept shooting until I got the "memory card is full" message, then inserted the card into the Belkin and initiated the upload. I timed the process with a stopwatch, and it took a whopping 10 minutes to complete the transfer.

Figure 5-25. The Belkin Memory Reader with CompactFlash card and iPod

You probably don't want to wait that long before you start shooting again, so I suggest you carry one, maybe two extra memory cards so that one can be uploading while you're shooting with the others. The good news is that you can put the iPod and media reader in your backpack during the transfer process and keep moving.

In case you're curious, it took only 16 seconds to upload that same 256 MB of video from the iPod to the computer via the FireWire connection. Don't you just love bandwidth?

It's true; you'd go crazy trying to shoot a full-length feature movie with this rig. But the Belkin iPod Memory Reader does provide you with a reliable backup solution while you're on the go. And, thanks to the ample hard-disk space in the iPod, you can shoot many memory cards' worth of video and pictures before having to retreat to your computer.

Photoshop Magic
Hacks 62-74

If you've ever attended a Photoshop class or seminar, you know that Photoshop means many different things to different people. The problem with many of these workshops is that you, the digital photographer, must endure detailed explanations about techniques for graphic designers, web producers, and fine-art artists. All you wanted to learn was how to straighten a crooked picture.

This chapter is by no means an exhaustive survey of Photoshop technique. But everything here is meant just for you, the digital photographer. I asked all the contributors to this book, digital photographers themselves, to give me one or two of their must-know Photoshop hacks. And of course, I've added a few of my own favorites too.

Just like everything else we've covered here, these techniques work equally well on both Windows and Macintosh computers. Sometimes, you'll see a Windows screenshot, sometimes one from a Mac; it doesn't matter, the technique is the same. Regardless of which platform you prefer, we're here to help you master image editing on your computer.

Also, when I refer to *Photoshop* generically, I mean that the technique works for Photoshop 7 (the older pro version), Photoshop CS (the current pro version, US$650), and Photoshop Elements (the current hobbyist version, US$80). Many of the hacks in this chapter work with all three versions. If I show you something that works only in Photoshop CS, I'll point that out clearly and refer to the application as *Photoshop CS*.

If you're serious about digital photography, I recommend you invest in one of the three versions of this excellent image-editing application. I realize that $80 here and $30 there add up to some serious money. But Photoshop is one of the two core applications that I consider essential for digital photographers. (The other is QuickTime Pro, used extensively in Chapter 5.)

So, for the moment, put down your camera and put your hand on the mouse. It's time to talk shop for photographers—Photoshop, that is.

Match Resolution to Output

#62 Image resolution remains one of the great mysteries to hobbyist photographers; there's one setting for computer viewing and another for print output. Here's how it works.

I can't resist starting this chapter with an anecdote. Usually, I wouldn't, but I feel that this story sets the tone for the entire chapter.

About a year ago, after teaching a two-hour digital photography seminar, I was fielding questions from attendees while packing up my equipment. One gentleman approached me and said, "I have just one question for you. How do I change the resolution of my pictures without changing their dimensions? I know there's one little thing I need to do, but for the life of me, I can't remember what it is."

This guy had patiently sat through an entire seminar, probably about stuff he already knew, just so he could ask this question afterward.

I reopened my laptop, launched Photoshop, and showed him the magic box that he needed to uncheck. His eyes lit up, he grabbed my right hand, and he shook it vigorously. "Thank you, thank you!" he exclaimed and ran out the door. Most likely, he headed directly home and went to work.

For me, that experience sums up Photoshop for digital photographers. You know there's some way to accomplish everything you want to do, but for the life of Moses, you can't figure out half of them. Or, as in the case of my student, you can't remember what you already know. How to adjust picture resolution for printing falls squarely into that category for many photographers. This hack will solve that problem for you.

Your Camera's Resolution

Resolution is expressed in *dots per inch* (dpi) or *pixels per inch* (ppi). The higher the ppi, the more densely packed the pixels are, and the higher the resolution. Because of the inherent differences in various media, printing requires higher resolution than computer viewing.

Your digital camera is basically a miniature computer that contains a built-in scanner. It scans its images at 72 ppi. That happens to be the same resolution at which most computers display their images. So, going from digital camera to computer is like going from apples to apples. If you were always going to view your pictures solely on a computer, that would be the end of

this conversation. But chances are, you want to make prints too. Prints don't look so good at 72 ppi. The ideal printing resolution for photo quality starts at 200 ppi. So how do you get there from here?

Working with Image Size

Open your picture in Photoshop and find the Image Size command. In Photoshop Elements, the path is Image → Resize → Image Size. In Photoshop CS, the path is Image → Image Size.

You'll notice in the dialog box that Pixel Dimensions is the top section and Document Size is the middle area. Pixel Dimensions shows you the current size of the image at the current resolution. Chances are, the resolution is set to 72 ppi.

The Document Size box shows how big a print you can make at the current resolution. As shown in Figure 6-1, I can make a 31"×23" print from this four-megapixel picture. Though that's technically true, it wouldn't look very good printed at 72 ppi. That's just not enough resolution.

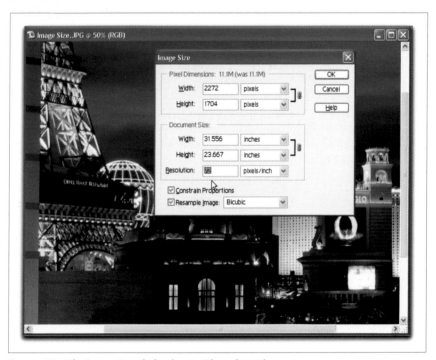

Figure 6-1. The Image Size dialog box in Photoshop Elements

I want a photo-quality print, so I'm going to change the resolution. But first, here's the secret: before you do anything else, uncheck the box labeled Resample Image, as shown in Figure 6-2. Now, enter 200 in the Resolution box. You'll notice that your previously impressive 31" ×23" print has shrunk to 8"×11". But it will look darn good.

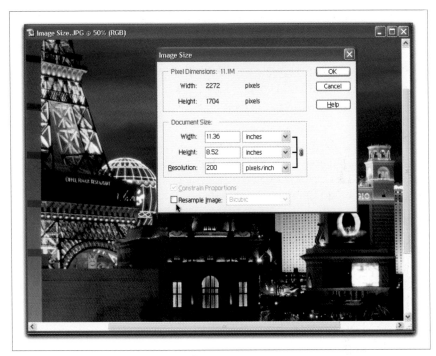

Figure 6-2. Changing the image's resolution

If you resample images when adjusting them for printing, Photoshop will add more pixels. You don't want Photoshop to do that, because it doesn't add pixels at the same quality as your camera records them. That's why you turn off resampling. Notice that the file size (listed next to the Pixel Dimensions label) stays the same when Resample Image is turned off. That's your best clue that you're doing this right.

I recommend you use the Save As command at this point and leave the original image alone. You can add *print* to the new filename to remind you that this version of the picture is for print output.

A Final Photo Tip

You saw how drastically the print size shrunk when I changed the resolution from 72 ppi to 200 ppi. You can fudge this process a bit by using 150 ppi, and you'll still get good-looking prints.

But the real point is to shoot at your camera's highest resolution so that you always have the option of making a reasonably sized print. The images in this hack were recorded with a four-megapixel camera set to the highest-quality settings for resolution and compression. I recommend you use those settings too, regardless of how many megapixels your camera has.

You can always make copies of the image and size them down for other uses [Hack #64].

HACK #63 Secrets of Sharpening

Every digital photographer knows that some pictures need a little sharpening, but few understand the best way to do it. Here's how.

I could tell you about the years of trial and error in which I've experimented with different sharpening settings, the countless articles I've read on the subject, or the debates in which I've engaged with other knowledgeable photographers. Or, I could just show you what I've learned through all those experiences. I'll give you the shortcut.

Regardless of whether you're using Photoshop 7, CS, or Elements, this hack works the same. The only sharpening tool I recommend is Unsharp Mask, which works its magic on the edges of the pixels by increasing their contrast. The more contrast, the sharper the image appears.

You'll need to use this tool after scanning and when you sample down a picture [Hack #64]. Unsharp Mask can also help when your picture appears a little soft because of less-than-perfect photo technique. But it can improve things only so much, so always try to record the sharpest image you can.

Apply Unsharp Mask as the last step in your image-adjustment process. If you apply it early, other adjustments could degrade its effect and you'll have to do it again.

First, open your image and choose Unsharp Mask from the Sharpen menu (Filter → Sharpen → Unsharp Mask). Make sure the Preview box is checked. You'll see a close-up sample of your picture in the preview box, as shown in Figure 6-3. If you want to see a close-up of a different area of the picture, just click the mouse button and move the mouse around inside the preview pane.

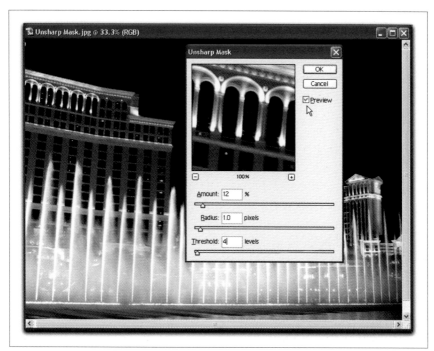

Figure 6-3. Unsharp Mask in Photoshop Elements

Enter these settings in the three fields of the dialog box:

Amount: 12%

Earlier, I mentioned that Unsharp Mask works its magic by increasing the contrast on the edges of the pixels. The Amount setting specifies the amount of contrast. Keep this setting low, around 12%. If the effect isn't strong enough, repeat the process. It's better to apply the filter three times at 12% than one time at 36%.

Radius: 1.0 pixels

As you apply these changes to the pixels in your image, they also affect the pixels adjacent to them. This is important to keep the picture looking natural and not too digital. The larger the number you set in the Radius field, the wider the band of adjustment that affects other pixels will be. You want to keep this setting at 1 or 2. Beyond that, your picture will lose too much detail.

Threshold: 4 levels

This setting looks at the amount of contrast between neighboring pixels and applies sharpening to them. If the setting is set to 0 (the lowest threshold), all the pixels in the picture get sharpened. If the setting is high—20, for example—only areas of the image with substantial

contrast between pixels get sharpened. A setting of 4 is a good starting point. If you leave the setting at 0, the default in Photoshop, every pixel edge will be sharpened. This can unduly increase image noise and make smooth areas, such as skin tones, look a little blotchy. The general range for this setting is between 2 and 20.

Click OK and inspect your picture. If you feel it needs a bit more sharpening, repeat the process or use the keystroke combination Ctrl-F, which repeats the last filter you applied. These settings are designed to maintain as much quality as possible while still producing the desired sharpening effect. You can apply them two, three, or even four times to a picture, as necessary.

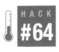

HACK #64 Sample Down for Email Attachments

Your high-resolution photos are perfect for printing but not so good for sending to Aunt Betty, who has AOL dial-up. Have mercy on Betty and learn to sample down.

We've all been there before: someone in the family gets a brand-new mega-megapixel camera, and the next thing you know, you have a slew of emails with 1 MB attachments. Your only salvation is to hope that Photoshop Elements came bundled with the new camera, so you can explain how to sample down those images for more reasonable email attachments.

I'll start with a 3.2-megapixel image shot at the highest resolution and quality settings on the camera. Its compressed file size on my computer is 1.5 MB—too big for sharing via email but nice for making an 8"×10" print.

To sample it down for publishing on the Web or sending via email, open it in Photoshop and choose the Image Size command (Image → Resize → Image Size in Photoshop Elements; Image → Image Size in Photoshop CS).

As shown in Figure 6-4, the dimensions for the picture are 2048×1536 pixels at 72 ppi. That's way too big to share online. Generally speaking, you want to sample down the image to 400×300 or 640×480 for attachments.

To change these dimensions, make sure the Constrain Proportions and Resample Image boxes are checked and then change the Width dimension to 640, as shown in Figure 6-5. Notice how the Height setting automatically changed to 480? That's because you had the Constrain Proportions box checked. Click OK.

I almost always sharpen an image a little after sampling down; for some reason, it seems to lose a little edge in the process. From the Filter menu, select Sharpen → Unsharp Mask. Change the Amount setting to 12% and leave the Radius setting at 1.0 pixels. The Threshold can stay at 0. Click OK and

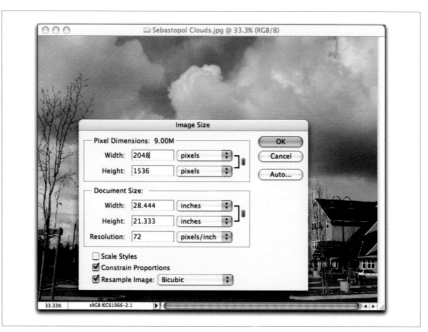

Figure 6-4. A full-size 3.2-megapixel image, too big for email attachments

Figure 6-5. The resized image, much more portable

examine the picture. If it needs another round, apply the same settings again. Your photo should now look crisp and clean.

Select File → Save As and give your picture a new name. You might want to add *lorez* or *email* to the title to help you remember that it's been sampled down. Keep your master safe and sound at full resolution so that you can make beautiful 8" × 10" prints when those requests come rolling in.

A second dialog box will appear, asking you to set the Image and Format options. I recommend a quality of 8 and Baseline Optimized, respectively, for these settings. Your picture will still have lots of quality but a much more reasonable file size. Click OK.

The new 640 × 480 version of the image is only 155 KB in size. That's quite a reduction from the 1.5 MB size of the original file. Plus, when your adoring audience opens the picture on their computers, it won't take over their entire screen.

There you have it: better family relations through sampling down.

HACK #65 Crop and Resample in One Step

Preparing a whole batch of images for a project such as a slideshow can be a laborious process at best. This hack shows you how to crop to size and resample, all in one swift motion.

When I have a whole folder of pictures that I need to adjust to the same dimensions and resolution, I just smile. That wasn't always the case. I used to curse, procrastinate, and question my decision to work on the darn thing in the first place. That was before I discovered hyperspeed cropping.

With this technique, you can resize your pictures to standard dimensions, such as 640 × 480, and change their resolution *at the same time*. It's high-speed cropping and image resizing, all in one.

Open the first picture in your batch and click on the cropping tool, as shown in Figure 6-6. You'll notice that a new menu appears on the top toolbar. This is a contextual menu that changes depending on the tool you select. There are three settings you can adjust here: Width, Height, and Resolution. The values for Width and Height are in pixels (px), and Resolution is in points per inch (ppi). I've entered 640 px, 480 px, and 72 ppi, respectively.

Now, all I have to do is drag the cropping tool across the image to select the area I want to keep, as shown in Figure 6-7. Notice how the selection area is constrained to the proportions that I set in the contextual menu. When I double-click in the selected area, Photoshop will crop the image to the dimensions I've indicated and set the resolution too, all in one stroke.

Figure 6-6. Entering the parameters for your speed cropping

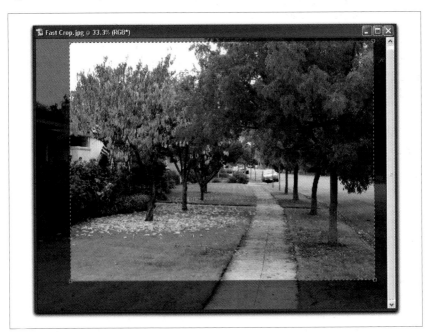

Figure 6-7. Selecting the area you want to keep

You can whip through an entire batch of pictures in just minutes by using this technique. Keep these few tips in mind:

- After cropping, use Save As to give the file a new name. You might want to add *crop* or some other description of the action to the filename to help you remember that this is a processed image. Always keep your original master safe and sound.

- When you're finished with the batch, be sure to hit the Clear button in the contextual menu bar. This will remove your custom settings, enabling you to crop at any size you want in the future.

- If you want to crop by inches or some other measurement, use that determiner in the Width and Height boxes. So, to make 4"×6" prints at 150 ppi, enter 4 inches, 6 inches, and 150 ppi, respectively. This is a great way to prepare a batch of images to send to a print service.

Most pictures need some sort of cropping to improve their composition. With hyperspeed cropping, you can do this quickly and resample at the same time.

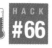 HACK #66 Level That Dipping Horizon

Wrangling with LCD viewfinders sometimes leads to less than perfectly level horizon lines. Thankfully, a hidden tool in Photoshop CS can straighten things out.

I know that my digital camera's LCD monitor isn't the best tool for lining up straight images. But I like that little television screen for so many other things, such as gauging exposure in real time, that I use it anyway. There are days, however, when composing a picture in the LCD feels like backing up a trailer into the driveway. I turn the steering wheel one way, and the trailer goes the other.

Even professional photographers using cameras mounted on tripods have problems composing scenes accurately. They might think they have a straight image, only to be unpleasantly surprised when opening the picture on the computer to see that the horizon line is dipping slightly to the right. Thanks to Photoshop, it's easy to straighten those images.

Figure 6-8 shows a horizon line that needs to be straightened. I can use the Rotate Canvas command to guesstimate the amount I need to adjust the photo, but it might not be accurate. And I'll have to keep guessing and cropping until I get the picture right. But there's a better way!

In Photoshop CS, there's a handy-dandy little ruler that will help you find accurate horizontal and vertical angles. What, you don't see it in the floating Tools palette? That's because it's hidden behind the Eyedropper icon.

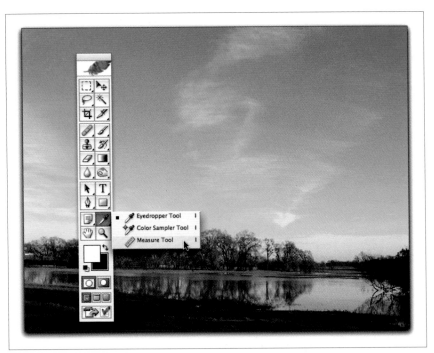

Figure 6-8. A crooked horizon doesn't have to stay that way

Click on the Eyedropper, hold down the mouse button, and you'll see a Color Sampler tool and a Measure tool. Select the Measure tool.

Using your mouse, place the tool cursor in your image window on one end of the line you wish to straighten and then drag it across to the other end of the line. When you release the mouse, the Measure tool calculates the angle needed to straighten the line. Photoshop remembers this angle.

Now, select Image → Rotate Canvas → Arbitrary. Photoshop automatically fills the angle measurement and direction of rotation in the dialog box. In fact, the dialog box displays the precise angle adjustment that is needed, as shown in Figure 6-9.

Click OK to straighten your image. Now, all you have to do is crop off the crooked corners, and it's just like nothing ever went wrong (see Figure 6-10).

This trick also works for straightening vertical lines, for those times when that lamppost looks as if it's leaning to the right or that skyscraper resembles the Leaning Tower of Pisa. From now on, use the Measure tool to keep everything on the straight and narrow.

—*Jan Blanchard*

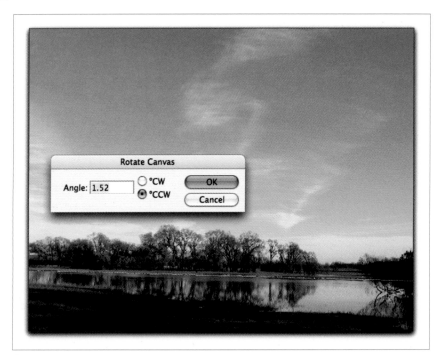

Figure 6-9. The precise correction amount, filled in for you

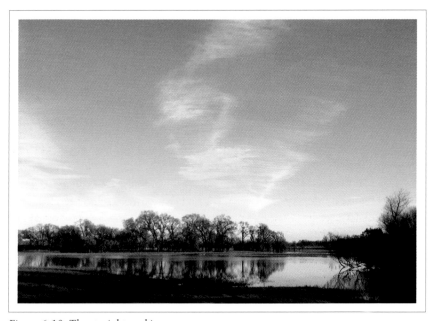

Figure 6-10. The straightened image

Power-Line Vanishing Trick

#67

The Clone Stamp in Photoshop Elements is a pretty good tool for removing unsightly wires from your scenes. Photoshop 7 and CS have an amazing piece of magic called the Patch tool. Either way, wires be gone!

Wires, wires, everywhere wires. Most folks might not realize just how many wires are strung around the landscape. But if you have a photographer's eye and enjoy shooting landscapes, you understand what I'm talking about. It can be challenging to find an interesting roadside shot that doesn't involve wires. Have you ever found that nearly perfect shot: nice landscape elements, beautiful colors, intense sky, and some magic light illuminating the entire scene? You hit the brakes, grab the digicam, and start clicking the shutter button. It's then you notice the wires crisscrossing the horizon. What do you do? Lament the unspoiled vistas of times past and give up?

Keep shooting! There's a Photoshop CS tool to save the day: the Patch tool. Prior to Photoshop 7 and still in Photoshop Elements, the Clone Stamp (rubber stamp) was the savior of choice to eliminate distracting elements. Even though it's amazing, photographers found it difficult to match subtle tone differences, in skies, for example, where power wires often reside. Then, Adobe added the Patch tool to enhance this type of retouching. And what a good addition the Patch tool is. It's faster and much better at blending subtle tones.

In this example, I was out for a roadside walk and heard the geese before I saw them. They were headed my way, in formation, on their way to their next feeding grounds. I started shooting, looking through the viewfinder, following them with the lens. After I loaded the images onto the computer, however, I noticed that some shots included unsightly utility wires, as shown in Figure 6-11.

Now, I have a few options for dealing with this image. I could just crop the wires out. But I don't want to do that, because I would lose precious sky real estate that I want to preserve. When there's motion in a composition, it's best to leave some room in front of the motion so that it has a place to go. If I were to crop out the sky in front of the geese, you would experience a feeling of claustrophobia when viewing the picture. Subconsciously, you might think, "they don't have any place to fly."

If I were working in Photoshop Elements instead of CS, the Clone Stamp would be the tool of choice. You'd think that those little ole wires would be easy to remove, but blue-sky tones are subtle, so they're difficult to retouch seamlessly.

Figure 6-11. Distracting wires, marring the shot's appeal

The trick with the Clone Stamp is to Option-click (to choose the area to clone from) as close to the wire as possible, as shown in Figure 6-11, to match your tones. Sometimes, this takes a bit of trial and error, but it can be done. In fact, for years, that was our only option.

But if you have Photoshop 7 or CS, select the Patch tool, which is located in the Healing Brush (Bandage) menu. Click and hold your mouse on the triangle in the Healing Brush tool to open the menu of hidden tools. Select the Patch tool, as shown in Figure 6-12. In the Tool Options bar (in the top menu) select Source. Place the Patch tool cursor near the area to be retouched and click, hold, and drag to select the entire adjustment area, just as you would make a selection with the Lasso tool. For best results, keep the selection area as small as possible, but make it large enough to include all of portions that need to be eliminated, as shown in Figure 6-12.

Once the area is selected, place the cursor within the selection area (the *source*) and drag it to another area of the picture (the *destination*) that is a similar match in color and texture. Release the mouse button to replace the source area with your destination area. Then, choose Select/Deselect. Photoshop doesn't just paint over the source area with the destination area; it

Figure 6-12. Patch Tool selection in Photoshop CS

actually blends together the qualities of the two areas—texture, brightness, and color—all while eliminating those unwanted wires. It's almost magical.

Alternatively, you can use the opposite process. Select Destination in the Tool Options bar. Drag the Patch tool cursor around a clean area, drag it to the area to be retouched, release the mouse, and deselect. The source area covers and blends into the destination area. This process is helpful when there are several similar areas to be retouched.

The Clone Stamp tool is still probably the better choice for areas with patterns, multiple colors, and textures. But when you can select similar source and destination areas, the Patch tool provides a quick, high-quality result. Try it the next time those dreaded wires intrude into your masterpiece.

—Jan Blanchard

H A C K
#68 ## Combine Two Pictures

The camera doesn't always reproduce faithfully what the eye sees. But Photoshop CS can help make your photos look like the real thing. Just take two pictures instead of one.

Sometimes, I need to take two pictures to tell one story. This often happens when I'm trying to recreate something that my eyes can see easily, but that

camera limitations prevent me from reproducing photographically. In part, this is because our eyes see the world differently than cameras do. We can see deep, detailed shadows and brilliant highlights at the same time.

Our cameras, on the other hand, make us choose between capturing one or the other, but not both. This is why many people become frustrated with photography and remark, while showing a disappointing print to someone, "Well, it didn't look like that when I took the picture."

The adept digital photographer can overcome these limitations by taking two pictures of the same subject—exposing one for the light tones and the other for the dark tones—and then combining them in Photoshop 7 or CS. I use this technique all the time to create illustrations that more closely resemble what my eyes observed in real life.

For example, take another look at the image shown in Figure 6-13 (last seen in Chapter 1) of a Flare Buster arm attached to the hot shoe of a digital camera. In real life, my eyes could see detail both in the camera and on the LCD monitor. But in the studio, the image on the monitor faded considerably, because the flash I used to illuminate the black camera wiped out the image on the LCD.

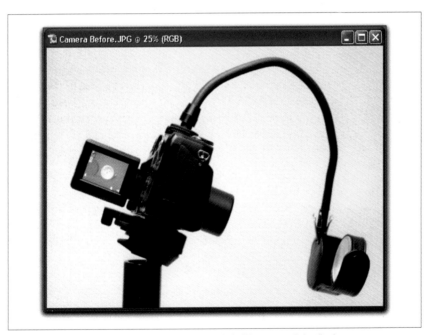

Figure 6-13. The image on the LCD monitor faded because of the flash

So I turned off the flash and took a second picture, exposing only for the LCD monitor, as shown in Figure 6-14.

Figure 6-14. Second picture exposing only for the LCD monitor

Now, we have to turn to Photoshop CS to complete the job. Open both images and select the entire first image (the bright one) by using Select → All. Copy the selection, click on the dark image to activate that window, and use the Paste command. When you do this, Photoshop automatically creates a second layer, as shown in Figure 6-14. Select Layer → Add Layer Mask → Reveal All. This tells Photoshop to create a layer mask for you.

Select the Brush tool in the Tools palette and select the diameter for the Brush. Make sure to select black as your painting color, as shown in Figure 6-15. Here comes the fun part. Paint on the areas of the picture where you want the bottom image to show through. As you paint, it magically appears. Now, I have good exposure for both the LCD monitor and the camera itself.

If you want to see the actual mask shown in red, hit the backslash (\) key to toggle on that option. I recommend you save your work as a Photoshop file (*.psd*) with the layers preserved. That way, you can go back to make adjustments, without having to start all over. You can use the Save As command to save the picture as a JPEG and flatten all the layers into one.

Figure 6-15. Use the Brush tool to let the parts of the bottom image show through

This technique works best when the camera is mounted on a tripod and kept in the same position during both exposures. That way, you'll have perfect alignment when you paste one image on top of the other.

Once you get the hang of it, you'll look at taking pictures in a whole new light. By knowing that you can use this technique to reproduce the shot as you saw it, you'll remember to take two pictures instead of just one. The first exposure is for the highlights; the second is for the shadows. Then, let Photoshop CS take it from there.

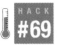

HACK Sponge Out Red Eye
#69

What works better than Visine for getting the red out? Photoshop's desaturating sponge is fast and effective, and it doesn't sting.

The ancients knew that red eye was caused from drinking too much Barolo, a wine so red it colored your teeth purple. We moderns like to think it has to do with dilated pupils looking directly at a camera whose flash is too close to the lens.

Of all the goodies Photoshop provides, it doesn't have one of those nifty automatic red-eye-removal tools, or at least there isn't one called out on the

floating Tools palette. Instead, Photoshop gives you a more powerful tool: the desaturating sponge. This hack will show you how to use it.

Why Desaturate?

Red eye is the reflection of the flash off the retina in the back of the eye. Typically, this happens in low-lighting situations, when the pupil is dilated. We want to neutralize the red retina, and let it go back to being the unilluminated body part it really is. That is, we want to lose all the color information, leaving it a dark, gray shadow.

But we don't want to lose any of those sparkling little highlights near it. Several generations of the Peale family became portrait painters who were famous for dotting the eyes of their subjects (such as George Washington) with a touch of titanium white, just to get the translucent effect of that catch light. Keep the tradition alive. Don't change the luminance; just change the color.

How to Desaturate

In any version of Photoshop, open the image that features your red-eyed subject. Click on the Sponge tool, and at the top of the contextual menu bar, choose Desaturate, as shown in Figure 6-16. Set the flow to 100% and pick a brush tip that's appropriate for the diameter of your subject's eyes. In the case of this little boy, 13 pixels seemed about right for the tip of the brush.

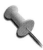
In Photoshop, the bracket keys ([and]) increase and decrease the size of the brush. You'll also want a soft-edged tip rather than a hard one. This somewhat blends the edges, so your edit won't be noticeable.

To help make your work a little more accurate in any image-editing software, set the cursor to display as the brush size. That makes it easy to size the brush to the red eye itself. In Photoshop, you can change this setting via the Display & Cursors preference box (Edit → Preferences → Display & Cursors).

Make sure your image is at 100% magnification, and use the desaturating sponge to paint the area that shows the red eye. Like magic, the red will disappear, but the rest of the eye will still look normal. You can see the difference after just a few seconds of work. When you've exorcized the red demon from your subject's eyes, save the image and move on to the next possessed photo.

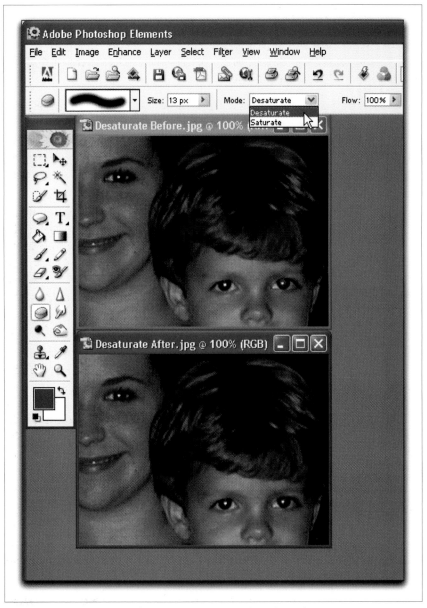

Figure 6-16. Setting up the desaturating sponge in Photoshop Elements

One thing the ancients had right was their appreciation for the simple things in life. This technique is one of them. It's a must-know technique for anyone who shoots flash pictures with a point-and-shoot digicam.

—*Mike Pasini*

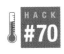

Brighten Teeth

It seems like everyone wants whiter teeth these days. You might not have the time for peroxide-based solutions, but there's no need for such drastic measures anyway. This Photoshop hack takes only a few seconds and instantly removes years of stains.

Most teeth, by design, have a slight yellow cast. Add coffee, wine, tobacco, and a host of staining foods, and the smile isn't quite as bright as it could be. In everyday life, this isn't a major issue. But for special portraits, a warm, inviting smile is important. This Photoshop hack is so easy, you'll wonder why you never figured it out before. As long as you show a little restraint with the technique, the results look quite natural.

First, open your portrait in any version of Photoshop. I'll use Photoshop Elements for this illuminating exercise. Use your favorite tool to select the teeth. I usually start with the Magic Wand. Click on a middle-toned tooth with the wand and see what it selects. By holding down the Shift key, you can make another selection to add to the first one. At this point, I switch to the Lasso tool to clean things up. You can add to the existing selection by holding down the Shift key and lassoing more areas. Or, by holding down the Option key, you can deselect areas that you don't want affected by the upcoming adjustments.

Now it's time to remove some of that natural yellow tint. In Photoshop Elements, open the Hue/Saturation dialog box (Enhance → Adjust Color → Hue/Saturation). The path is a little different in Photoshop CS (Image → Adjustments → Hue/Saturation). Choose the Yellow channel from the Edit drop-down menu and move the indicator on the Saturation slider bar to the left, as shown in Figure 6-17. This will desaturate the Yellow channel—or, in English, get rid of the stain.

I've found that setting the Yellow channel to somewhere between –70 and –80 does the trick nicely. Once you've toned down the yellow, select Edit → Master and move the indicator on the Lightness slider bar to the right, as shown in Figure 6-18. As you move the indicator to the right, you're brightening the teeth. Be careful with this adjustment, however, because you can overdo it and create an unnatural, super-bright smile.

Click OK to exit the Hue/Saturation dialog box and review your handiwork. You might want to hide the selection marker (known by Photoshop pros as the *marching ants*) to get a better look at the adjustment. Just press Ctrl-H or choose View → Selection. If you need to make further adjustments, reopen Hue/Saturation and give it another go.

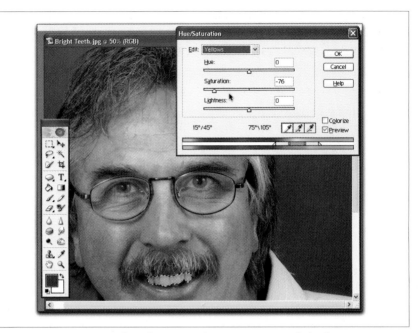

Figure 6-17. Desaturating the yellow tint in the Hue/Saturation dialog box

Figure 6-18. Using the Lightness control to brighten teeth

Once the smile is clean and bright, deselect the teeth by choosing Select →
Deselect. Then, use Save As to give the file a new name. You never know
when you might want to go back to the original portrait, so keep it in a safe
place.

Remember, the best corrections are the ones that look natural.

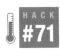

Intelligent Auto Color Correction

HACK #71 Photoshop CS includes a helpful Auto Color function. The problem is that it
needs to be calibrated. Here's a calibration how-to that reveals the secret to
fast color correction.

Our everyday world is a mishmash of lighting. We read at home by tung-
sten lamp, ride to work under overcast skies, and toil at the office beneath
fluorescent tubes. We normally don't think about all these different lighting
situations, because our eyes and brain automatically *correct* what we see.
Our environment, at least in terms of lighting, appears relatively consistent.

This isn't the case for digital cameras. As wonderful as their little computer
brains are, they're not as powerful as our human brains; they have a more
difficult time rendering the world in a consistent light. As photographers, we
can assist our digital cameras by taking care to set the white balance as accu-
rately as possible. But even with our best efforts, we sometimes need to cor-
rect the color in postproduction, to render skin tones and the overall
environment in the same light that our eyes perceive.

Color correction is one of the most difficult tasks in digital photography.
You can spend a lot of time fiddling with it and still not get the results you
want. This hack will change all that. By combining two handy functions in
Photoshop CS, you can correct color quickly and accurately, enabling you to
process an entire folder of images in short order.

The secret starts with opening the Curves dialog box (Image → Adjustments
→ Curves). Click the Options button to reveal a second dialog box. Enter the
settings shown in Figure 6-19 and be sure to check the "Save as defaults"
box. Click OK to close both dialog boxes, and save your image.

Open another image from the same batch of photos. This time, choose the
Auto Color function (Image → Adjustments → Auto Color). Photoshop will
use the settings you established earlier to correct the picture. Many times,
you'll be finished at this point, because the color correction will be close
enough for most tastes. If so, save the image and move on.

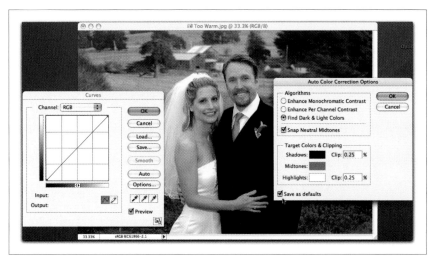

Figure 6-19. Setting your auto color defaults in the Options dialog box

If, however, the Auto Color function overcorrected your picture, making it too cool or too warm, you have a nifty option to back off a bit. After you run Auto Color but before you do anything else, enable the Fade command (Edit → Fade). Fade is one of those magical tools that, once you discover it, you'll use for a variety of purposes. Fade allows you to back off the last adjustment you made—in this case, color correction.

If you move the slide indicator all the way back to 0, the image will return to its original state (before you applied the color correction). If you leave the indication at 100, the full correction stays intact. But, if you move the indication to the left, from 100 toward 0, you'll see a percentage of the color correction that has been applied. So, if the original shot was too warm and the Auto Color correction was too cool, using the Fade command to back off the correction to 70% might be just right, as shown in Figure 6-20.

Once you find that sweet spot, use Save As to indicate in the filename that the color in the picture has been corrected. Once again, your world appears as it should.

Figure 6-20. Using the Fade command to back off the intensity of the last correction

HACK #72 Soften Facial Lines

You've taken great care to capture your subjects in the best light. But sometimes, artistic lighting accentuates facial lines. Here's how to soften them for a more natural look.

I know from experience that the best light for photographing people comes from the front. "Pro Portraits with Just Two Flashes" **[Hack #43]** discussed this technique in detail, and it's a lighting rule I follow most of the time—but not always.

Sometimes, I like the effect of illuminating from the side. Certain models have a personality that is better expressed by more dynamic lighting. The downside is that illumination from a side angle enhances texture. This byproduct doesn't thrill models when facial lines that weren't there before now appear.

So, how do I get my dynamic lighting and satisfy the model too? I could spend more time and money on equipment to produce just the right effect. But I'm cheap and like to work quickly. So I go with my instincts while shooting and use a little Photoshop magic afterward.

For example, I used only two lights to shoot the portrait in Figure 6-21: one from the front and a hair light from the top. We worked quickly and finished

the entire session in less than 45 minutes. By shooting at this pace, the model stayed fresh and brought plenty of energy to the camera. If I had spent a lot of time fiddling with the equipment, I might have lost her interest.

Figure 6-21. A two-light portrait

I really like this shot, but the side lighting does the model injustice by accentuating facial lines. She doesn't look like that in real life. Normally, you

don't see the smile lines on both sides of her mouth, but my lighting has created that effect.

Fortunately, this is an easy fix in Photoshop CS. I can use the Healing Brush to eliminate the lines and then apply the Fade control to make my fix look natural. Here's how it works:

1. Open the image in Photoshop CS and use the Zoom control to magnify it to 100%.

2. Select the Healing Brush tool from the floating palette. It's the one with the Band-Aid icon.

3. From the contextual menu, choose an appropriate diameter for the brush tip. In the Mode drop-down box, choose Normal, and for Source, click on the Sampled radio button. You're now ready to go to work.

4. Option-click on an area of skin that has the texture you'd like to see applied to the problem area. The Healing Brush is a texture-replacement tool. It puts the texture you want in place of what's already there and then matches the tones around it. This tool is really amazing.

5. Click on the area you want to retouch and drag the Healing Brush over the skin that needs to be fixed. The tool will read the area you Option-clicked in the previous step and apply that smoother texture to the area being repaired. This takes a little practice. If you don't like your first attempt, select Edit → Undo Healing Brush and try again. You might want to reposition your sampling area by Option-clicking on another part of the face. After a few tries, you'll get results that come close. And close is all you need, because the final step is the true magic of this hack.

6. Choose Edit → Fade Healing Brush. Make sure the Preview box is checked. You'll see a slider bar that goes from 0 to 100% opacity. It will be set at 100%, showing the full effect of the adjustment you just made with the Healing Brush.

7. Slide the indicator in Fade Healing Brush slowly to the left. You'll see your adjustment fade and the original skin texture begin to appear. If you go all the way to 0, her skin will look just like it did before you applied the Healing Brush. We want something in between. The goal is to soften the lines, not eliminate them altogether.

8. Find the opacity percentage that makes your model look attractive and natural and then click OK. Repeat this procedure on other areas of the face as needed.

After applying this procedure to a few areas of the face, I was able to restore the model to her natural beauty, as shown in Figure 6-22, before I subjected her to my harsh photographic lighting.

Figure 6-22. After applying Healing Brush with Fade control

If the model's teeth need a little brightening, use the technique described in "Brighten Teeth" **[Hack #70]**. The key to all these adjustments is *restraint*. You don't want to change the subject's appearance. Instead, you're trying to compensate for the ill effects produced by photographic lighting.

All of us like to see ourselves in a favorable light. By using good photographic technique and a little Photoshop magic, we can give that gift to friends, family, and clients.

HACK #73 Fix Flash Falloff

Built-in flashes on digital point and shoots sure are handy—that is, up to about eight feet. Here's how to brighten those dark areas when your flash runs out of juice before your subject does.

During the holidays and other social events, the setting is usually larger than our little flashes can cover. So, the people in the front of the scene get overexposed and the folks in the back fade to black. Thanks to a nifty tool in Photoshop called an *overlay mask*, you can correct this uneven treatment of your guests.

> You can use Photoshop Elements or CS for this hack. I'll work in Elements this time around, just to show how powerful this entry-level image editor really is.

After opening your picture, open the Layers floating palette, found in the Window drop-down menu. Select Layer → New Layer. Choose Overlay from the Mode pop-up menu and set the opacity to 50%, as shown in Figure 6-23.

Check your Tools palette to ensure that your foreground color is white and the background black. Then, click on the Gradient tool, as shown in Figure 6-24.

Use your Gradient tool to draw a black-and-white linear (rather than, say, radial) gradient straight up the image, from the brighter guys to the darker ones. Try to follow the flash falloff itself. You can begin your gradient off the image or in the middle of the image, wherever it works best. You can also redraw it until it's just right. It's just right when you have a dark mask over the bright area, fading evenly to white over the dark area. The image now looks much more evenly illuminated.

Click on the Background label in the Layers palette to highlight the background layer. Then, open the Levels dialog box (Enhance → Adjust Brightness/Contrast → Levels). Move the middle triangle to the left until the overall brightness of the scene is pleasing to the eye, as shown in Figure 6-25.

What an amazing difference between Figure 6-23 and Figure 6-25! It's like having a powerful flash that can light up the entire room.

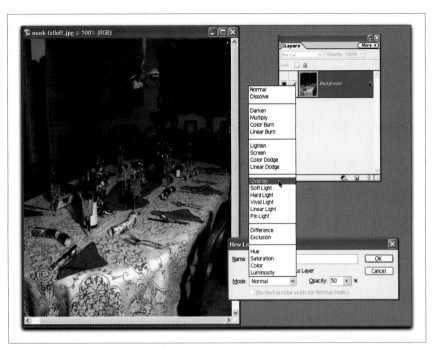

Figure 6-23. Adding an Overlay layer

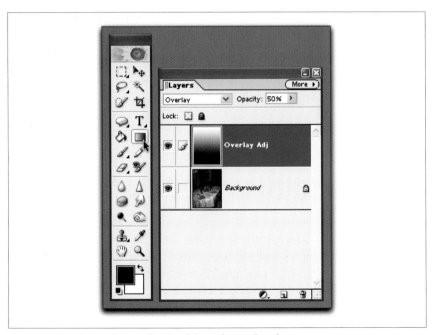

Figure 6-24. Choose the Gradient tool from the Tools palette

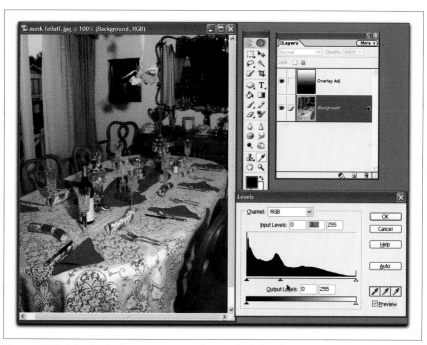

Figure 6-25. The final adjustment, using the Levels dialog box

Save the image as a Photoshop file (*.psd*). This will preserve the layers so that you can go back and readjust in the future if you wish. Then, select Save As and choose JPEG for the format. This will flatten the file (eliminate the layers) and reduce its size so that you can share it with friends and family more easily—especially those who were in the back of the picture and are now cast in a new light, thanks to your Photoshop prowess.

—*Mike Pasini*

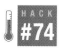

H A C K
#74
Hand-Color with the History Brush

Combining the richness of color and the mood of B&W photography, you can create eye-catching artistic effects. And with the History Brush in Photoshop CS, it's easy.

I always shoot my original images in color, even if the sole purpose of the assignment is to deliver B&W prints. Why? Because when you shoot in high-resolution color, you have a full complement of options available later in Photoshop. For example, you can always convert a copy of the photo to B&W, keeping the color original intact. Or, as in this hack, you can mix the two formats.

For this assignment, I want the image to have the artistic feel of B&W photography. I'm also interested in playing with hand-coloring to produce an unusual effect. By shooting the original photo in full color, I can use a little Photoshop magic to combine these looks.

For my source image, I selected a night picture of the Port of San Francisco, as shown in Figure 6-26. The clock tower dominates the foreground, and you can see the Bay Bridge off in the distance. Even though I like this photo in full color, I see some creative possibilities that might emerge by playing with it a bit.

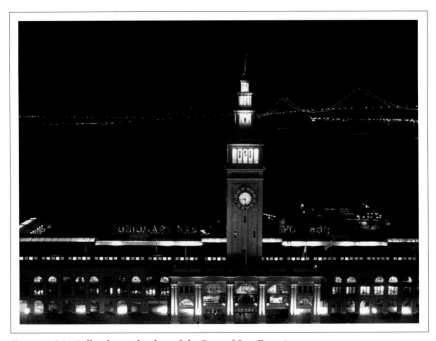

Figure 6-26. Full-color night shot of the Port of San Francisco

What I have in mind here is to desaturate the entire image, essentially converting it to a B&W photo. I chose to desaturate it instead of converting it to grayscale, because that way, I can retain all the RGB information. That information will provide me access to those channels later, when I'll be ready to return some color to the picture.

First, you convert the image to B&W by applying Image → Adjustments → Desaturate. In effect, you now have a B&W photo. Make whatever level adjustments you like to make the tones pleasing to your eye. Now, you're ready to start hand-coloring.

Choose History from the Window drop-down menu. This opens the History palette, which enables you to keep track of what's going on. Next, from the Tools palette, select the History Brush, as shown in Figure 6-27.

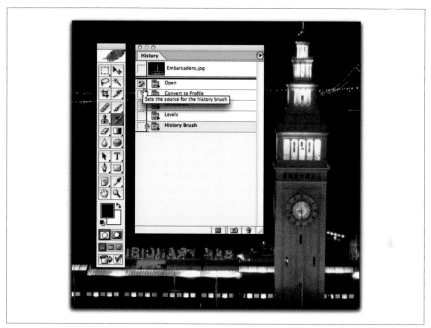

Figure 6-27. Use the History Brush to restore color to specific areas of the picture

In the History palette, click in the box next to the level you want to serve as the source for your painting. Generally speaking, you'll want to go all the way back to the original state of the photo. Next, determine your brush size. I like to use the keyboard for this; the left bracket ([) makes the tip diameter smaller, and the right bracket (]) makes it bigger.

At this point, all you have to do is start painting the color back into your image. If you find that an area looks a little too intense right after you finish restoring the color, select Edit → Fade History Brush to back off the intensity.

Once you finish restoring the color to the selected areas of the photograph, you can perform a final saturation adjustment by choosing Image → Adjustments → Hue/Saturation. You might want to pull the color back a little by sliding the indicator on the Saturation scale to the left. This gives your artwork a nostalgic, hand-colored look. But any look is possible with this technique, so experiment and see what you discover.

The final result is guaranteed to attract attention, as illustrated in Figure 6-28.

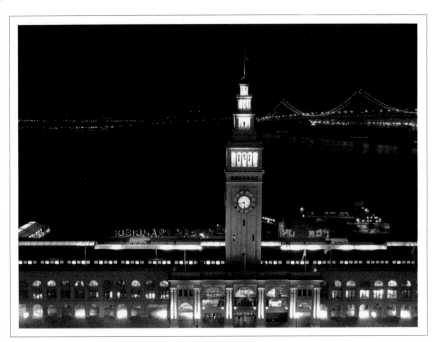

Figure 6-28. The final version of my hand-coloring (for now, anyway)

As usual, keep the original image as a Photoshop document (*.psd*), with the history steps intact, so that you can go back in time and make changes as your artistic eye dictates.

Camera-Phone Tricks
Hacks 75-85

Camera phones outsold regular digital cameras in 2003. According to the respected research firm IDC, that trend will probably continue. Camera phones are wildly popular in Japan, where they were introduced a few years ago, and the U.S. market has recently caught fire too.

It's true that camera-phone lenses and features leave much to be desired. But what they lack in quality they make up for in portability. The best camera is the one in your hand when something happens. And these days, the odds are good that a camera phone will be the one that gets the unexpected shot.

I've read stories about camera phones being used for everything, such as reporters monitoring election fraud in South Korea and real-estate agents forwarding pictures to their clients, helping them close deals quickly. Camera phones are infectious little devices that send the mind reeling with possibilities.

This chapter is designed to help you cope with the limitations of these tools while leveraging their unique advantages. For the time being, at least, we don't enjoy our digicams' resolution or features on camera phones. But progress is on the march. Texas Instruments, for example, has developed new processors that will lead to resolution as high as four megapixels on camera phones. Other chipmakers are also innovating. Indeed, this year, the U.S. and Europe will see some of the first-generation megapixel camera phones; some will even sport a flash.

In the meantime, I'll show you how to improve the images you take with your sub-megapixel model, including stitching together pictures to create bigger ones, capturing and editing video, and stirring your creative juices with a few fun tips.

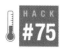

Live with a Less-Than-Perfect Camera

Ansel Adams might not have used a camera phone to photograph "Moonrise, Hernandez," but I bet he would have loved to have one around when he was hanging out with Edward Weston.

The value of a photograph taken with a camera phone does not lie in its photographic quality. The value lies in the sense of immediacy and the knowledge that you are able to capture—and, indeed, share **[Hack #77]**—a moment in time that would have been lost had your camera phone not been with you.

Most of us who are not professional photographers do not carry cameras with us all the time. Many of us, however, take our mobile phones everywhere we go. We take photographs for their personal value. Photographs can let us relive a special moment time again and again. So, for many of us, the choice between a nonexistent six-megapixel image (because the digital SLR is home, safe and sound, in the file cabinet) and a small, slightly blurry picture from the camera phone is clear: pull out the camera phone! For example, I can show you the rainbow in Figure 7-1 only because I had a camera phone with me to capture it.

Figure 7-1. Camera-phone picture of a rainbow

How Photos from Camera Phones Are Different

Anyone who has played with taking pictures on a camera phone knows that it's not the same as *regular* digital photography, at least not yet. We're already seeing impressive improvements in camera-phone technology in Japan, and those improvements will soon spread across the globe. Until then, here are some of the main reasons why photographs taken with camera phones don't look quite as good as those taken with regular digital cameras.

Pixel resolution. Many camera phones still take pictures at 640×480 pixel resolution (0.33 megapixels). In printing terms, these dimensions translate to output that is 3"×4", before cropping. We're starting to see

more camera phones with higher megapixel resolution, so if making prints is important to you, look for that specification in your next phone.

Optical properties of the lens. The camera lens used in camera phones cannot be expected to compete with hobbyist, semiprofessional, or professional camera lenses. Moreover, if you look at a camera phone's lens, you will notice that it has some kind of plastic or other clear material to protect the lens. Although this protective covering generally appears transparent to your eye, it probably does not allow the perfect, unimpeded transmission of light through it to the camera lens. It is also susceptible to tiny scratches (or worse) that might contribute to image blurring and chromatic (i.e., color) aberration.

Image sensor properties. Instead of film, digital cameras have an image sensor. As you might imagine, the image sensors in camera phones generally do not have the same image-capturing quality found in conventional digital cameras, especially compared to new digital image-processing technologies such as Canon's DiGiC, Kyocera's RTUNE, and Olympus' TruePic, which are all sophisticated and greatly enhance signal processing.

Lack of automated image-enhancing features. Many conventional digital cameras have preset options that automate various camera-focusing and light-capturing characteristics. These preset options help you take clear photos of objects at various distances from you, under all kinds of lighting conditions. Camera phones have minimal, if any, such adjustments (either manual or automated).

No flash. A few camera phones have an integrated or add-on flash. Most, however, still do not. This makes it difficult to take photographs in dimly lit or backlit conditions.

Ways to Improve Your Camera-Phone Photographs

The drawbacks should not discourage you from taking lots of photographs with your camera phone, though. There are several easy ways to improve the quality and enjoyment of your camera-phone photographs.

Take a lot of test photographs. As soon as you get your camera phone, learn about its photographic characteristics by taking plenty of pictures. How do its images look under different lighting conditions? How accurate is its color reproduction under different conditions? How close can you get to an object before the photo becomes blurry?

Accept that sub-megapixel images are small. Figure 7-2 shows a .33-megapixel (640×480) photograph taken with a Nokia 3650 camera phone, laid over a photograph taken with a 4-megapixel (2272×1704) Canon

PowerShot G3. As you can see, there is a significant size difference between the camera phone image and the Canon picture.

Figure 7-2. Size comparison of .33-megapixel and 4-megapixel images

Learn to move closer to your subject before taking a photograph. Otherwise, you will have a tiny photograph with tiny, hard-to-see main objects.

Get a commercial or open source image-editing tool. A good image-editing tool will help you deal with some of the other issues discussed in this section. Throughout the book, we've been working with Photoshop, but alternatives, such as the open source GIMP image editor and the commercial JASC Paintshop Pro image editor, perform similar image-editing functions under Fedora Linux and Microsoft Windows XP, respectively.

Use unsharp mask. The Unsharp Mask filter [Hack #63] is available in many photo-editing applications. Camera-phone photographs tend to look like soft-focus (blurry) photographs. You will usually want to sharpen the image to improve its appearance.

Apply color balancing. The Color Balance feature of your image-editing application will adjust for the camera phone's color-reproduction characteristics. Once you figure out the general direction in which the color

shifts for your particular camera phone, you can quickly make corrections in Photoshop or the image editor or your choice.

Adjust brightness and contrast. Camera-phone photographs are often under- or overexposed. Adjusting the brightness and contrast of your image can make it look more like what you recall seeing, or at least make it look more appealing. If your image-editing software has a Gamma Correction tool, such as Levels, you should learn to use it as an alternative to the Brightness tool because it enables you to adjust the midtones. Camera phones often have difficulty rendering midtones correctly.

Increase color saturation. Camera-phone photographs sometimes appear undersaturated (i.e., faded). The act of adjusting brightness can also reduce the perceived color saturation. Increasing color saturation can help make the photograph look closer to what you remember seeing when you took the photo.

The Techniques in Action

Figure 7-3 shows an original camera-phone image, and Figure 7-4 illustrates how it can be improved with an image editor such as Photoshop Elements. The original photo was taken outdoors in a shaded area. Like many camera phones, the Nokia 3650 I used to take this photograph does not have a flash. So, I could not use a fill flash to deal with the lighting problem when the picture was taken. The other significant issue is the strong magenta tint that is especially noticeable in the exposed skin areas.

I applied a number of corrective actions to restore the image to what I recall seeing in real life:

Unsharp Mask
Used to sharpen the image

Gamma Correction
Used to lighten the midrange values

Color Balance
Increased the green value to reduce the magenta tinge and increased red and yellow values to get the skin tone to look more accurate

Increase Contrast
Used to restore the contrast, which was reduced while applying the Gamma Correction

Noise Edge Preserving Smooth filter
Applied to reduce some of the blocky effect created by the Unsharp Mask

Figure 7-3. Original photo, taken with a Nokia 3650 camera phone

Figure 7-4. The same photo after image correction

Most camera-phone photos do not require this many corrective steps. As you learn the kinds of photographs produced by your camera phone under different conditions, you'll start to develop a set of standard procedures to maximize your enjoyment of your photos while minimizing your post-production time in front of the computer.

—*Todd Ogasawara*

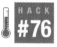

HACK #76 Send Snapshots to the Desktop

Your desktop is your camera phone's photo lab. But before you can do any processing, you need to get your pictures into the computer.

Most camera phones store digital-photo files in their internal memory. This internal memory is generally limited to two to four megabytes. Some of this memory is reserved by the phone's operating system, and some is used for applications (including games) you install on the phone.

This means that your images share internal storage space with telephone numbers, addresses, calendar events, user-installed applications, and other

system information. With my phone, I've found that this configuration has left me with enough space for only about 15 to 20 photo files. This is not an issue, though, on camera phones that support the use of Multi-Media Cards (MMCs) or Secure Digital (SD) cards for additional data storage.

File-Transfer Options

At some point, you will want to copy the photo files from the camera phone to your computer or personal digital assistant (PDA) for safekeeping. This section shows five possible ways to achieve this task successfully. Note that most camera phones work with only a subset of these methods. Figure 7-5 illustrates how these file-transfer options work with your phone, PDA, and computer.

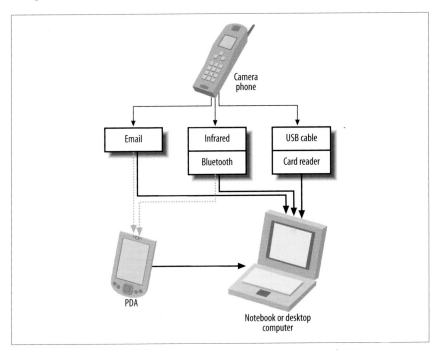

Figure 7-5. File-transfer options from camera phone to computer and PDA

Email photo files to yourself. Check to see whether your mobile-phone service plan includes its own email account. The feature you're looking for might be called something like Multimedia Mail or Multimedia Send on the phone. After you send an email message (containing the JPEG image file) from your phone, the email server will store the message until you retrieve it on your personal computer. You should learn the file sizes of photos created by your camera and any storage limitations your email

account might have. Also pay attention to any extra charges that might apply when you use this service. Be sure to test this procedure before you start deleting image files on your camera phone.

Use infrared to transfer photo files wirelessly. Many camera phones have an infrared transceiver to transfer data to and from another device. Most PDAs and some notebook computers also support the Infrared Data Association (IrDA) standard and can receive files wirelessly from your camera phone.

Use Bluetooth to transfer photo files wirelessly. Some camera phones support the Bluetooth wireless protocol. Bluetooth has several advantages over infrared. It does not require line-of-sight positioning. With a maximum transfer rate of 720 Kbps, it is generally faster than the common IrDA-SIR speeds of 115.2 Kbps, and it has a greater range (typically 10 meters, compared to IrDA's 2 meters). Some notebook computers and PDAs have integrated Bluetooth capability. If your PDA, notebook, or desktop computer doesn't, you can purchase Bluetooth cards and USB accessories relatively inexpensively.

Configuring Bluetooth differs from device to device (Mac OS X, Linux, Microsoft Windows, various mobile phones, and various PDAs). However, the general procedure is for the desktop computer, notebook computer, or PDA to use its Bluetooth Manager discovery function to identify the phone's Bluetooth services. You should also configure Bluetooth security to prevent *Bluejacking* and *Bluesnarfing* (i.e., unauthorized use of your devices via Bluetooth).

After configuring Bluetooth, you can copy files from device to device, in either direction, by using the file manager you are already familiar with (Windows Explorer, for example). Figure 7-6 shows a Pocket PC using File Explorer to copy a file from a Sony Ericsson T610 phone via Bluetooth.

O'Reilly's MacDevCenter provides an excellent article that outlines this process, step by step; see *http://www.macdevcenter.com/pub/a/mac/ 2002/10/18/isync_bluetooth.html.*

Transfer files via a USB or serial cable. Some camera phones can use a USB or serial cable to link to a notebook or desktop computer. This functionality might require the installation of synchronization software provided by the camera phone's manufacturer.

Use a storage-card reader. A few camera phones provide additional file-storage capability in the form of an MMC or SD card. These are the same kinds of storage cards used by many conventional digital cameras. You can remove these cards from your camera phone and place them in

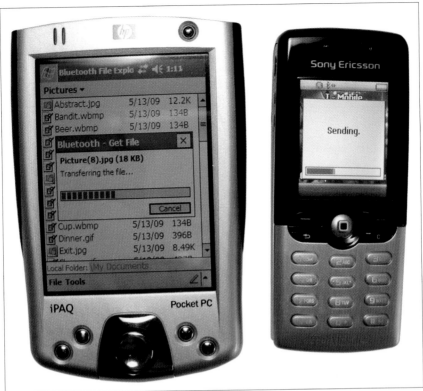

Figure 7-6. Using Bluetooth to wirelessly copy a file from a phone to a Pocket PC

a storage-card reader to copy files quickly. Many PDAs, notebooks, and desktop computers come with integrated storage-card readers. If yours doesn't, you can purchase inexpensive external readers that can be attached by a USB cable.

Notebook computer users can purchase a PC card adapter for SD/MMC cards. If your printer is designed for use with digital cameras, it might have its own slot to read SD/MMC storage cards. When an SD/MMC card is inserted into the computer with a PC card adapter, it appears on your desktop as a hard-drive icon, usually titled *NONAME*. You can double-click the icon to open it and see all the files stored in the memory card.

Final Thoughts

If you travel light, you will want to seriously consider pairing your camera phone with a PDA that is capable of infrared or Bluetooth wireless file transfer. PDAs can now use storage cards with megabytes of storage space. So, it

Be Wise with Your Bluetooth

Bluetooth is often termed a *cable-replacement* technology; it replaces those snaking USB and serial cables between your various devices and stands in for wires when they just won't do—between your cell phone and PC, for instance.

But lest you forget that Bluetooth does indeed float through the ether, some devices (particularly first-generation Bluetooth-enabled handsets, such as the Sony Ericsson T610 and T68i, as well as the Ericsson T39, R520, and T68 models) are vulnerable to interference by bystanders. Adept, mischievous types can exploit these vulnerabilities, allowing them to access and alter the data on your phone without your knowledge. Such an attack, called *Blue-snarfing*, is considered rare, but there's no real way to know.

Manufacturers of Bluetooth-enabled handsets are working to plug the holes, but many experts advise you to set your Bluetooth to Hidden or Nondiscoverable mode (though there are still some vulnerabilities), or even turn it off, when you're not using it. Doing so will provide at least a little peace of mind.

is possible to store many relatively low-resolution (sub-megapixel) digital photographs on a PDA until you can access your larger-capacity desktop or notebook computer.

—*Todd Ogasawara*

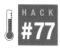

HACK #77 Transfer Images Via Email

Wireless photo transfer is one of the great advantages of camera phones. These tips will have you filling up your friends' phone mailboxes in short order.

Email might be the simplest way to get a photograph from your phone to somewhere else. It doesn't require a special cable, computer peripheral, or additional software. Only a few camera phones (mostly in the Smartphone category) allow additional file storage using MMC or SD cards. This means that if your phone has limited storage space or if you have installed a number of aftermarket applications that have their own data requirements, you'll fill up the phone's internal storage with just a few photos. Emailing your photo might be the only way to free up storage space on your phone if you do not have ready access to a desktop, notebook, or PDA to which you can offload the phone's photo files.

To make sure you do not incur any unexpected extra cost, you should check your mobile phone's service plan before transferring photos via email. Most

mobile-phone service providers have a set of email and data services to choose from. If you plan on emailing photo files frequently from your camera phone, I recommend choosing an unlimited email or data plan. Generally, these plans are reasonably priced.

After you confirm that you can send photo files using email on your camera phone, the next step is to add email addresses to your phone's contacts list. You can create and edit contacts by using the phone's keypad. However, you might find it faster and easier to create the contact entries on your notebook or desktop PC and then synchronize the list with your camera phone.

Most camera phones come bundled with software to synchronize data with a Microsoft Windows system. If you use Mac OS X, check whether Apple iSync (*http://www.apple.com/isync/*) will allow you to synchronize your computer's address book with your camera phone. Linux users should investigate Wammu-Gammu GUI (*http://www.cihar.com/gammu/wammu/*) to see if it meets their needs.

Once you have laid the groundwork, sending a photo in email from a camera phone is easy. On my Nokia 3650, I start by choosing Send → Via Multimedia, as shown in Figure 7-7. Multimedia Messaging Service (MMS) is an extension of the text-only Short Messaging Service (SMS), which allows text, sound, images, and video messages to be sent between MMS-capable phones. However, these messages can also be sent through conventional email if the operator of the mobile phone provides this service.

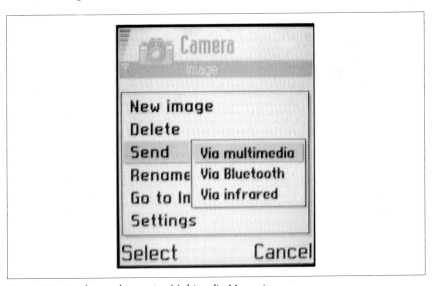

Figure 7-7. Sending a photo using Multimedia Messaging

The email address in Figure 7-8 was selected from my phone's contacts list. As mentioned earlier, this process is much more fun if you have the addresses of friends and family in the phone. The text name associated with the email address is shown in the To: field. The subject is out of view in this screen.

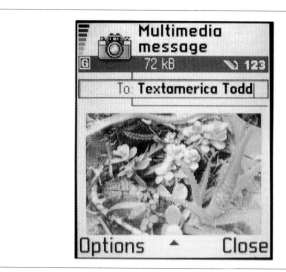

Figure 7-8. Image ready to send

If you're not careful, it's easy to fill up someone else's email box (or your own) with camera-phone photos. For example, when set to its Fine image setting, the Nokia 3650 creates JPEG files that range in size from 50 to 80 KB for 640×480 (0.33-megapixel) images. Emailing 40 to 50 of these image files will fill up a mailbox with a three-megabyte limit (typical for some free mail services). File size will become even more of an issue as one- and two-megapixel camera phones become more common and file sizes increase geometrically.

—Todd Ogasawara

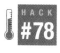

HACK #78 Send a Paper Text Message

Who says that technology has taken the personality out of our communication? Use your camera phone to send messages in your own handwriting.

Regular text messaging with Short Messaging Service (SMS) lacks an element of personality. ASCII letters just don't possess the individual flair that handwritten notes convey. That personality was certainly part of the charm of passing notes in class as a child, in addition to the element of risk.

Today's camera phones don't pose much risk, but they can help you recapture the charm of handwritten notes. Say you're waiting for a plane in an airport and want to let your girlfriend know that you're thinking about her. You could send the following SMS text message: "Wish you were in the next seat! Miss you..." She would certainly appreciate that.

But if you used the camera phone to take a picture of a handwritten note, as shown in Figure 7-9, you'd put a big smile on her face.

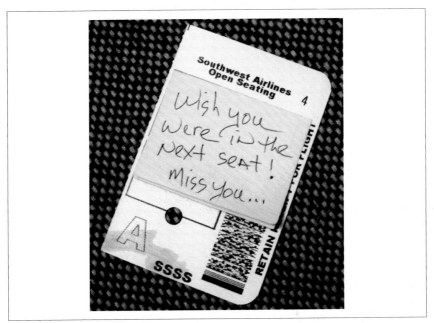

Figure 7-9. A picture note in your own handwriting

The technique is quite easy. First, use your camera phone to take a picture of the handwritten note. Most camera phones give you the option of saving or sending right there on the spot. Find and click the Send button. You'll be prompted to address and, optionally, provide a subject for your note, as shown in Figure 7-10. Enter the destination phone number or select your friend from your contacts, hit the Send button, and your "handwritten" note is on its way.

Once you start thinking about the possibilities of paper text messaging, you might even go so far as to keep a little pad of Post-it notes in your briefcase just for this purpose.

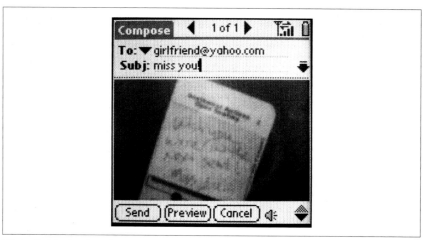

Figure 7-10. Sending the MMS picture note

Communicate in a Foreign Country

A picture is worth a thousand words, especially if you don't speak the language.

A while back I ran a photo-tips contest via my weblog on the O'Reilly Network (*http://www.oreillynet.com*), and one of the winning entries caught my eye as a creative hack for this book.

The entrant, Phil Calvert, submitted this tip:

> While traveling in Japan, I found a novel use for a digital camera. Most of the restaurants there have lifelike plastic displays of the food they serve. Since I couldn't speak Japanese, I just took a picture of what I wanted to eat and showed it to the waiter. He thought it was very funny, but I did get what I ordered.

Phil got me thinking. While traveling in a country where you don't speak or read the language, or at least not very well, why not use your camera phone for a variety of communication needs? You could even store a few standard icons in your phone's memory for when the occasion arises.

For example, a picture of a taxicab, as shown in Figure 7-11, could be quite useful when you'd like the restaurant's maitre d' to call for one to get you back to your hotel.

Perhaps you could add a shot of money to ask "How much?" or an image of a plane to communicate *airport*, and don't forget a picture of your hotel, just in case you forget how to find it after a day's touring. The possibilities are endless. The main thing to remember is that pointing to a picture on your phone is much easier than fumbling with a language you don't know at all.

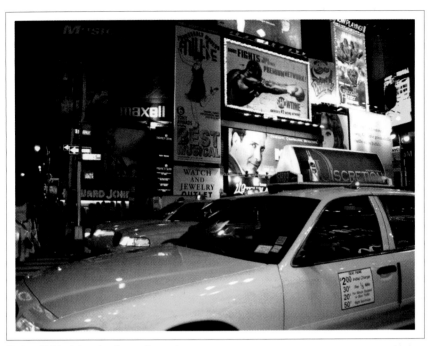

Figure 7-11. A handy photo of a taxi

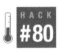

Create a Home Inventory

Creating a home inventory and storing it in a safe place will make it easier to work with the insurance company at a time of loss.

A home inventory can make dealing with an insurance company much easier. And your camera phone is a convenient way to create and store this inventory. With a little preparation, you can canvass your entire residence in just an hour or so.

You'll need a stack of 3"×5" cards and a bold-tip felt marker. Carry out your inventory one room at a time. Daytime hours are best, because you'll have enough ambient light to record the objects without using flash. Many camera phones don't have flash, and for this job, it's just as well. Photographing shiny objects with a flash is difficult at best; it's hard to record detail in the lighter tones. Ambient light is less contrasty, which makes it better for this project.

Start with your first item and write the following information on a 3"×5" card:

- Name of object
- Serial number

- Date purchased
- Purchase price

Make your letters big and bold, as shown in Figure 7-12. Put the card next to the item and snap a picture.

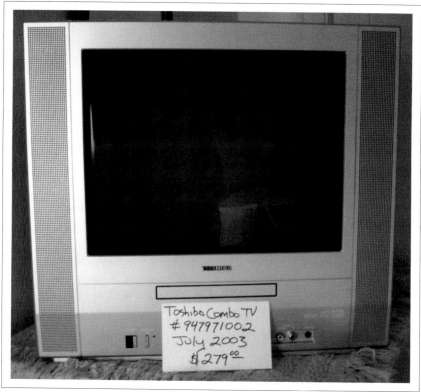

Figure 7-12. A sample item in a home inventory

When you finish one room, move on to the next until you've completed the entire house. Then, upload your images to the computer [Hack #76]. You might want to give each image a filename that makes sense, such as *bedroom_tv.jpg*, *bedroom_vase.jpg*, *bedroom_lamp.jpg*, and so on.

A handy way to organize these images is to actually build a web photo gallery [Hack #50] and burn it to three CDs: one to keep at home for reference, one for easy-access backup at your office, and a final copy in a safe-deposit box or another secure location.

When you need to refer to the catalog, simply load the CD into your computer, double-click *index.html*, and a thumbnail catalog of your entire home inventory will appear in your web browser. You can click on any of the

thumbnails to enlarge the image and read the details you wrote on the 3" × 5" card.

When creating your inventory, keep these tips in mind to ensure the best detail possible:

- To prevent camera shake, hold the camera steady when making the exposure. Chances are, you're shooting in less light than your camera phone likes, so the shutter speed will be slow.

- Increase the ISO setting, if that's an option on your camera. ISO 400 requires much less light for a good picture than ISO 100 requires.

Take more than one picture of each object. Then, after you upload the photos to your computer, pick the shot that has the largest file size **[Hack #47]**. The bigger the file size, the sharper the picture will be.

- Use *pink* 3" × 5" index cards. Pink cards reflect less light than white ones do. This will make them easier to read, because they will require about the same exposure as the objects you're photographing.

Finally, remember to update your home inventory at least once a year to keep it current.

HACK #81 Rental-Car Tips and Other Auto Hacks

A camera phone can help you prove that you didn't put those dents in a rental car. And if you do get in an accident, it can document what really happened.

As you've probably figured out, many camera-phone hacks are also appropriate for regular digital cameras. What makes your camera phone unique is that you probably have it with you in some odd situations, such as when you're renting a car or find yourself involved in a fender bender.

Rental-Car Checkout

At most rental-car shops, an agency rep walks around the automobile with you before sending you off into the world. This is a great time to pull out your camera phone and photograph any scratches or dents he points out. Be sure to get his hand in the picture to make an identifying element that is unique to that car.

Then take a few more shots: one from the front, looking down one side of the car, and another from the back, looking up the other side. Be sure to get the license plate in at least one of these pictures. Also, get one full shot of the agency rep standing next to the automobile. Work quickly, so that you don't interfere with the regular flow of business.

When you return the car to the lot, take your basic photos again to prove that you returned it in good shape. Be sure to get at least one shot that shows where you are, and if there's an agent accepting the return, get him too. This documents that you returned the car in good shape.

Fender-Bender Documentation

Nobody likes being involved in a fender bender, but they happen all the time. After you've interacted with the other parties and exchanged insurance information, pull out your camera phone and snap a few pictures like the one in Figure 7-13.

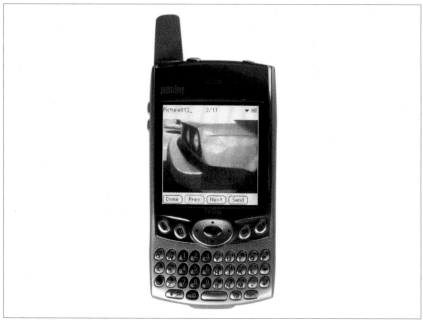

Figure 7-13. Quick documentation of a fender bender

First, record the overall scene, including the placement of vehicles, damage incurred, debris in the roadway, skid marks, and anything else that looks important. Also try to photograph the point of impact, especially if one of the cars crossed a centerline or barrier.

You can even be a good citizen and take some pictures as a witness of an accident you weren't involved in. Then, contact the police department and let them know what you have.

Timestamp

In any of these scenarios, send at least one picture via email to yourself to create a reliable timestamp of the event. With rental cars, you can prove that on this particular day this car was in good shape. As for the fender bender, by sending an email minutes after the event, you can help establish when the accident actually happened.

Nobody wants to have rental-car hassles or incur damage to their car, but if trouble arises, your camera phone can help establish the facts and help resolve the situations quickly and accurately.

HACK
#82

Get the Big Picture with a Little Camera Phone

If a scene is just too big to fit in your little camera phone, shoot a series of images and stitch them together.

Have you ever photographed a breathtaking landscape or something extremely tall, such as a giant redwood or skyscraper, only to feel a little disappointed when looking at the image on the computer screen? The scale of the scene didn't survive the translation to the computer.

One reason is that the conventional camera has a *monocular* field of view, which is much smaller than the *stereoscopic* field of view that our two eyes provide. This issue is compounded by the camera phone's generally low resolution (sub-megapixel) and narrow depth of field; objects are not sharp, except for a narrow range of distance from the camera. You also might not be able to back up far enough to get a large vista or object entirely in a single frame.

One way to solve this problem is to photograph the scene or object in segments and then assemble the pieces into a single large image. The technique, called a panorama **[Hack #19]**, is pretty simple. Figure 7-14 shows three pictures stitched together into one.

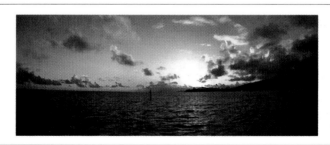

Figure 7-14. A panorama created from three camera-phone images

Here are a few tips to keep in mind when you're creating these types of images:

- Decide which kind of panoramic image you want to create. The two most likely choices are horizontal and vertical.

- Some digital cameras provide on-screen tools to help you line up stitched images as you're shooting them. Camera phones, however, do not have this feature. You can work around this by visually scanning the area you want to photograph and choosing visual segmentation points to help you line up the photographs and create assembly segments. The rule of thumb is to overlap each frame by 30%.

- Camera phones don't have sockets that you can attach to tripods to ensure smooth panning. So, this is hand-holding country. To produce the best results, minimize your body movement when you're photographing each segment. I recommend keeping your feet in a single spot throughout the entire process. Twist your waist, while keeping your back as vertical as possible, for horizontal panorama scenes. When photographing vertical scenes, try to bend your shoulders and waist straight back (when shooting upwards) or forward (when shooting down). These behaviors minimize segment mismatches that create unusable visual areas.

- Bring the photo segments into a photo-stitching (sometimes referred to as photo-merging) application. A number of general-purpose, commercial photo-editing applications include photo-stitching tools, such as Photomerge in Photoshop CS and Elements.

 Standalone photo-stitching tools, such as ArcSoft PanoramaMaker (*http://www.arcsoft.com/en/products/panoramamaker/*), are also available. For this project, I used the PhotoStitch application that came bundled with my Canon PowerShot G3 digital camera. You can also find open source photo-stitching tools associated with the Panorama Tools project (*http://panotools.sourceforge.net/*).

- Most applications automate the bulk of the actual photo-stitching process. However, there are usually options to adjust for different ways of producing and merging segmented images. You should experiment with these different methods to learn which ones work best with your photographic technique.

I'll now walk you through the basic steps of creating a panorama with your camera phone. First, take your series of shots, working left to right and overlapping by 30%. Upload the pictures to your computer. Open the images in your stitching program, as shown in Figure 7-15.

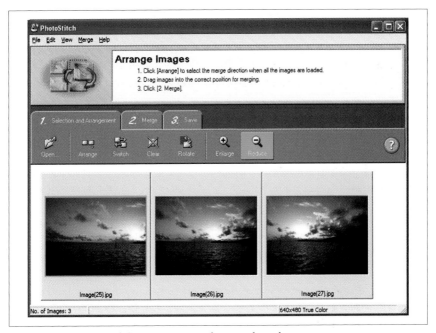

Figure 7-15. A series of shots in Canon's PhotoStitch application

Now, merge the images together, as shown in Figure 7-16. If you give the stitching application enough visual information to work with, it will do an amazing job of creating a seamless panorama.

Once the application works its magic, you have a much broader view. Crop out the rough edges, as shown in Figure 7-17.

A bonus of using this technique is that you've also added resolution to your landscape, which enables you to make a bigger print than you'd be able to make of a single 640×480 picture. You don't have to be limited to small prints or narrowly composed scenes with your camera phone. Just remember to gather all the parts while you're taking the pictures. Then, pull things together later on the computer. It's that easy.

—*Todd Ogasawara*

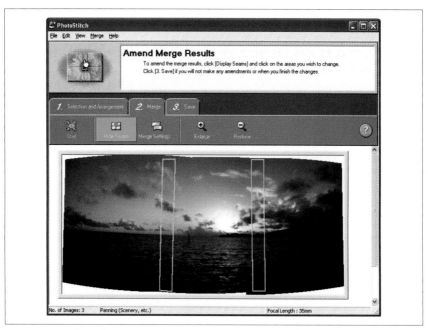

Figure 7-16. Photos being merged together

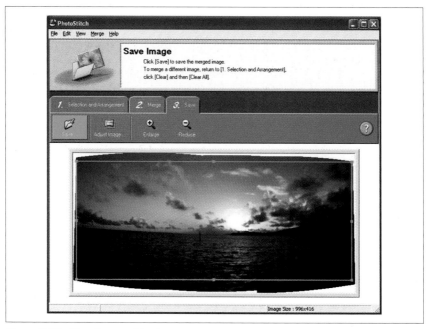

Figure 7-17. Cleaning up after the merge

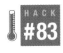

Photo Moblogging

#83 Camera phones have added a colorful new dimension to the text-heavy world of weblogging. With photo moblogging, you can publish pictures to the Web directly from your phone.

If you want to share your latest cool camera-phone photo with a lot of people, you should investigate the world of photo *moblogs*.

The word *blog* is a contraction of *web log* and refers to a linear, journal-like, informal text-entry system. A *moblog* is a mobile blog that allows entries to be made from a wireless mobile device, such as a wireless phone or PDA. Moblog content can be text, audio recordings, photographs, or even video. Figure 7-18 shows an example of a photo moblog. This hack will focus on moblogs that can handle photographs and videos. Perhaps we should call these kinds of moblogs *multimedia blogs*, or *mublogs*?

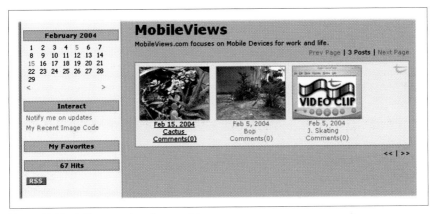

Figure 7-18. A Textamerica photo moblog

Just as text-based blogs let you satisfy the urge to be a journalist or essayist, photo moblogs let you satisfy the urge to be a photojournalist or photo essayist. Photo-moblog web services let you send your camera-phone photographs directly to your own web site. You don't need to wait to get back to a desktop computer or buy an additional hardware peripheral. You will, however, need email service from your mobile-phone service provider.

A growing number of photo-moblog sites offer free accounts:

Buzznet (http://www.buzznet.com)
 Buzznet lets you participate in various kinds of communities based on themes, social groups, or geography. It can also syndicate your photos using Atom or RSS (Versions 0.91, 1.0, or 2.0). Another option creates a

simple JavaScript source that you can embed on your web site to display the five most recent images posted to Buzznet.

Expressions (http://www.my-expressions.com)
Expressions is a hosted, visual blogging system, designed and developed by photographers, artists, and bloggers.

Fotolog (http://www.fotolog.net)
Fotolog is a free-service meeting ground for photo bloggers of all types who want to share their images with others.

Fotopages (http://www.fotopages.com)
You can use Fotopages to create a photo journal, a visual diary, a photo album, or even a regular blog.

mLogs (http://www.mlogs.com)
mLogs lets you add audio commentary, as well as photos.

Phlog (http://www.phlog.net)
Phlog has a clean and easy-to-use web interface. It gives you access to a Cascading Style Sheet (CSS) that lets you customize your web page's look and feel if you are comfortable working with CSS.

Textamerica (http://www.textamerica.com/)
Textamerica gives you the ability to upload 3GPP video files with sound as well as still photos. It also provides an RSS 2.0 syndication feed to let you display photos and videos on your own web site.

New photo-moblog sites are appearing rapidly as the number of phone cameras continues to explode. This technology fad will probably take the same evolutionary path as other web fads and eventually see a consolidation of sites in the near future. So, make sure you keep an archive of your favorite camera-phone photos, just in case the photo moblog you use now disappears in the future.

Most photo-moblog sites give you at least two ways to get your photo files from the camera phone to the site. The first method is the familiar web-browser interface that lets you copy files from your desktop computer to the web site. The mobile nature of moblogs leads to the second method, which you will probably want to use with your camera phone: emailing the photo directly from your camera phone to the moblog web site.

Each photo-moblog service provides specific instructions on how to email a photo from your camera phone to that service. The general procedure is to email your photo to a special email address that the service assigns to you with an authorization password. You provide this password as part of the email address in the format *AccountName.Password@DomainName.com*.

After emailing your photo to the photo-moblog site, it might take a few minutes (or longer) before the photo is viewable on your moblog page. The reliability of posting video files varies from service to service. After emailing a video to one moblog service, I found it took up to 12 hours for it to appear on one site. Another video-upload test to a different site did not work at all, but it didn't generate any error message either. Video uploads in the form of 3GPP video files should be considered experimental at this point, but you can expect to see video moblogging mature and stabilize in the near future.

The ability to share your camera-phone photos does not end with the web pages provided to you by the moblog service. Some services provide RSS or some other XML-based syndication feature. For example, in Figure 7-19, I've used Buzznet to syndicate my camera-phone photos to a personal web site.

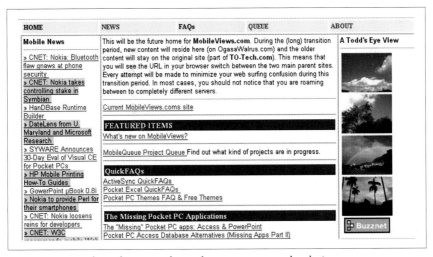

Figure 7-19. Syndicated camera-phone photos on a personal web site

Regardless of how this technology evolves, the ability to publish photos and video directly from your phone to a web site provides tremendous opportunity for keeping friends, family, and the world at large up-to-date on the world you see before your eyes.

—*Todd Ogasawara*

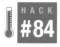

Capture Life's Little Moments with Camera-Phone Video

No, you're not going to record camera-phone video of your son's entire graduation ceremony. But you might catch him receiving his diploma.

Some camera phones can record video as well as still images. However, various hardware factors often limit the video segments to just a few seconds. Here are some of the limitations of recording video with camera phones:

- Not all video camera phones can record sound with the video.
- The visible frame size is small.
- The video clips are considerably more grainy and pixelated than video clips taken with still digital cameras that have video-recording capability.
- The 3GPP (Third-Generation Partnership Project) file-storage format can be viewed but not readily edited by common video-editing applications. You can find more information about 3GPP at *http://www.3gpp.org*.
- The maximum recording time for a video segment is usually measured in seconds. For example, the Nokia 3650 can record a maximum of 95 KB (about 15 seconds) of video with sound. My experience is that 10 seconds is the maximum clip duration.

A lot can happen in 10 seconds. The world's fastest human can run 100 meters, with a fraction of second to spare. Your child can scamper through a good portion of your home or yard. And don't forget that you can edit multiple clips together **[Hack #56]** to create several minutes of memorable video.

You can view 3GPP video natively using a number of desktop applications. Apple QuickTime (*http://www.apple.com/quicktime/*), Nokia Multimedia Player (*http://www.nokia.com*), and Real Video (*http://www.real.com*) are all capable of playing 3GPP video files.

Although viewing 3GPP files on a desktop is not a problem, you have to do a little preparation before you edit and splice the video files. Many video editors don't work with 3GPP files. However, you can work directly in Quick-Time or convert the 3GPP video files to a more familiar format, such as Audio Video Interleaved (AVI). Let's cover the conversion process first and then touch on QuickTime.

First, you can use the free 3gpToRawAvi application for Microsoft Windows to convert 3GPP camera-phone video files to the Raw AVI format. You can find 3gpToRawAvi at *http://www.allaboutsymbian.com/downloads/3gpToRawAvi.zip*.

The files should be unzipped and installed in a dedicated folder. The filenames for the folder and any of its parent folders cannot contain any spaces. 3gpToRawAvi does not have any installation routine. You use the application by launching *Convert3gp.vbs* (a VBScript file) from its installation folder or, more conveniently, by placing a shortcut in the Windows Start menu. After you've launched the application, you'll be greeted with the interface shown in Figure 7-20.

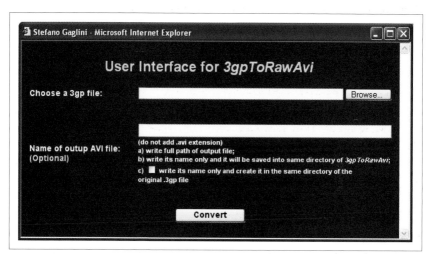

Figure 7-20. The 3gpToRawAvi user interface

Import the converted AVI video files into Windows Movie Maker (bundled with Windows XP) to turn several 10-second video segments into a single video, as shown in Figure 7-21.

The resulting Windows Media Video (WMV) file can be played on platforms supported by Windows Media Player: Windows 98SE/ME/2000/XP, Macintosh OS 9 and OS X, and Pocket PC. Of course, you could produce MPEG video files for use with other video editors.

As mentioned earlier, you can also edit your video files in QuickTime Pro [Hack #56] and export your completed movie as a QuickTime *.mov* file that can be played on any Windows or Macintosh computer. You can add scrolling titles [Hack #58], a music soundtrack [Hack #59], and even a voiceover track [Hack #60]. As you can see, if you have the right tools in place, you can do much with those 10-second video clips from your phone.

It's also possible to send video files directly from your phone to some moblog sites [Hack #83]. This lets you create a series of camera-phone videos (with

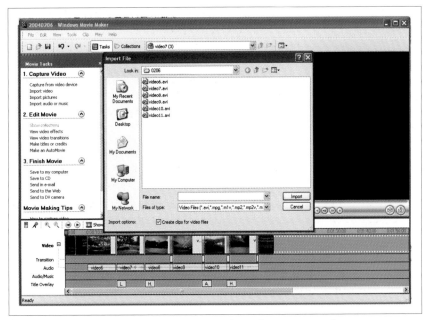

Figure 7-21. Editing AVI video files in Microsoft Windows Movie Maker

sound) that can be viewed by friends, family, and the general public on a public web site.

—Todd Ogasawara

Use Your Camera Phone as a Slideshow Viewer
HACK #85

> Smartphone color displays are higher in quality than the pictures captured by their built-in cameras. But what if you could view your high-resolution digicam images on your Smartphone's backlit display? You can!

We've established that camera phones don't take the world's best pictures. And they aren't adept at close-ups, low-light photography, or anything that requires a zoom lens. The irony is that their high-resolution screens are quite good for displaying images, and they are many times bigger than the little LCD monitor on your regular digital camera. So when you're on the go, why not use your Smartphone to show off the beautiful pictures you've just captured with your digicam?

With a little planning, there's no reason why you can't. Many Smartphones have memory-card slots that accept postage-stamp-sized Multi Media Cards (MMCs) and Secure Digital (SD) cards. These little cards are also popular with digital cameras.

I did a little testing with my Contax SL300R T* and a palmOne Treo 600 I had on loan. The Contax is a three-megapixel camera with a Carl Zeiss zoom lens; it captures beautiful images and stores them on an MMC or SD memory card. The Treo 600 includes a camera of its own, but the quality of the images leaves much to be desired. The 160×160–pixel CSTN backlit display, however, supports 4,096 colors and is truly brilliant. I was anxious to see how the images captured with the Carl Zeiss lens would look on the Treo.

First, I tested the compatibility of the memory card. I took a 256 MB SD card out of the Contax and inserted it in the top slot of the Treo. If you haven't used this feature before, be sure to remove the plastic placeholder before trying to insert the memory card. Right away, the Treo launches an application called Card Info that provides the vital specs of the SD card, as shown in Figure 7-22.

Figure 7-22. The Card Info screen on the Treo 600

Bingo! Looks like I have compatibility. According to the readout, there are five images on the memory card. But how can I view them? I tried using the Camera application (included with the Treo) to look at the pictures on the SD card. No luck there. I then became somewhat excited when I discovered a Move command, only to learn that I could move images from the Treo to the SD card, but not the other way around. Nuts!

It was time to do a little web research.

I uncovered a number of promising candidates but settled on an application called Resco Photo Viewer (*http://www.resco-net.com/palm/palmviewer.asp*) because it has so many useful photographic features. The most important function of this application, of course, is that it allows you to insert your camera's memory card into the Treo, or any device running Palm OS Version 4.0 or higher, and view JPEG pictures on the high-resolution screen, as shown in Figure 7-23.

Figure 7-23. Image of a pink camellia, viewed with Resco Photo Viewer

Once you have an image on the screen, you can zoom in, rotate, adjust brightness, contrast, and color, and even add text annotations. One of my favorite features of this application is that the Properties menu displays EXIF data for the image, as shown in Figure 7-24. Many digital cameras won't show you the aperture and shutter-speed settings, but if you load the pictures into the Resco viewer, that info is just a menu click away.

I can play slideshows of my pictures directly from the memory card, using a variety of transitions. And if I want to send an image to another device, Resco supports infrared and Bluetooth file transfer.

Figure 7-24. EXIF data display in Resco Photo Viewer

Since you don't have to quit the application or even power down the phone to insert the memory card, you can use your Palm device for a quick, enlarged view of the pictures you just shot with your digicam. For example, if you just recorded a group shot, pop the card out of the camera and into the Smartphone to show your subjects a bigger, 160×160 rendering of the photo. They will actually be able to see their smiles.

The Resco application is also available for Pocket PC and Symbian devices. You can use any media combination that works with your hardware. For example, if you have a Sony CLIE and Sony digicam, you can move the Media Stick back and forth between devices, just as I did with the Contax and Treo 600.

Resco will let you download and use the Photo Viewer for 14 days. If you decide you like it, the purchase price is US$20.

Weekend Photo Projects
Hacks 86-100

One of my favorite folk tales about the great color photographer Elliot Porter embraces the spirit of this chapter. On a beautiful day during his waning years, he asked to have his wheelchair rolled up to the top of the building and placed on its back so that he could hold a camera and shoot pictures of the clouds passing by. That's my kind of photographer.

Photography is a lifelong endeavor. In the hands of a seven-year-old, a camera provides us with a glimpse into their world. This journey continues as long as there is light and breath. Taking pictures is the ultimate hobby.

The following pages introduce you to new ways to capture images, shortcuts for managing them, and creative methods for sharing your vision with others. Peruse this chapter when you have a little time on the weekend to explore something new, or when you want to add a spark to your shooting prowess.

Regardless of age, taking a great picture is one of the best feelings in the world.

HACK #86 Create a Coffeetable Photo Book

Beautiful, hardcover photo books were once reserved for published photographers. But thanks to print-on-demand technology, you can make one for less than the price of a memory card.

When I share my pictures with others, I use a variety of media to show off my work. The computer screen is a natural display, especially for digital slideshows. And colorful, 4"×6" prints are always welcome. But the one format that really lights up smiles is the hardbound picture book on glossy, archival paper. The first thing I typically hear when I hand such a book to a friend is, "You made this?"

Yes, I did. And you can too, easily. I first heard about these books from Apple CEO Steve Jobs when he debuted iPhoto, a digital shoebox for Mac OS X users. For a while, it seemed you'd have to borrow someone's Mac if you wanted to create these books. But not for long; Windows users can also now build their own printed masterpieces, and just as easily.

A Look at iPhoto

I want to give iPhoto (*http://www.apple.com/ilife/iphoto/*) its due here, because this digital-shoebox application has popularized hobbyist book production. You have to run Mac OS X to use it, and it's part of Apple's iLife suite of programs that includes iTunes, iDVD, iMovie, and GarageBand.

Making a book in iPhoto is easy. Create an album of pictures by selecting File → New Album and dragging images from your master iPhoto Library into it. Once you have all the pictures in the new album, arrange them in the order you want them presented in the book. The first photo will be the cover shot, and the sequence goes on from there. When you have the images in the desired order, click on the Book button, as shown in Figure 8-1. iPhoto will build a draft of the book for you in the default template, Picture Book. You also have other themes to choose from, such as Catalog or Storybook.

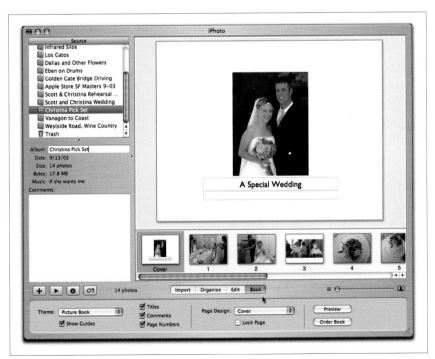

Figure 8-1. Building a picture book in iPhoto

At this point, you can add text, adjust the layout, and even change the order of the pages. When a page looks the way you want it to appear in the final book, click the Lock Page box to ensure that it doesn't change as you work on the rest of the book.

iPhoto's Book Themes

Apple's designers have provided a solid selection of templates (or *themes*) for your photo book. The default theme, Picture Book, is a good choice for photographers who want all eyes on their images and don't need any accompanying text. But you have six others to choose from: Catalog, Classic, Collage, Portfolio, Storybook, and Yearbook. Each provides you with different picture layouts and text options. Apple's web site provides samples of each theme at *http://www.apple.com/ilife/iphoto/books.html*. Be sure to look at all of them before making a final decision for your first book project.

When you think you have things right, press the Preview button to review an electronic version of your publication. You can also make a PDF version of your book to share with others by selecting File → Print and choosing the Save As PDF option.

When you're ready to place your order, make sure your computer is connected to the Internet and click the Order Book button. iPhoto will walk you through the ordering process, upload your images, and generate a confirmation email once everything is set. Most books cost less than US$40 and arrive in about a week. (Pricing starts at $30 for a 10-page book and $2.99 for each additional page.)

MyPublisher for Windows

Thanks to MyPublisher (*http://www.mypublisher.com*), printing a custom photo book from Windows is just about as easy as from the Mac. The process is similar to iPhoto, except that you build your book in MyPublisher's BookMaker software, which runs inside the web browser. The software downloads quickly because it's only about a megabyte large. Once the download is complete, the program launches and you can begin constructing your book.

Make sure all your images are in one folder, preferably in the order you'd like them to appear in your book. You can control the order of the photos by labeling them *Wedding 001*, *Wedding 002*, and so on. Click the Get

Photos button in BookMaker and navigate to the folder containing your images, as shown in Figure 8-2.

Figure 8-2. Choosing the images you want for your book

BookMaker puts the photos on a sequence line to let you know they are included in the project. Click the Organize button if you'd like to change the order of the images. You also have the option to perform some basic image editing—such as rotate, zoom in, or convert to B&W—by clicking the Enhance button.

Once you have matters in hand, click the Book button to apply the finishing touches, such as adding text and modifying the template, as shown in Figure 8-3.

Place your order by clicking the Purchase button. After helping you set up an account, MyPublisher receives your files for printing. The pricing is the same as with iPhoto, usually about US$40. The minimum page count is 10, but you can certainly add more—up to 100 pages, at $2.95 each—if you need to.

Figure 8-3. Adding text to the pages

Book-Making Tips

The most important thing to keep in mind is that the book is the *final output* of your images. Make sure you've looked at each picture closely in your image editor to ensure that the color and exposure are as you want them. Just one bad picture in the entire book will ruin the whole project for you. Believe me; that bad egg will drive you crazy.

I like to print sample images on my inkjet printer, or order prints online, before I build my books. That way, I can see how they look printed, not only individually, but also next to each other.

Also, keep in mind that ample image resolution is important for quality output. For the highest quality, I recommend you set your photos to 200 ppi [Hack #62].

These books are a beautiful way to show off your work, and they make cherished gifts for others. The output is quite stunning, especially if you take time to prepare your images carefully before assembling the book.

Create Custom Greeting Cards

#87 Create professional-looking greeting cards and even have them addressed and mailed for you.

We all get them, those wonderful holiday cards from our friends or family. They usually have a great candid shot, with a message printed right on the card. Now, it's your turn to impress friends and family with a holiday card printed from one of your digital snaps.

This hack will get you on your way to sending out your own holiday cards that are even fancier, putting you one step ahead of that pesky brother-in-law. There are two ways you can make cards: print them yourself on your inkjet printer or have a photofinisher do it for you. I'm going to focus on using an online photofinisher for a few reasons:

Time-effectiveness

The photofinisher handles all the headaches of proofing and output for you. You essentially upload one file and move on to the next item on your busy holiday task list.

Cost-effectiveness

Yes, by the time you factor in the outrageous cost of specialized inkjet printing paper, ink cartridges, and your time, it's cheaper to use a professional service.

Durability

Pro shops use a modern version of the traditional printing process. Your cards will hold up much better to adverse conditions than cards printed on an inkjet printer.

You might want to see which services your local photofinisher offers. Many photofinishers have great options for printing custom cards. If, however, you'd rather work online, there are many Internet services that let you customize your cards in myriad ways. Ofoto (*http://www.ofoto.com*), Snapfish (*http://www.snapfish.com*), ClubPhoto (*http://www.clubphoto.com*), and Shutterfly (*http://www.shutterfly.com*) are all worth checking out. Shutterfly is one of the leaders in online image printing, and for good reason. Using Shutterfly, you can create you own cards with plenty of options; they'll even mail them for you!

To get started, sign up for an account at *http://www.shutterfly.com*. You'll be prompted to upload some pictures during this process; make sure the one you want to use for your greeting card is among them. After setting up your account, log in and click on Create a Card. You'll be greeted by the screen shown in Figure 8-4.

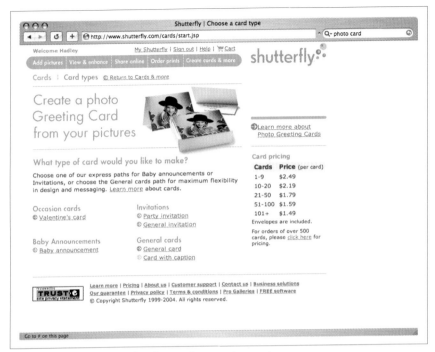

Figure 8-4. Getting started with an online greeting card

Choose which kind of card you want to create. Shutterfly has cards to capture specific occasions, or you can just choose a general card. Note the pricing for the cards—not a bad deal, especially if you order more than 20. Once you've chosen the kind of card you want to send, you need to decide whether you want the cards boxed and sent to you or whether you'd rather have Shutterfly mail them directly to the recipients.

With the business details taken care of, you can begin to design. There are a variety of borders from which to choose. I've selected the balloon border for my son's birthday invitation. Shutterfly prompts me to choose a picture by clicking it. Ta-da! The image I select appears in the card mock-up, as shown in Figure 8-5. I can also edit the image online, deleting red eye, zooming in, and applying effects. All changes take place in real time.

Once you have your image in place, it's time to create the *typography*: the font and color for your message. Shutterfly then renders the message according to your specs, letting you preview accurately how the final card will look, as shown in Figure 8-6. Spell checking is not available, though, so make sure you check the wording carefully. Click Back to edit your message, or click Next if you think everything looks fine.

Figure 8-5. Greeting card with my picture

Figure 8-6. Preview of the card's interior

If you want Shutterfly to mail your cards for you, you'll be prompted to build your address list. No worries, though; you don't have to spend a long evening typing everyone's information. Shutterfly lets you import your address list from your Outlook or Palm address book.

And that's it. Your cards are on their way, and you can move to the next item on your holiday to-do list.

—Hadley Stern

HACK #88 Keep a Digital Diary

Diaries enable us to document the big and little moments in life. And your pocket digital camera might be the greatest journaling tool of all.

Life moves so quickly. Before we know it, an entire year has raced by. Sometimes, we have difficulty remembering what we had for dinner last night, let alone what we did last month.

Keeping a diary helps give life perspective. Not only can we look back and appreciate the richness of our existence, but a diary can help us remember the specific dates that events happened. Many people don't want to take the time to explain, in words, the big and little moments as they occur. That's understandable. But our pocket digicams and camera phones can help us document our lives, and computers make organizing those images easy.

I'm going to walk you through an easy and effective way to keep a photo diary. Once you get a feel for the workflow and the types of tools you need, you can create a system that works better for you. Here are the necessary components:

Digital camera

You can use a pocket digicam, camera phone, or both. The key to a photo diary is having a camera available when events happen. It's not going to work if your only camera is a bulky digital SLR. In this case, portability is more important than image quality. Not only does your camera record the images of your life, it also captures when they happened. Every picture you take is timestamped. For this to work properly, be sure to set the correct date and time on your camera.

Digital shoebox

As you record the events of your life visually, you need a place to store the images. In this hack, I use Apple's iPhoto (*http://www.apple.com/iphoto*). I can upload my images, write comments about each one, and output the diary to paper, CD, or even a web site. Other great digital shoeboxes, such as Adobe Album (*http://www.adobe.com*) and iView Media Pro (*http://www.iview-multimedia.com*), work just as well.

Taking a picture every day is a good habit to acquire. It doesn't have to be a masterpiece, just something to show what kind of day it was. If it's autumn, a simple picture of colorful leaves will do. Caption it, "The maple trees in the front yard are in full color today and look beautiful."

Seems kind of boring, doesn't it? You'll be surprised that, over time, those images are anything but boring. Have you ever wondered, in hindsight, when the trees in the front yard turn colors? You'll know the exact date by referring to your digital diary.

Once a week or so, upload the pictures to your digital shoebox. All shoeboxes allow you to create custom albums, so you'll want to make one exclusively for your diary, as shown in Figure 8-7.

Figure 8-7. A photo diary using iPhoto

The date and time are embedded in the image file itself, so you don't have to worry about when something happened; the software will display that information for you. But you might want to add a few words about what was happening when you took the photo. Don't worry about writing an essay here; just use a few words to describe where you were and what you were doing, as shown in Figure 8-8. This whole process should take only a few minutes. The idea is to make this easy; otherwise, you won't do it.

Over time, your digital diary will grow and become quite interesting. Even after only a couple of months, you'll find that looking back is more fun than you would have imagined when you started the project. But there's more.

A great benefit of the digital approach is its archiving ability. At the moment, optical discs, such as CDs and DVDs, are the best bet for preserving a diary. But what about software compatibility? I don't necessarily want

Figure 8-8. Add a few words to each image to complete the record

to burn an iPhoto library onto a CD, because my nephew, who works on a PC, won't be able to read it.

To archive your diary, export it as a web catalog that can be viewed on any computer with a simple web browser. Any good digital shoebox allows you to do this. In iPhoto, make sure that the album is selected and choose File → Export. You have some basic options to choose from, as shown in Figure 8-9. Most important is the "Show comment" box, which ensures that the text you've included with each photo is transferred to the web catalog.

After you click the Export button, the digital shoebox will assemble your web pages and place them in the folder you designated. To check your work, simply open that folder and double-click on the *index.html* file.

Your web browser will open and you'll see a page of thumbnails with the date beneath each, as shown in Figure 8-10. The highlights and mundane events of your life are there before your eyes.

If you click on any image on the thumbnail page, the full version will open with the comment text below it, as shown in Figure 8-11. This is nothing like the diaries from the days of old. You have full-color images that capture the moments of your life with the precise dates and comments about what happened. Your diaries can be viewed on any computer by anyone you want to share them with.

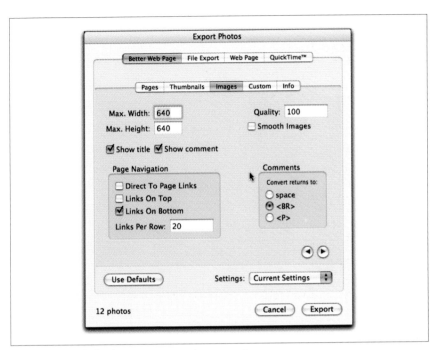

Figure 8-9. Include photo comments when exporting

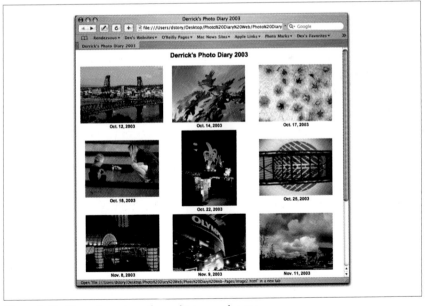

Figure 8-10. Your diary, transformed into a web page

Figure 8-11. The full version of an individual day

At this point, I recommend you burn the web version of your diary to at least two CDs or DVDs: one to keep on hand at home and another to store offsite, perhaps at your office or in a safe-deposit box. This will ensure that your memories will be safe for years to come.

One last thought about sharing your memories: you might want to post your diary on your personal web site **[Hack #50]** or even make a hardbound photo book **[Hack #86]**. This is the great advantage of digital storage: once you have the information neatly tucked away in your computer, there are countless ways to share it with others.

Capture Pictures of Your TV Screen

You can photograph images of your television screen just as easily as any other subject, as long as you know the secret camera settings.

Your brain might forget that a television picture is really a series of scan lines moving faster than the eye can detect. But the camera isn't fooled so easily, and often, first attempts at capturing TV images result in mysterious black bars spanning the screen, as shown in Figure 8-12.

Figure 8-12. Television picture caught in mid scan

If you have a digital SLR or an advanced prosumer camera that has a Shutter Priority setting, all you have to do is set the shutter speed to 1/15 of a second to solve the problem. That exposure is long enough for the television to complete a full scan cycle and render a complete picture, as shown in Figure 8-13.

But what if you don't have a Shutter Priority mode or some other way to set the shutter speed? Does that mean you're banned from television photography? Certainly not. You just have to get a little creative. Your success depends on fooling the camera into using a slow shutter speed. Here are a few tricks to accomplish this:

- Set the ISO to the lowest setting, usually 50 or 100. This helps create a longer exposure, which is what you want.
- Turn off the flash. It can't help you in any way with this type of photography.

Figure 8-13. A complete picture of the television screen

- Turn on the Spot Meter function, if your camera has one. That way, the camera will meter off the TV screen only and not be affected by ambient room light.

- Mount the camera on a tripod to steady it during the exposure. The longer shutter speeds are good for preventing scan lines from the television, but they put you at risk for camera shake, which deteriorates sharpness.

- Try to time the exposure for when there isn't a lot of movement on the screen.

- Shoot multiple exposures. The nice thing about using a digital camera is that you don't have to worry about wasting film.

These techniques will usually render a good image of the TV screen. But if for some reason you're still getting scan lines, there are a few super-tricks you can try. If your camera has a Nighttime Mode or a Long Shutter mode, activate it. Also, get your best pair of sunglasses—neutral in color, if possible—and hold them in front of the lens. They will serve as a polarizing filter and darken the image, forcing the shutter to slow down.

Sometimes, digicam autofocus systems have a hard time focusing on television screens. Hold the shutter button halfway down until you hear the focus-confirmation beep. Then, continue pushing down to make the exposure.

TV pictures have that certain, well, *television* look. But for those times when you want to document a world that would otherwise be out of reach, these techniques will get the job done.

Fax from Your Digital Camera

When a fax machine isn't handy but your digital camera is, you can still sign and return documents as if by fax magic.

Paper isn't going away, though there are days when I wish it would. A great example of such a time is when I receive a document in the mail that requires my signature and an immediate return fax. The signature part isn't usually a problem. But I often don't have a fax machine available. Fortunately, I always have my digital camera, which I can use to solve this problem.

Here's the basic procedure:

1. Sign the document.
2. Place it under an even light source and photograph it with a digital camera.
3. Upload the picture to your computer and open it in Photoshop.
4. Crop the image to standard document size.
5. Save the file as a PDF.
6. Attach the file to an email, with instructions on how to open and print it.

Once you get the hang of how to do this, your "digital-camera faxes" can actually look better than the output from half of the business fax machines being used today. But there are a few tricks you'll need to use along the way.

Photographing the Document

You want an accurate reproduction of the original document. With this technique, you'll be amazed at how good your "fax" will look. Follow this procedure to capture the image:

1. Place the document under an even light source, such as next to a north-facing window or beneath a desk lamp.
2. Put your digital camera in Close Up or Macro mode (look for the flower icon).
3. Adjust the white balance. If your camera has a Custom White Balance setting that reads the light and adjusts it accordingly, use that. Otherwise, use one of the presets, such as the Light Bulb preset for tungsten lighting.

4. If the document is printed on white paper, set your exposure compensation to +1.

5. Increase your ISO setting to 200 to avoid camera shake.

6. Hold the camera over the document so that the plane of the camera is parallel to the plane of the document. This helps eliminate distortion.

7. Make sure that the document is as squared-up as possible on the LCD monitor. Then take three or four shots of it.

Processing the Document

Now, you've essentially scanned your document. Upload the images to the computer, open them in Photoshop, and choose the best-looking one. You'll first want to rotate the image to make it vertical. Simply choose Image → Rotate and rotate the picture 90°. Next, you'll want to crop it to document size **[Hack #65]**. You'll want to set the width to 8 inches, the height to 10.5 inches, and the resolution to 150 pixels/inch, as shown in Figure 8-14.

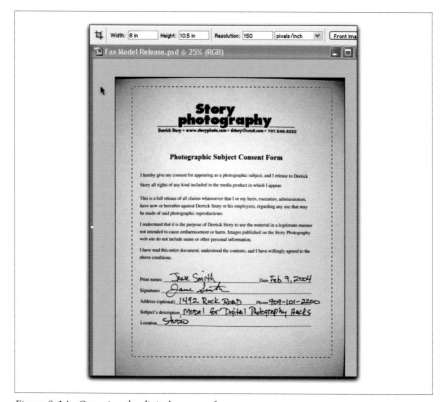

Figure 8-14. Cropping the digital-camera fax

If you have any nasty color casts you want to eliminate, open Hue/Saturation and move the indicator on the Saturation bar all the way to the left, where it reads −100. This essentially removes the appearance of all color from the file. If you need to brighten the image, you can do so by moving the indicator on the Lightness bar to the right.

Once you have the appearance the way you want it, choose File → Save As, give the document a descriptive name, and choose Photoshop PDF from the Format drop-down menu, as shown in Figure 8-15. Click OK.

Figure 8-15. Saving the document as a PDF file

You'll get a second dialog box, called PDF Options. Click the JPEG button and set Quality to 10. This provides you with a sharp-looking document and a small file size. The other option, ZIP, is a tad crisper but at a substantial cost. In my testing, the ZIP files were about 3.5 MB, while the high-quality JPEG files ran only about 750 KB and looked almost as good as the ZIPs. Save the bandwidth and go with the JPEG option.

Documents in Portable Document Format (*.pdf*) can be opened and printed on any computer platform. Plus, they rarely get corrupted when they're transferred by email.

Final Steps

All you have to do now is attach the file to an email and instruct the recipient to open it. The document will look darn close to the original.

Figure 8-16 shows the final document with the signature. I printed it on a regular inkjet printer and compared it to the original. It holds up just fine.

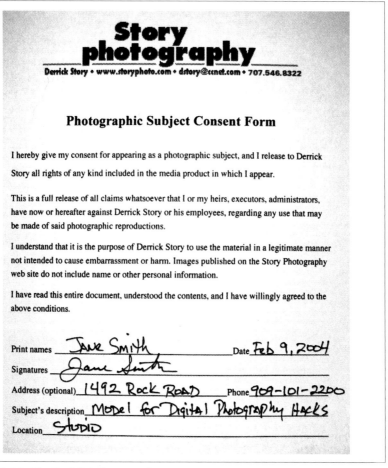

Figure 8-16. The final digital-camera fax

Your digital-camera document is really no different from a regular fax—except, that is, that it might look better.

Copy Slides with Your Digicam

#91

Dedicated slide scanners can be expensive and more than a little tedious to use. The digicam you already own might be your best bet for digitizing some of your favorite slides.

I have a lifetime of slides neatly tucked away in my closet, and I know it would take two lifetimes to properly clean, preview, scan, correct, and

archive my legacy image collection. But wait! What about using a digicam to copy all those images?

Previously, the preferred method was to enslave yourself to an ergonomic chair in front of a dedicated slide copier that was connected to your computer. Nikon, Minolta, Microtek, and Polaroid all have competent units.

Inexpensive flatbeds with transparency units in the lid don't do nearly as good a job as the dedicated slide copiers. Agfa, Epson, and Microtek make more expensive flatbeds that do better. The inexpensive units are not only cumbersome and time-consuming. They also don't have the resolution for small formats, such as 35mm, nor do they capture the density range that can hide in a slide. You're really better off renting time on a dedicated slide scanner.

This brings us back to using a digicam for this project. Before getting too excited, let's examine some of the potential drawbacks:

Compressed density range
> Most digicams (prosumer digital SLRs are the exception) capture *8-bit channels* (the amount of image information recorded by the device). Even inexpensive scanners usually do better, and the best scanners capture 16 bits per channel. So, expect to lose some shadow and highlight detail, much as you would when you're copying film to film.

No inline image correction
> There's nothing quite like scanning a faded slide and seeing it pop back to life with no scratches on your monitor. Many dedicated slide scanners have advanced software that analyzes the image and tries to fix its imperfections during the scanning process. That's not going to happen in your digicam. Expect to spend some time correcting color and cleaning up scratches.

Lower resolution
> Dedicated scanners know they're working with 35mm images that are destined to be enlarged substantially, so they offer very fine resolution (4,000 ppi) to capture huge files. Your digicam isn't going to do any worse than it does with anything else it shoots, but it won't approach the level of detail that a dedicated scanner delivers.

Interpolated color
> Scanners can move down the image, reading RGB at their leisure to create a full red, green, and blue sampling for each pixel (even sampling the same pixel up to 16 times to eliminate noise). Digicams capture the image in a fraction of a second, interpolating two of the three colors for every pixel.

Okay, so now your hopes are somewhat deflated. Don't give up yet. Copying slides with digicams also presents a few advantages:

- You can load several slides or negatives at a time, copying a roll of film in just a few minutes.

- Those compact file sizes are also an advantage. They're perfect for viewing on-screen and printing in standard sizes. What else do you need?

- The quality, I've found, is just fine. For important pictures, there are a few tricks you can perform to optimize the capture. And you can always resort to a dedicated scanner for the problem slides that need extra attention.

Using the Right Camera

This entire hack hinges on having the right digicam. Not every model is capable of capturing a tiny 35mm frame. First, your camera must have a Macro mode. Second, it has to capture a sharp image, corner to corner, with no lens distortion. Third, it has to get pretty close to the subject. Sometimes, that means adding a close-up converter lens.

 One sure sign that your digicam is capable of copying slides is if the manufacturer offers a slide-copying adapter. If so, you're in business.

I don't want to discourage you from rigging up an attachment to hold a slide in perfect alignment to any digicam's sensor plane. The US$40 Happenstance (*http://www.steves-digicams.com/happenstance.html*) is a simple device with which you mount your slide against a translucent piece of plastic and photograph it in Macro mode. I found that adding a little duct tape around the side, to keep ambient light from hitting the front of the slide, improved results.

If you have a digital SLR, you can adapt an old film slide adapter **[Hack #12]**. This system is cheap and works well. The only drawback is that most digital SLRs have more magnification than their traditional 35mm brethren, so your adapted 35mm slide adapter won't copy full frame. You will have to do some cropping, whether you want to or not.

Beyond that, some people have even built rigs with nothing more than a paper cup and rubber band. Put the slide in the paper cup so that the light shines through the bottom of the cup, illuminating the slide, and use a rubber band to attach the whole thing to your camera. Crude, yes. But in a pinch you can get a decent image out of it.

That said, I prefer to use the manufacturer's device for copying slides with my digicam. I need every advantage I can get.

Coolpix 990 with Slide Copier

When I want to copy film with a digicam, I use a Nikon Coolpix 990 with the US$80 Nikon Slide Copying Adapter (ES-E28). The Coolpix's Macro capability sets it apart from many other digicams, and the slide copier takes full advantage of it.

The Nikon adapter is a bulky but lightweight cylinder that screws into the lens thread, as shown in Figure 8-17. It has slots on both sides to slip in either the double-slide holder (which lets you leave the slides in their mounts) or the six-negative film-strip holder. The adapter holds them in place with a strong metal spring. The front of the adapter is a piece of milky Plexiglas that diffuses the light source.

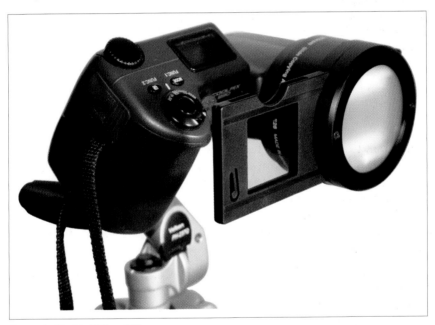

Figure 8-17. My Nikon 990 setup

In addition to sliding the holder back and forth, you can adjust the two-piece barrel up and down and change the angle of rotation. You can use a set screw to fix any adjustments you make.

Unlike some rigs I've seen, the Nikon adapter does not permit any ambient light to fall on the front of the slide. Not only is it enclosed, but it's also black inside. So the only light that hits the lens is transmitted through the slide.

You'll also need a tripod and your camera's power adapter. You want the camera to stay on while you reload the holders, and you don't want it sliding around as you shoot.

Finally, get a can of compressed air, preferably the environment-friendly kind that doesn't use CC and HCFC. Shooting this close greatly magnifies imperfections, such as scratches and dust, so cleanliness is a big issue. Just a couple shots of air on both sides of each slide or negative strip will help deliver clean images.

Technique with the Coolpix

Fortunately, no elaborate studio lighting is required. I've happily used nothing but sunlight as my light source. For night work, I've used my 16"×18" portable light table with two short, fluorescent tubes of certainly the wrong degrees Kelvin. I've also used a soft box. Anything that provides bright, even illumination to the diffused white plastic will work, but I do balance the light by setting a custom white balance while no slide is mounted. I even do that for sunlight so that the color cast of the slide itself isn't a factor.

If you use sunlight, remember that it moves. Make sure shadows don't fall across your setup as the day passes. I just take a look at the front of the adapter every time I reload it.

This kind of work is best done in Manual recording mode. Aperture Priority mode lets you choose a sharp f-stop (between f-4 and f-5 for this lens). You can adjust exposure for underexposed or overexposed slides by using the EV setting, which changes the shutter speed.

Manual focus is also worth considering. Once you've found focus, it won't change. Automatic focus systems that are based on contrast detection can be confused by flat subjects such as seascapes.

The next trick is to align the slides to the sensor. Since the adapter screws into the lens mount on the camera, I reset the alignment every time I attach the adapter.

With a loaded film holder positioned in the adapter, use the zoom control to display a nice, tight crop in the LCD, as shown in Figure 8-18. Take a shot and pull the card out of the camera. Then take a look at it in your image-editing program. Did you get the whole image? Is it too low or too high? Is it square? Make any necessary adjustments and continue testing until you get the alignment right.

Then, it's just a matter of loading the holder, blasting both sides of the slide with air, slipping each slide into the adapter, and firing the shutter for each image.

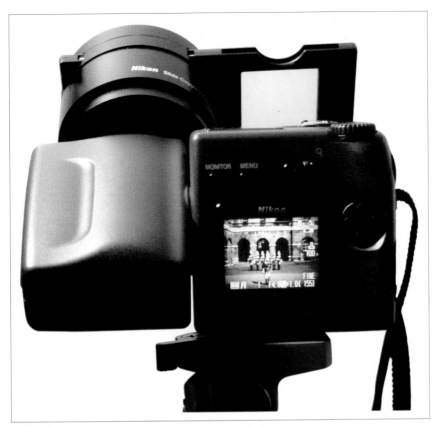

Figure 8-18. The slide in the LCD viewfinder, ready for capture

Extending the Density Range

While your digicam captures only eight bits per channel, this setup is ideal for bracketing two 8-bit captures that can later be blended into a single 16-bit image in Photoshop. This technique can greatly extend the dynamic range of images that have a lot of contrast.

Take at least two shots of any difficult image: one underexposed and the other slightly overexposed. You aren't limited to two, of course. I've taken as many as five.

Open each image in Photoshop and convert it into a 16-bit image. Use the Blend Exposures plug-in from Reindeer Graphics' Optipix suite (*http://www.reindeergraphics.com*) to create one 16-bit image whose tonal range and contrast provide the best of both images. When you're happy with the blend, save the image as an 8-bit channel image with the detail intact.

Copying Color Negatives

Color negatives are a special case. There's a great deal of misinformation about them, especially on how to handle the orange you see. It's important to understand that the orange tint you see when looking at a color negative is not equally distributed in the highlights and shadows, so you should not simply mask out orange from the image.

Shoot the negative normally (with a custom white balance) and convert it using custom curves in an image-editing program. You can batch your curves to apply to whole rolls at a time. If manipulating curves sounds too tricky, you might consider LaserSoft Imaging's NegaFix, part of their Silver-Fast Ai package (*http://www.silverfast.com*).

Final Thoughts

With the right equipment, it's easy, quick, and inexpensive to get pleasing results when copying slides and negatives with your digicam. But the real thrill is having digital access to all your old images, many of which might never have been printed, were perhaps given away, or have been forgotten.

If you can't spend the rest of your life scanning every slide in your collection, the next best thing is to copy your favorites with a digicam.

—Mike Pasini

HACK #92 Preview Film Pictures with Your Digital Camera

Digital cameras can take the guesswork out of film photography by allowing you to preview the composition and lighting before you make the film exposure.

One of the advantages of sticking with a camera brand—such as Canon, Nikon, Minolta, or Olympus—as you move from film to digital is that many of the accessories that work with your traditional SLR should be compatible with your prosumer or digital SLR. This benefit shines brightest when dealing with the challenges of flash photography with your film camera.

That's right; some of us still shoot film and will continue to for a long time. I prefer film for wedding photography, brightly lit landscape scenes, and any time I have to deliver a ton of prints that I don't want to edit in Photoshop. Heck, sometimes it's nice just to hand over the whole shoot to a photo lab and let them do the work.

One of the drawbacks of film photography is that you don't get to see how the picture turns out until it comes back from the lab. For important shoots,

such as weddings, this causes great anxiety. To get around this problem, photographers sometimes use Polaroid cameras, or a Polaroid back on their film camera, to preview the exposure.

Actually, this technique works quite well. You expose the Polaroid, and if the shot looks okay, you use those same settings to expose the film. That way, everyone sleeps better at night.

The problem is that Polaroid film is messy, expensive, and not always accurate. Digital cameras are actually better proofing devices, as long as you spend a little time calibrating them first.

This brings us back to staying with the same brand name so that your accessories work on both your film and digital cameras. For the last couple years, I've been using a Canon EOS Elan 7 to shoot weddings. But for proofing, I also keep a Canon G2 digital camera in my bag. The G2 has the same hot shoe as the Elan 7 (see Figure 8-19), which means that it accepts the same external flashes. The Canon flashes behave the same way for the G2 as they do for the film-based Elan.

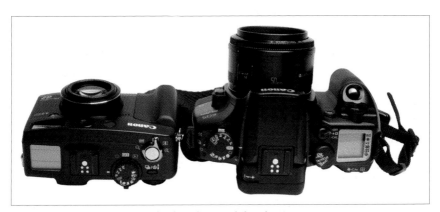

Figure 8-19. The hot shoe on the digital G2 and the Elan 7

So I did a little testing and discovered that the film I use for weddings reacts to light about the same as my G2 set on ISO 200. Ah, I can feel a good night's sleep coming on already.

After a wedding ceremony, when it's time to take the group shots, I get everyone in place. Then, I take a picture with the flash attached to the G2. I review the image on the LCD monitor and zoom in to make sure that everyone's face is visible and illuminated properly. If I detect a problem, I make an adjustment and take another shot with the G2. When everything looks good, I take the flash off the G2 and put it on the Elan. I double-check my

settings (shutter speed, f-stop, etc.), to make sure they are equivalent to what I used on the G2, and then take a few frames with the Elan.

Since I've started using this digital proofing system for film photography, I haven't been disappointed with a single group shot. And I sleep so much better at night. This system works within just about any family of camera accessories.

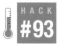

HACK #93 Photograph Zoo Animals Without Bars

With a little photographic wizardry, you can take pictures of your favorite animals at the zoo and eliminate the bars that stand between you.

Zoos and animal parks present great opportunities for wildlife shots that many of us would be unable to get otherwise. The problem is that we have to contend with those troublesome bars. Or do we? This hack shows how to set your images free; you can get great animal shots and eliminate the bars that cage them.

You can get rid of the bars, or minimize their impact on the photo, by taking advantage of the same shallow depth of field you use to blur the background in portrait shots [Hack #27]. However, in this case you want to blur the foreground. You need to open the aperture wide to make the depth of field shallow, with only the subject in focus, not the bars. Figure 8-20 shows the difference that changing the aperture can make.

The easiest way to shoot with the aperture wide open is to put the camera in AV (*Aperture Value* or, as we refer to it, *Aperture Priority*) mode so that you set the aperture while the camera picks the best shutter speed to obtain a good exposure. Once you're in AV mode, just set the aperture to as low a number as possible, such as f-2.8, f-3.5, f-4.5, or f-5.6. If your camera doesn't have an AV mode, give Portrait mode a try. This setting usually makes the camera favor a larger aperture.

The next thing to think about is your position in relation to the animal and the bars. The ideal situation is for you to be as close as (safely) possible to the bars while the animal is as far away from the bars as possible.

You also want to shoot perpendicular to the bars. The greater the angle you shoot at, the more of an impact the bars will have on the final photo, because their apparent spacing will become closer. Your camera's autofocus might not behave well, because it doesn't know if you want it to focus on the bars or the distant subject. If this happens, give manual focus a try.

For most photography, I tend to advocate taking the shot a little wider than you need to and then cropping it later. This allows for different printing aspect ratios and lets you adjust for crooked shots. Shooting through an

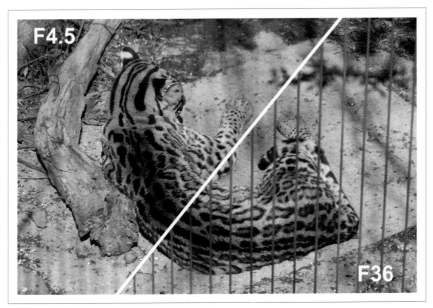

Figure 8-20. Same shot at different apertures—f-4.5 and f-36

obstruction such as bars at the zoo is an exception to this rule. You want to zoom in as close as you can; a focal length of 200mm is better than 100mm. The longer zoom also helps to blur the bars in the foreground. If you want to see how much of an impact this makes, take a shot of the entire animal and then take a shot zoomed in on the animal's face under the same conditions. You'll see that the bars interfere much less with the composition when you're zoomed in tighter on the subject.

One last factor to think about for this type of shot is sunlight on the bars. Although you can apply this hack under any conditions, the bars tend to disappear easier when there isn't any direct sunlight on them. If you are having problems, you might want to try changing your position and shooting from another angle. If you can, find a place where a tree is shading a section of the bars. Or, if you're really patient, wait for a cloud to come by.

Figure 8-21 summarizes the key factors involved in hiding bars in your shot. The box on the left shows the ideal conditions, and the box on the right shows the conditions to avoid.

So why does your photo look a little flat? Because you're not magically making the bars disappear; you're just blurring them heavily. So, although you don't see them as bars anymore, they still have an impact on the photo. The blurring effect casts a gray film over the image and lowers the contrast of the

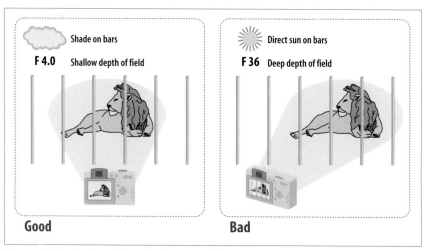

Figure 8-21. *Ideal conditions for eliminating bars*

shot. This effect is more apparent with thicker, narrowly spaced bars than with wire-thin, widely spaced bars.

You can compensate for this side effect during postprocessing in Photoshop. Applying the Auto Levels command (Image → Auto Levels) should brighten things right up.

As mentioned earlier, you can use this technique with any camera that lets you control the aperture, but as a rule of thumb, SLRs (digital or film) tend to create a narrower depth of field than point-and-shoot digicams. This narrow depth of field is what eliminates the bars. So this ability, along with the potential to choose a lens with wider aperture settings, gives the digital SLR a bit of an advantage here.

And remember—although you can free them from their bars, please don't feed the animals.

—*David Goldwasser*

HACK #94 Get Close with Digiscoping

Chances are, you already have the tools to get close to your subjects, even if they have little beaks and are perched way across the yard.

Wildlife photos taken with consumer-level digital cameras are often disappointing. To get a better shot, you must inch forward slowly, hoping to get close to the animal, or have powerful optics that make it seem like you're closer than you really are. Since most birds won't tolerate you standing next

to them while they peck at their dinner, most enthusiasts find themselves longing for telephoto camera lenses they can't afford.

To address this situation without maxing out the credit card, birders have turned to innovation. The most common hack is known as *digiscoping*. In its simplest form, digiscoping simply means using a spotting scope to zoom in on the subject and then holding the camera to the eyepiece to record the image.

Many consumer digital cameras have lens diameters that are similar in size to the lenses on birding scopes (or any other optical device), so they are a natural fit. Digiscoping can be used to get impressive, high-quality wildlife photos, to help prove and document what you've seen, or simply to give you a fun way to share and record your informal observations.

> Never let the lens of your camera touch the lens of your other optics, such as your spotting scope. You want your camera and scope in alignment, but no kissing!

Surprisingly good results can sometimes be achieved by simply holding the camera up to the scope's eyepiece. This method is useful mainly when you have plenty of light (which gives you fast shutter speeds) and need to act fast. In lower-light situations, where shutter speeds are slower, your slight movements while holding the camera are magnified by the scope, which results in a *soft* picture. A variety of commercial brackets that allow you to focus the scope and then move the camera into place quickly are now coming to market, but they are pricey. Many people have had stunningly good success with homemade rigs.

For example, I attached my Nikon Coolpix to a scope with some industrial-grade Velcro and a Pedco Ultrapod II **[Hack #1]**, as shown in Figure 8-22. I used a Nikon auxiliary lens adapter to fit the camera lens inside the rubber cup on the spotting scope's eyepiece. This setup isn't the height of elegance, but the pictures I captured pleasantly surprised me. I've also learned that if your camera doesn't have a lens-adapter attachment, you can cut the bottom out of a plastic film canister and rig that up instead.

This is not to say that I got perfect results with the first exposure. I learned many little tips and tricks that have really improved the percentage of successful pictures:

- The goal is to get as much detail as you can. Set your camera to the maximum *optical zoom*. Do not use digital zoom! Also, shooting at anything less than your camera's maximum resolution is a waste of time. Use the highest-quality settings.

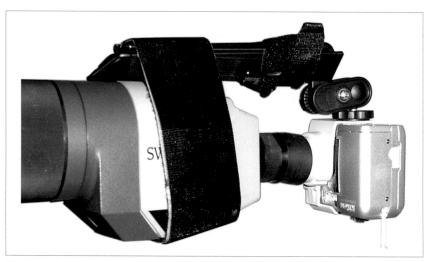

Figure 8-22. A digiscoping rig

- You need to get the lens of your camera within the *eye-relief range* of the scope lens—usually, the closer the better (without the lens surfaces touching, of course!) The eye-relief range is the distance from the surface of the lens to the point where you can see a full and focused viewing field—usually, where you place your eye. The image becomes focused within this range. If the lens of your camera is not within eye-relief range, you will get *vignetting*: a dark circle surrounding the image and/or bad focus. Eye relief varies by lens, so if you have multiple lenses for your scope, you might want to experiment. Fixed eyepieces might give you better results than zoom eyepieces.

- Do everything you can to prevent camera shake. A sturdy tripod for the scope is essential, of course. You want to do anything you can to steady the connection between the scope and the camera. For this reason, digiscoping might not be feasible in windy weather.

- If you can use a remote shutter release with your camera, do so. It will cut down on camera shake immensely. If not, try using the self-timer to initiate the exposure.

- Experiment with focusing. Use manual focus set to infinity and compare your results to those you get using your camera's autofocus. Results vary, depending on the situation and equipment, so find out what works best for you.

- A sunshade for your LCD viewer **[Hack #10]** can help immensely.

In my birding community, the most popular digiscoping digicams have been the Nikon Coolpix 950/990/995/4500 series (*http://www.nikon.com*). Their

internal zoom optics make it easier to get close to the scope's eyepiece without actually touching, and the swivel joint allows easy adjustment of the LCD viewer of the camera. The most popular scope seems to be the Swarovski AT HD 80mm (*http://www.eagleoptics.com/Swarovski/Spotting+Scopes/pid3453*). However, don't be discouraged if you have something else; experimenting is half the fun, especially if you can do it without going broke. Read on!

Digiscoping on the Cheap

Don't despair if you don't already have a scope; you can still get some of the benefits of digiscoping at a fraction of the cost by using a good pair of binoculars or a monocular.

To *digibinox*, you'll need to attach your binoculars to a tripod. I was able to get an inexpensive (US$10) binocular bracket mount that lets me use my Nikon Action binoculars with any standard threaded tripod head, as shown in Figure 8-23. Many binoculars have a threaded socket; sometimes, it's hidden beneath a removable button in the front, where the two halves meet. Once you get your binoculars mounted, you might want to keep the lens cap over one lens and work on getting exact focus on the side you'll use for the camera.

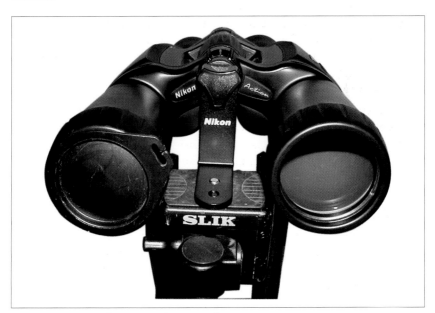

Figure 8-23. Binoculars mounted to a tripod

It also helps if you can fully extend your binocular's eyecups and use them to get a snug and stable fit against one binocular lens. You can try various tubelike adapters to achieve a nice fit. The Nikon Coolpix 775 is a low-end camera, but I've found that the optional UR-E3 converter/adapter (normally used for attaching accessory lenses) is quite useful for fitting the camera lens into the eyecup of binoculars or a scope, and it keeps out ambient light.

Since binoculars have a lower magnification than scopes, camera shake isn't as much of a problem, and your results when hand-holding the camera can be quite satisfying. They won't give you the super-close views of a scope with a professional camera-attachment system, but you might be pleasantly surprised by what you can achieve at a fraction of the price.

Figure 8-24 shows a comparison of the results you can achieve with your normal zoom lens, binoculars, and a spotting scope. For all three shots, I used a Nikon Coolpix 775 two-megapixel digital camera that was positioned 22 feet away from the subject. The top image was captured with its built-in 3x optical zoom. The middle shot was also taken with the 3x optical zoom, but the lens was hand-held to the eyepiece of a pair of Nikon Action 7 ×50 binoculars. The bottom image also used the 3x optical zoom, but this time it was hand-held to a Swarovski ST-80 scope with a 22x eyepiece.

Also experiment with monoculars, if you have them. Some varieties even have threaded screws that can be used to attach them elegantly to cameras.

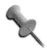 Special thanks to the Golden Gate Raptor Observatory (*http://www.ggro.org*) for the use of their scope for this hack.

See Also

- Laurence Poh (*http://www.laurencepoh.com*), the "father of digiscoping."
- Yahoo! Digiscoping Group (*http://groups.yahoo.com/group/Digiscopingbirds/*), an active community of digiscopers.
- Tips and tricks by Stéphane Moniotte (*http://www.md.ucl.ac.be/peca/test/tips.html*); includes an especially helpful section on adapter hacks and a page on *digibinox*.

—Terrie Miller

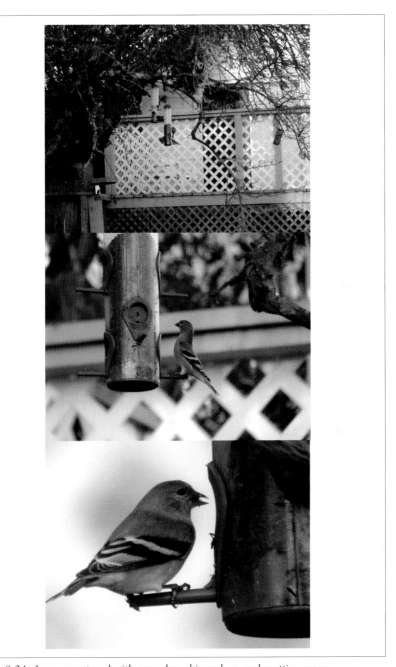

Figure 8-24. Images captured with zoom lens, binoculars, and spotting scope

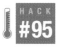

Advanced Panorama Technique

#95 Once you've played a bit with panoramas, you might want to raise the bar and produce professional-quality images. Here are some secrets the pros use.

"Get the Big Picture with a Panorama" [Hack #19] discussed the basics of capturing photos to be stitched into panoramic images, including putting the camera on manual exposure, using a fixed white-balance setting, and maybe even using manual focus. One trick you might not be using to broaden your shots is turning the camera vertically. Though you'll have to take more shots to span the same 180° scene, you'll capture more height in your composition.

When positioning the camera, it's import to keep it level. If your horizon is flat, you can use it as a guide. Better yet, you can use a hot-shoe level [Hack #9] where your flash would normally go. Once the camera has been leveled, don't continue to fiddle with its alignment; you'll have a harder time stitching the images together on the computer.

Avoiding Parallax

One of the most important terms related to panoramic photography is *parallax*. Parallax is the very thing that gives humans depth perception, but it is the enemy of panoramic photography. Here is a demonstration of parallax. Hold your finger out at arm's length; first close one eye, then the other. You finger moves relative to objects in the background. This is how we perceive depth. Now, while your hand is still out, close one eye again and this time rotate your head. You notice that your finger still moves relative to the background. This is because you rotate your head around your neck rather than your eye. If you were able to rotate around your eye, your finger would not move relative to the background.

When taking panoramic photographs, your goal is the lack of a parallax when you rotate the camera. It's not really an issue if you are shooting a distant landscape without any foreground objects, but as objects get closer, minimizing the amount of parallax (known as the *parallax error*) becomes more important.

So how do you avoid parallax? Well, every camera has an axis point beneath the lens (commonly referred to as the *nodal point*) around which you can rotate the camera to avoid any parallax error. This point is typically inside the lens. Once you have a method for holding the camera, you can use a little trial and error to hone in on just the right spot. I'll describe a technique for this later. Don't worry about perfection on this; for most shots, you don't have to be perfect, just in the ballpark. However, if you are shooting in a small, confined space, such as a car or small room, you want to put some time into finding the nodal point.

One option for successful camera rotation is to use a high-end, professional panoramic head. These are stable and easy to work with, but they're also expensive and heavy. Many of the companies that offer high-end panoramic heads also build entry-level models that are more in line with a typical consumer's budget. These panoramic heads mount the camera vertically and then offset it back and to the side so that the nodal point is over the center of the tripod. They also click in at set increments as you rotate, making it easy to get shots at equal spacing. For example, every 45 degrees might result in eight shots for a full 360-degree circle.

So, you're not ready to buy one of these? No problem; you can still capture excellent panoramas without one. Even the pros who use the high-end panoramic heads still find themselves in situations where they want to shoot a panoramic photo but can't drag all the equipment along.

Expert Hand-held Panorama Technique

When shooting panoramas, the natural tendency is to rotate around your heels with the camera out in front of you; however, you should not do this. As shown in the right half of Figure 8-25, when you rotate around your heels, the camera lens circumscribes a large circle.

| Good | Bad |

Figure 8-25. Proper handheld panorama technique

This is bad because the nodal point in the lens, represented in Figure 8-25 as short black lines, is nowhere near your center of rotation. Because of this, you have introduced a parallax error, just as you did when you turned your head with your finger out.

Instead, you should keep the lens position stationary, as shown in the left half of Figure 8-25. Stand with your left foot forward and right foot back. Place the ball of your left foot directly under the camera lens. Play around with your stance and the spread of your feet until it feels comfortable. Then, rotate around the ball of your left foot. The camera lens should stay at the same spot, while your right heel makes a circle.

The Cardboard-Tube Cradle

I have come up with a solution that is somewhere between hand-holding and using a full panoramic tripod head. This technique is ideal to use with a monopod and is best described as a *lens cradle*. I don't want to use the word *mount*, because the camera is not really mounted to the cradle; it just rests there, as shown in Figure 8-26. When using the cradle, I recommend you keep a hand on the camera and keep the neck strap around your neck.

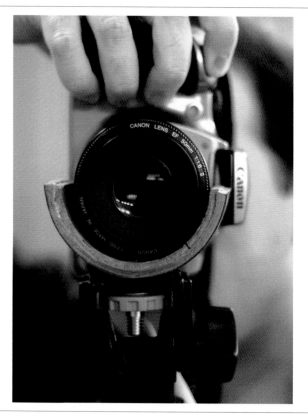

Figure 8-26. Cardboard-tube cradle

The only raw material you need to build this cradle is a tube. I used a heavy-duty cardboard tube, but I don't see any reason why you couldn't use PVC or some other material. The tube should have a diameter of roughly three inches. For tools, you'll need a knife or saw to cut the tube, and a drill with a 3/16" bit.

Here are step-by-step instructions for how to assemble the lens cradle:

1. Find a tube that fits the specifications described previously. It should be thick; otherwise, you will have to layer and glue a few pieces together.

2. Cut about a 1.5-inch section off the tube. Then, cut that section in half so that you have two pieces that each look like a C.

3. You will likely want to layer these pieces and glue them together, as shown in Figure 8-27, to make the cradle more rigid and thick enough that the tripod screw won't poke through the top. If the material is thick enough, you might be fine without layering.

4. Drill a hole in the center of the C to mount it to the monopod or tripod. I used a 3/16" drill bit. You might need to go bigger than this, depending on your tube material.

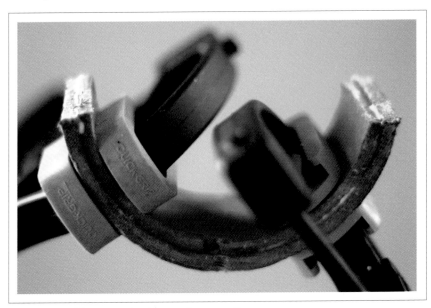

Figure 8-27. Gluing together layers of your cradle

Once you screw the tube onto the monopod, you're ready to go. Turn the camera sideways, rest the lens in the cradle, and shoot. You should focus ahead of time because the cradle might interfere with focusing, and you

should also take care to keep the monopod level. Mounting a level on the monopod, as shown in Figure 8-28, can make this easier. Also make sure that the camera is level in the cradle, not tilted up or down.

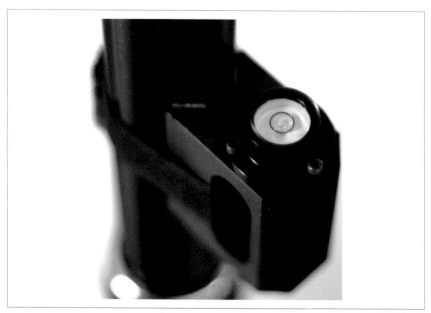

Figure 8-28. Bubble level attached to a monopod

So, now that you know how to rotate around the nodal point, how do you fine-tune the location of the nodal point for your lens? Basically, it's done by trial and error. Set up for a panoramic photo in a location where you have one vertical element close to the camera and another vertical element off in the distance. Place the camera with just a sliver of space between the two vertical elements. Rotate the camera to the left and then to the right. If that gap does not disappear or grow, you are right where you need to be. If the gap does change, try sliding the camera forward or backward in the cradle. If it gets worse, you went the wrong way or just went too far. Just keep adjusting with small moves until you are happy with the results; then make a mark on the cradle for future reference. Keep in mind that the nodal point of a lens will change as you zoom your lens, but most of the time, you will be shooting panoramic photos at the full, wide setting of the lens.

Perfecting your panoramic photography skills takes a while, but putting in the time up-front to learn how to get the best photos will save you time at the computer and give you a better photo in the end.

—*David Goldwasser*

Shoot the Moon

The moon is a fascinating photo subject, and with a little equipment and some experimentation, you can capture fantastic results.

The moon enhances the mood of evening landscape compositions [Hack #37], but it's also a great subject unto itself. With a little additional equipment and some hacking technique, your digital camera can get up close and personal with our favorite celestial body.

This hack discusses two advanced techniques for taking pictures of the moon. The first focuses on adding telephoto-lens attachments to the front of your digital camera lens, or attaching a telephoto lens to your digital SLR. The second technique involves attaching your digital camera to the eyepiece of a telescope to really zoom in on lunar surface detail. But first, let's look at some standard lens attachments you can use for this project.

Getting Your Glass Together

Job one is to use a lens with a focal length that is large enough to provide sufficient magnification. By doing so, the moon will be rendered as an acceptable size in your viewfinder.

When we discuss digital-camera lenses, we often use the so-called *equivalent* focal-length terminology, denoting the focal length (in millimeters) of a 35mm film-camera lens that has the same angle of view. For example, an Olympus C-3050 digicam might list its zoom lens as 7–21mm, but in film-camera terms, it's a 35–105mm *equivalent*. This means that the lens gives the same range of angles as a 35–105mm lens on a 35mm film camera.

To figure out how big the moon is going to look in your viewfinder, multiply the equivalent (or, in the case of a 35mm film camera, *actual*) focal length by 0.033 (or divide it by 30 for the same result). The result is the percentage of your frame the moon will fill vertically. Table 8-1 provides some of the more common focal lengths and their respective vertical-frame-fill percentage.

Table 8-1. Common focal lengths and their vertical frame fills

Focal length	Percentage of vertical frame fill
105	3.4
140	4.6
200	6.5
300	9.8
400	13.1
600	19.6

The values for 35mm film cameras are higher by a factor of 1.08x because of the different aspect ratio of the film frame—2:3, as opposed to 3:4, which is common for digital cameras. The coefficient value of 0.036 should be used for film cameras.

Obviously, size matters. While 200mm seems to be a reasonable minimum, the bigger the better. A few digital cameras have really long zooms (some models from Sony and Olympus go up to the equivalent of 400mm), sometimes even with image stabilization to avoid handheld camera shake. These long zooms can be used to shoot moon pictures right out of the box.

Olympus makes a good TCON-300 attachment for their E-10 and E-20 cameras, extending the focal-length range to 420mm. Moreover, this attachment can be used with another one, TCON-14B, providing an effective focal length of 600mm (oh, my!), which renders a surprisingly nice image, as shown in Figure 8-29.

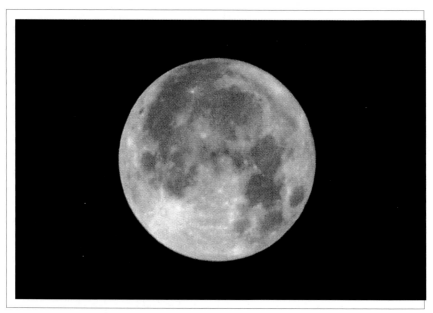

Figure 8-29. Moon shot with Olympus E-20 and attachments

Some other digital cameras—most notably, the Nikon CoolPix series, Canon G series, and Olympus 3000 models—have a provision for attaching auxiliary lenses. Check for lens accessories from outfits such as EagleEye (*http://www.eagleeyeuk.com/erol2row/erol.html*) and Kenko (*http://www. kenko-tokina.co.jp*).

If you have access to a digital SLR, such as the Canon Digital Rebel, you can beg, borrow, or buy long telephoto lenses to mount right on the body. If that option is available, it's the best way to go.

Making the Correct Exposure

The bright moon against a dark sky can fool your camera's automatic exposure system. So, it's best to go straight to manual exposure. Otherwise, your metering circuitry will average the exposure over the night sky (most of the frame) and the bright moon in the center, resulting in a hopelessly overexposed frame. Even if you have spot-metering, you won't avoid this problem, unless you are using a focal length of 400mm or higher.

Also, the moon happens to be one of the easiest subjects to set the proper exposure for manually. Its distance from the sun is almost the same as earth's, and it has no clouds. Therefore, the daylight moonscape is illuminated much like an Arizona desert at high noon. We can use the *sunny 16* rule here: with an aperture of f-16, set the shutter speed to the ISO speed setting. So if your ISO setting is 100, expose at 1/125 of a second.

You might be asking, "Why use the same settings you'd use for a sunlit landscape? The moon is so far away from us, 384,000 km, and we know that the light decreases as a square of the distance!" Yes, but so does the moon's apparent size, so the amount of light per pixel remains the same, regardless of the distance from which we're shooting it.

Remember, we are using the moon not as the source of illumination (we're using the sun for that) but as the subject of the picture. If we moved the moon twice as close to the earth, the exposure values would stay the same, although the moonlit scenes on the earth would be four times brighter. Got it?

The moon's apparent motion (about 360 degrees per day, 1/4 of a degree per minute, or one moon diameter every two minutes) is much too slow to be a concern at the shutter speeds we're talking about. For example, when the diameter of the moon is about 400 pixels, as in Figure 8-29, you need to expose at about 1/3 to get a one-pixel motion blur. And this is with an effective focal length of 600mm and a five-megapixel image size!

Since the moon fills just a small part of the frame, your picture will probably need to be cropped. For this reason, image sharpness is important. To make sure you get the sharpest image possible, use a fast shutter speed and mount your camera to a tripod. If you don't have a tripod handy, try to get

some support (a fence, top of a car, etc.) and shoot a number of frames to select the one with the least camera shake.

Finally, if your camera has manual focusing, switch to manual and set the focus for infinity (or, in case of an SLR, focus manually). Be aware that some cameras allow you to manually focus past infinity when a lens attachment is used.

Postprocessing Your Pictures

The original picture from your camera should have a significant amount of detail, but it might need some postprocessing in an image editor to add the finishing touches. The moon's image suffers when it passes through the earth's atmosphere, which significantly degrades the contrast and, to a lesser extent, the sharpness as well. So you might want to play with your pictures a little in your favorite image editor to brighten them up. When you're ready to sharpen, which should be the final step, refer to "Secrets of Sharpening" [Hack #63].

Also, be prepared to see some chromatic aberration on the borderline between the sunlit moon's surface and the sky (that's where it's usually most visible). Chromatic aberration usually appears as a green tint. This is unavoidable, unless you are ready to cough up US$7,000 for a 600mm professional lens. If you find this effect objectionable, desaturate your picture to monochrome [Hack #74]. Instead of the color fringe, you'll have just a bit of softness, which is much less noticeable.

Get Outta Town!

When using a long lens and a tripod, the detail in your picture will be affected by how clean the air is. There is one kilogram of air above you (assuming you're close to sea level) per each square centimeter, and that's looking vertically (if the moon is 45° above the horizon, the light path through air is about 40% longer). This is roughly equivalent to a glass pane 4 meters thick or 10 meters of water!

Humidity, dust, and density fluctuations all degrade the quality of your image, reducing contrast and sharpness. Therefore, observing some commonsense rules can greatly enhance the quality of your moon shots:

Get out of town. In rural areas, you avoid pollution, dust, and the scattered city light. Your pictures taken in West Virginia will be much clearer than those taken in suburban Maryland.

Get to the mountains. At the altitude of Denver, Colorado (1,500 meters above sea level), the air layer above you is reduced by about 20%. This

is a lot, considering that the air you've reduced is the warmest, most humid, and usually most polluted and density-fluctuated layer.

Choose dry weather. Humid nights (even without visible mist) are worse than dry ones. Arizona is much better than the east coast.

Remember that even if you can enhance the lost image contrast during post-processing, you will enhance, to the same degree, the inherent image-sensor noise of your camera. The same goes for sharpness enhancement; therefore, the less postprocessing you need to apply to your image to make it presentable, the more presentable it will be.

Try a Telescope

My friend Hong Zhao, from England, found an old telescope in her friend's closet. She dusted it off and used her Olympus C300Z (the same model is sold as the D-550 in the U.S.) to make the wonderful picture shown in Figure 8-30.

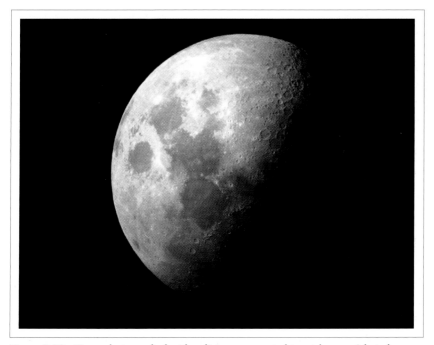

Figure 8-30. Moon photographed with a digicam connected to a telescope (photo by Hong Zhao)

The programmed exposure was 1/50 at f-2.9 (full aperture) and the zoom was set at F=6.6mm (EFL=33mm)—that is, at the wide end. At this focal length, the moon filled almost the whole frame height.

The camera was held to the telescope eyepiece. The telescope itself was a homemade Newtonian type with a 16cm mirror and f-8 aperture, 20mm Kelner eyepiece, and no equatorial drive. The shooting location was Hampshire, England—not far from London—and this is, I believe, Hong's first effort at astrophotography.

The three-megapixel camera did a respectable job for this assignment. The only postprocessing required for this image was a little brightening and slight sharpening. This clearly demonstrates how much you gain by using a telescope, even a relatively simple one. If you have an old Meade or Celestron gathering dust, get it out and start playing.

Final Thoughts

Really, though, why shoot the moon? We're all looking at the same moon. Your pictures will be much like mine or anyone else's. If, however, you enjoy photography as much as I do, you will not need a rational answer. Instead you can respond, to quote George Mallory, "Because it's there." In other words, it's your shot of the moon, and you can do whatever you want with it. Shoot the moon for fun, and for bragging rights.

—*Andrzej Wrotniak*

HACK #97 Remote-Control Camera

You don't always need to have your finger on the shutter release to control your camera. You might prefer to click the mouse button instead.

One of the things people often overlook when comparing digital cameras is the software that comes bundled with them. Throughout this book, it's clear that I think Photoshop Elements or its big brother, Photoshop CS, is essential software for digital photographers. A bundled copy of Elements is certainly something to keep an eye peeled for when shopping for a camera.

Beyond that, however, many manufacturers also include their own software to enhance the value of their product. This hack introduces another of my favorite bundled applications: remote-control software. I'll be working in Canon's excellent RemoteCapture program, which comes free with their cameras, but Nikon offers Nikon Capture, Minolta has DiMAGE Capture, and other manufacturers make similar products that are equally compelling.

RemoteCapture allows you to think about your camera in a whole new way. Instead of always needing to join photographer and camera at the index finger, you can mount your camera on a tripod, connect its USB cable to your computer, and watch what it sees on your computer monitor, as shown in Figure 8-31. You can even adjust its controls right from your keyboard. When you have everything the way you want, click the mouse to take the picture.

Figure 8-31. RemoteCapture setup

One of my favorite uses for this setup is photographing birds and other local wildlife that are shy around humans. Using a laptop computer, I can mount the camera on a tripod close to a bird feeder and then watch the activity on my computer screen. With RemoteCapture, I can zoom the lens in and out, control the flash, adjust exposure compensation, and even change the white balance, as shown in Figure 8-32. Once I take the picture, it appears on my computer screen for review. Based on a quick review of the shot, I can make further adjustments and take another shot.

If your USB cable isn't long enough for you to hide out of sight, you can add a USB hub on a cable to give yourself more working distance. Be sure to have an extra camera battery in your pocket if you plan on an extended

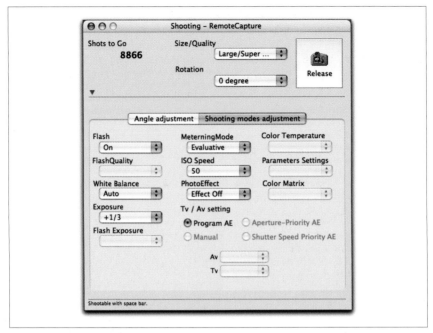

Figure 8-32. The remote-control panel for my digicam

shoot. RemoteCapture does turn off your digicam's LCD viewfinder, but the electronics are still active and draining the battery.

With this scenario, the power of your computer is extending the shooting capability of your camera. RemoteCapture's Time Lapse feature illustrates this point well. Using your computer, you can program your camera to take a picture at a specific interval over a designated period of time. The classic time-lapse series that we've all seen shows a butterfly emerging from its cocoon. But this technique has many other applications, including surveillance of an area when you're not present.

You will need an AC power adapter for both camera and computer. But who would have ever thought that your budget digicam could perform such sophisticated tricks?

Canon's RemoteCapture is a terrific enhancement to its digital-camera software bundle. If you're interested in pursuing these shooting options, be sure to investigate the bundled software, as well as the camera, when shopping for your next digicam.

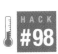

Show Who's Who in Group Shots

#98 Here's an easy way to let others know who's who in your group shots.

Most group shots are documented by listing the people in the photo from left to right. It's frustrating to count the names, then the people, to try to determine who's who. And, of course, people don't always stand in neat rows, as shown in Figure 8-33.

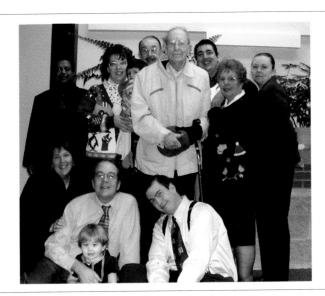

Figure 8-33. A family portrait without neat rows

Why not use your digital-editing abilities to make a handy photo key instead? Make a copy of the image and open it in Photoshop. Desaturate the image to simple black-and-white tones (Image → Adjustments → Desaturate), and then adjust the brightness and contrast (Image → Adjustments → Brightness/Contrast) until you have a *ghost* image of your photo.

Use the Text tool on the floating Tools palette to add labels to the image. Use a nice, bold font in a pleasing color to help separate the text from a busy image, as shown in Figure 8-34.

Now, output your photo label and attach it to the back of the printed original, or place it online next to the original. Anyone looking at the photo will be able to scan the key quickly to match names to faces.

You can also use this method to point out landmarks on a landscape photo, or to indicate areas of interest.

—Terrie Miller

Figure 8-34. Digital labels to help identify who's who

HACK
#99

Rename Photos Automatically in Windows XP

What do you do when you have a whole folder full of vacation photos with weird, camera-generated filenames that don't make sense? This simple Windows XP hack will give them all more meaningful names.

Unless you really have a lot of time on your hands, I doubt you want to go through the massive folder that contains your European vacation photos and rename them *Europe_1.jpg*, *Europe_2.jpg*, and so on down the line. If you're running Windows XP on your computer, you don't have to do this. Simply apply this hack to quickly apply a meaningful label to every picture in the folder.

First, open the folder and select View → Thumbnails. Click on the last picture in the folder you want to rename, hold down the Shift key, and click on the first picture; this will select them all.

Right-click on the first photo and select Rename from the drop-down menu, as shown in Figure 8-35.

Windows XP will highlight the filename for the first photo, enabling you to give it a descriptive name. After you type in the name, click on the white space outside of the photo and watch as Windows applies the name with a sequential number to each picture in the folder, as shown in Figure 8-36.

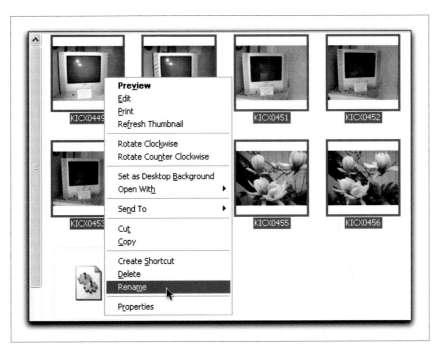

Figure 8-35. Choose Rename from the right-click menu

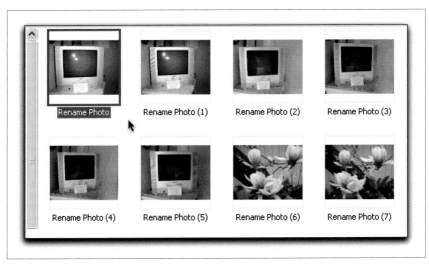

Figure 8-36. An entire folder of renamed folders

This is a quick way to manage all of those photo filenames that seem to multiply on your computer's hard drive. To learn more tricks for organizing these files, see "Name Folders to Organize Your Images" [Hack #49].

Stack Images to Remove Noise

You can dramatically reduce image noise by taking multiple photos of the same scene and layering them in Photoshop.

One of the main draws for switching to a digital SLR from a point-and-shoot digicam is the silky-smooth pictures they take. Short of taking the plunge into the digital SLR market, what can you do to get images like that with your current camera?

The most basic step toward reducing noise in images is to use the lowest ISO the camera offers. You want to set the ISO manually rather than leaving it on automatic. Otherwise, the camera might sacrifice the best ISO setting for a faster shutter speed.

Another common technique is to use postprocessing software to reduce image noise while protecting detail in the photograph. Most applications are good at this, but you can't push noise reduction too far or you will notice some loss of detail.

Which brings us to the *stacking technique*: a noise-reduction approach that does wonders for reducing noise without any negative effect on image detail. How does this work and what is the catch? The catch is that it requires extra work on your part, both while you're shooting and during postprocessing, and you can use this technique only on certain types of scenes.

This technique is based on the fact that most camera noise is random noise. If you take the same shot over and over again, most of the noise will be different from shot to shot. While none of these shots is any less noisy than the others, if you merge them together, you get a much cleaner image, as shown in Figure 8-37. On the left, the original image has noticeable noise in the sky and water. By stacking five shots, I've dramatically reduced noise, as shown in the image on the right.

If you're having trouble understanding why there will be less noise with these layered shots, think of a political poll. For one poll, I ask 100 people who they intend to vote for. Then, I conduct a second poll and ask 10,000 people who they will vote for. Odds are, the second poll will be more accurate because of the larger sampling. This is similar to the technique for stacking photos to reduce noise. With five stacked images, I have more information and therefore better results.

If you are shooting your kid's soccer game, this approach won't do you much good. But if you want to photograph a landscape or still life, you're in good shape. Your subject must be a static scene, and you need to mount your camera on a tripod, preferably using a remote release. Try not to touch the camera between shots, because any movement will blur the final results.

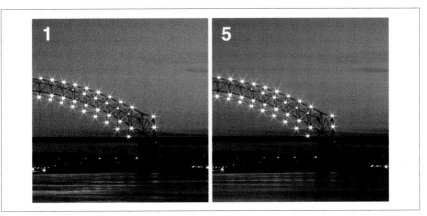

Figure 8-37. The original scene and the stacked image

If you can, set your camera to manual focus. Changes in focus can create subtle changes in the field of view. If your camera does not have manual focus per se, you can use the Infinity or Landscape mode that is identified by the mountains icon. The goal of all this is to use the same settings for each shot.

Three to five shots is a reasonable number of photos to take, although every additional shot makes the result a little better. However, there is a point of diminishing returns, where you're just wasting your time and valuable space on your memory card.

Here's a breakdown of your fieldwork:

1. Choose a static scene.
2. Use a tripod, with remote release if possible.
3. Use the lowest ISO setting.
4. Focus the shot and then switch to manual focus, if possible.
5. Shoot three to five shots.

Processing on the Computer

Now, what do you do once you have the photos on your computer? Although some applications can take a series of images and average them automatically, we can also work our magic in Photoshop Elements or CS. Here is the basic procedure:

1. Open the first photo.
2. Open the second photo.

3. Choose Select → All, copy the second photo to the clipboard, and close the second photo.

4. Go back to the first photo. Use the Paste command to place the second photo on top of the first one.

5. Repeat for the rest of the photos.

At this point, you see only the top image. You need to adjust the opacity of each image layer so that they contribute equally to the final image.

When you begin, all the layers are at 100%. You want to keep the bottom layer at 100%, but you want the next layer above it to be at 50%. Continue working your way up the layers, assigning the following opacity values to each subsequent layer: 33%, 25%, 20%, 16%, 14%, and 12%. You can continue this pattern for as many photos as you have, like so:

1. Go to the Layers palette and select the layer that is second from the bottom.

2. Set the opacity to 50%.

3. Go to the next layer up and set the opacity to 33%.

4. Keep repeating the previous step, while adjusting the opacity number down for each layer as you go up.

Understanding the Numbers

For those of you who love brain teasers, where did those strange numbers come from? The opacity for each image layer is determined by dividing 1 by the number of the given image layer number. So, the first image is 1/1 (100%), and the next ones are then 1/2 (50%), 1/3 (33%), 1/4 (25%), and so on. Those fractions you learned in grade school might just come in handy after all.

Figure 8-38 shows the Layers palette in action. For this demonstration, I have named the layers to match the opacity amount, but you don't have to do this. Just change the opacity in the box at the top-right corner of the palette.

Flatten the photo into one layer and save it as a TIFF or JPEG file. Congratulations; you're done! Now, you can continue your curves, levels, and sharpening adjustments as you would for any other photo.

Other Things to Consider

You might have noticed that there is moving water in my sample shot. Some motion—in particular, things that are flowing, such as water, cars, or

Figure 8-38. Stacked layers in Photoshop

clouds—is fine. As long as you like the end result, it is not a problem. The only thing to keep in mind is that the effective motion blur for the moving objects is determined by the combined exposure time of all the shots, as opposed to the time for an individual shot. For example, in the shot of the bridge shown in Figure 8-38, I used five 4-second exposures, so the final image has the motion blur of a 20-second exposure.

So on long-exposure shots, why do certain pixels jump off the background on each shot? These are called *hot* or *dead* pixels. They are not eliminated because they are not random. If you're lucky, all of the pixels will be healthy on your camera and you won't have any of these troublesome spots to correct. Some cameras deal with this internally, and there are also some software solutions. As a last resort, you can fix them with the cloning tool during postprocessing.

Digital photographers are not the first to use this stacking technique to clean up images. For a long time, astronomers have been capturing video through their telescopes and averaging hundreds of shots to get amazingly clean photos out of what would otherwise be a noisy image. With stars, you really don't want all that noise in the way. Of course, to do this with stars, your telescope needs to have a tracking system.

Final Thoughts

So grab your tripod and a big memory card, and start shooting. The only problem is, once you see how nice these shots are, you might become addicted to this technique and want to use it on all your shots. For a variation on this technique, you can bracket your shots at different exposures to help expand the dynamic range of your photographs.

—David Goldwasser

Index

We'd like to hear your suggestions for improving our indexes. Send email to *index@oreilly.com*.

Colophon

Our look is the result of reader comments, our own experimentation, and feedback from distribution channels. Distinctive covers complement our distinctive approach to technical topics, breathing personality and life into potentially dry subjects.

The tool on the cover of *Digital Photography Hacks* is a paintbrush. The camera is to photography what the brush is to painting. Our digicams enable us to capture light and create compositions in much the same way as a brush lets us direct raw color to express our vision.

Emily Quill was the production editor and proofreader, and Brian Sawyer was the copyeditor for *Digital Photography Hacks*. Sarah Sherman and Claire Cloutier provided quality control. Mary Agner provided production assistance. Julie Hawks wrote the index.

Hanna Dyer designed the cover of this book, based on a series design by Edie Freedman. The cover image is an original photograph by Hanna Dyer. Emma Colby produced the cover layout with QuarkXPress 4.1 using Adobe's Helvetica Neue and ITC Garamond fonts.

David Futato designed the interior layout. This book was converted by Julie Hawks to FrameMaker 5.5.6 with a format conversion tool created by Erik Ray, Jason McIntosh, Neil Walls, and Mike Sierra that uses Perl and XML technologies. The text font is Linotype Birka; the heading font is Adobe Helvetica Neue Condensed; and the code font is LucasFont's TheSans Mono Condensed. The illustrations that appear in the book were produced by Robert Romano and Jessamyn Read using Macromedia FreeHand 9 and Adobe Photoshop 6. This colophon was written by Derrick Story.

Need in-depth answers fast?

Related Titles Available from O'Reilly

Hacks

Amazon Hacks

BSD Hacks

eBay Hacks

Excel hacks

Google Hacks

Harware Hacking Projects for Geeks

Linux Desktop Hacks

Linux Server Hacks

Mac OS X Hacks

Mac OS X Panther Hacks

Spidering Hacks

TiVo Hacks

Windows Server Hacks

Windows XP Hacks

Wireless Hacks

Digital Media

Adobe Photoshop CS One-on-One

Digital Photography: Expert Techniques

Digital Photography Hacks

Digital Photography Pocket Guide, *2nd Edition*

Digital Video Pocket Guide

iPod & iTunes: The Missing Manual, *2nd Edition*

O'REILLY®

Our books are available at most retail and online bookstores.
To order direct: 1-800-998-9938 • *order@oreilly.com* • *www.oreilly.com*
Online editions of most O'Reilly titles are available by subscription at *safari.oreilly.com*